D0227893

Expressive Arts with Elders

*of related interest*

**Storymaking and Creative Groupwork with Older People**
*Paula Crimmens*
ISBN 1 85302 440 6

**Music Therapy in Dementia Care**
*Edited by David Aldridge*
ISBN 1 85302 776 6

**Contemporary Art Therapy with Adolescents**
*Shirley Riley*
*Forewords by Gerald D. Oster and Cathy Malchiodi*
ISBN 1 85302 637 9

**Medical Art Therapy with Adults**
*Edited by Cathy Malchiodi*
*Foreword by Richard Lippin*
ISBN 1 85302 279 4 pb
ISBN 1 85302 678 6 hb

**Discovering the Self Through Drama and Movement**
**The Sesame Approach**
*Edited by Jenny Pearson*
*Foreword by Anthony Stevens*
ISBN 1 85302 384 1

**Storymaking in Bereavement**
**Dragons Fight in the Meadow**
*Alida Gersie*
ISBN 1 85302 176 8

**Hearing the Voice of People with Dementia**
**Opportunities and Obstacles**
*Malcolm Goldsmith*
*Preface by Mary Marshall*
ISBN 1 85302 406 6

# Expressive Arts with Elders

## A Resource

*Edited by Naida Weisberg
and Rosilyn Wilder*

Jessica Kingsley Publishers
London and Philadelphia

Dementia Services
Development Centre
University of Stirling
STIRLING FK9 4LA

All rights reserved. No paragraph of this publication may be reproduced, copied or transmitted save with written permission of the Copyright Act 1956 (as amended), or under the terms of any licence permitting limited copying issued by the Copyright Licensing Agency, 33–34 Alfred Place, London WC1E 7DP. Any person who does any unauthorised act in relation to this publication may be liable to prosecution and civil claims for damages.

The right of the contributors to be identified as authors of this work has been asserted by them in accordance with the Copyright, Designs and Patents Act 1988.
First edition published as *Creative Arts with Older Adults: A Sourcebook.*
in 1985 by Human Sciences Press, Inc.
This edition published in the United Kingdom in 2001 by
Jessica Kingsley Publishers Ltd,
116 Pentonville Road, London
N1 9JB, England
and
325 Chestnut Street,
Philadelphia, PA 19106, USA.

*www.jkp.com*

© Copyright 2001 Jessica Kingsley Publishers

**Library of Congress Cataloging in Publication Data**
A CIP catalog record for this book is available from the Library of Congress

**British Library Cataloguing in Publication Data**
A CIP catalogue record for this book is available from the British Library

ISBN 1 85302 819 3

Printed and Bound in Great Britain by
Athenaeum Press, Gateshead, Tyne and Wear

# Contents

**Forewords**

Empathic connections      9
*Stanley H. Cath, M.D., Tufts University School of Medicine, Boston*

Why some older persons disconnect      13
*George S. Sigel, M.D., New England Medical Centre and Kit Clark Senior Services*

Editors' introduction      21
*Naida Weisberg and Rosilyn Wilder*

**Part I: Art experiences accessible to all      29**

Chapter 1    Approaches to training and curriculum design
in the visual arts for the elderly      31
*Pearl Greenberg, National Lecturer on Art and Gerontology*

Chapter 2    'To be remembered...'      44
*Addendum:* Thoughts of the millennium      55
*Georgiana Jungels, University of Buffalo, New York*

**Part II: Dance and movement:
A primary art expression      59**

Chapter 3    'Can you grab a star?'
Dance and movement in a senior resource center      61
*Jocelyn Helm, Senior Activities and Resources, New Jersey*

Chapter 4    'My cheeks are rosy anyway: I can't be dead'
A multi-arts program in a mental institution      79
*Dorothy Jungels, Everett Dance Company and Carriage
House Theatre, Rhode Island with John Belcher, Musician,
Massachusetts*

## Part III: The drama in our lives                                  91

Chapter 5    First encounters                                        93
             *Naida Weisberg and Rosilyn Wilder*

Chapter 6    Life journeys: The STOP-GAP method with elders          99
             *Don R. Laffoon, STOP-GAP Institue, California,*
             *Victoria Bryan, STOP-GAP Institute, California and*
             *Sherry Diamond, STOP-GAP Institute, California*

Chapter 7    '...Secrets I never told before...'
             Creative drama and drama therapy
             with handicapped elders                                112
             *Rose Pavlow, Drama Therapist, !Improvise! Inc.*

Chapter 8    A tapestry of voices: From interview to script         124
             *Bernice Bronson, Playwright, Director, Actress, Rhode Island.*

## Part IV: Intergenerational:
## Youth and elders come together                                   135

Chapter 9    Youth and elders inter-act                             137
             *Rosilyn Wilder, Expressive Arts Therapist*

Chapter 10   What does it mean to be Hispanic in
             Rhode Island?                                          151
             The oral history/life story theatre project
             *Naida Weisberg, Expressive Arts Therapist*

Chapter 11   The folk-tale as catalyst                             163
             *Rose Pavlow, Drama Therapist, !Improvise! Inc.*

## Part V: Music and sound to liberate the
## individual                                                       177

Chapter 12   Older adults are total people                          179
             *Marian Palmer, Music Therapist, National Speaker/*
             *Consultant and Gerontologist, Florida*

Chapter 13   A route to the heart in a short-term hospital setting  188
             *Christoph Grieder, Music Therapist, St Barnabas Hospital,*
             *New Jersey*

Chapter 14  'We've no less days...'
            Music as an activity in nursing home
            and senior center                                    200
            *Delight Lewis Immonen, Rhode Island College Faculty.*

## Part VI: Writing: The word unites experience: Past, present and future                    213

Chapter 15  Is it literature, is it art?
            Writing workshops with literate and illiterate       215
            *Laura Fox, Taproot Workshops, Long Island, New York.*

## Part VII: Significant resources: A psychologist and a poet                    239

Chapter 16  The creative powers within us
            A philosophy and a rationale                         241
            *Marilyn Barsky, Clinical Psychologist, New Jersey*

Chapter 17  Invocations of group process and leadership         253
            *Marc Kaminsky, Psychotherapist, Gerontologist, New York*

CONTRIBUTORS                                                     262
BIOGRAPHICAL SKETCHES                                           264
PROFESSIONAL ORGANIZATIONS                                      270
INDEX                                                           271

# Acknowledgements

### From Naida Weisberg

First of all, to Al, my husband of 50 years, for limitless support, jokes, and picture-taking.

To our children, Martha, David and Abby, for their concerned opinions, gentle questioning and empathic interest in my work.

An extra bow to Abby for typing, reading and proofing, and to my son-in-law, Peter, for his lunchtime tech assistance! To my young grandsons, John and Max, who tell extraordinary stories – in the bathtub, at the table, on the rug, in the car...

To the students, elders and staff in the Central Falls, Rhode Island Intergenerational Program: You will always be remembered with affection and admiration by !Improvise! Inc.

And to contributing author Marilyn Barsky, my dear friend; although she is no longer with us, her fine intelligence and generosity of spirit are alive in her writing. She was an inspiration to me; I loved and learned from her.

### From Rosilyn Wilder

There are persons who encourage and inspire us whether they are present or not. Such a one is my late husband, sculptor Ben Lieberman, long-time champion, merciless editor, and playful advisor.

My very present cheering-squad consists of our children, successful writers, teachers, and musicians: Jeannie Deva, Julie Lyonn Lieberman, and respective husbands Joseph Scoglio and Leonard Cascia; also friends and colleagues who, when the going has zigzagged, have said 'Go, go!'

I want to honor some of the major players unnamed in my 'intergenerational' chapter: Elsie Bragger, Carroll Clayton, Rasheeda Sampson and Marvin Jefferson, Lauretta Freeman and Lynne Kramer, among others; and to all the members of Autumn Stages, Older Adult Lifestory Theatre – 'Bravo!' Also Patricia O'Rourke and husband John Willemsen, and all Encomium Arts, Inc. board of directors, who believed in all our programs with elders and youth.

We thank our contributors who have eagerly shared expertise and revealed their commitment to the creative process with elders, and with children and youth collaborating with elders. We also thank the firm and infirm with whom we have worked in a great many places.

Especially, we gratefully remember our parents who aged as gerontocrats.

# Foreword

## Empathic connections

Art...is a concrete living expression of the lives
which have created it
and thereby a connection to tomorrow.

### Landscape of the soul

Very few things do not change in our lives. However, deep within us,
certain core experiences contribute to an ongoing nuclear sense of self.
Our earliest bonding and rupturing experiences consolidate either into a
feeling of cohesiveness and pleasure or, contrariwise, may set into motion
various protective devices we all use so as not to be hurt by loving and
trusting.

All our lives the landscape of the soul is, or is threatened to be, littered
with the debris of our search for others to complete and comfort our
idealized or disillusioned relationships, as well as shattered dreams. Thus,
by mid-years, a balance is struck between aspirations fulfilled and goals
never reached.

Then, with time pressing ever on, whatever personal integrity and grat-
ification has been achieved may be lost. Disability or illness may be super-
imposed upon ordinary disappointments. Our ability to grieve for our
losses and to recover from them may be outweighed by our burden of
depletion.

Many elders have lived long enough to know what it means to have
their sense of personal ongoingness irretrievably challenged by the loss of
children, spouses, or dear friends. Grieving soon enough becomes a
constant companion. Many illnesses demand increasing contact with the
medical community, which adds to generalized levels of anxiety. Some
cope beautifully with inevitable loss and disappointment by coming to
terms with the realization that the only perfection in life is to accept
imperfections in themselves and others. But this inordinate command for
courage and understanding may come at a time when the ability to grieve

for losses and recover from insults is unusually compromised. This may not only be due to the burden of normal depletions of inner resources, but often enough is accentuated by individual characteristics or psycho-pathological states.

In my work with long-lived people I have found a range of character types, various lifestyles and, above all, unique responses to the crises of disability, disease, depletion and death. In the passage of the evanescent to the senescent phases of life, three fairly distinct groups emerge. I think of them as gerontocrats, ordinary folks, and gerontophobes.

## Gerontocrats, ordinary folks, and gerontophobes

The first and rarest are the *gerontocrats*. Such people rarely need our aid, for they live long, well and beautifully. Should they encounter creative arts, they are well invested and may have developed particular skills in their hands or heads. These creative gerontocrats may well teach us a great deal, assist us in our work and make our job easy. Some have made their contribution intellectually, some artistically, and some in business or the political world. They can move on from one relationship to another, from one interest or career to another, without apparent pain.

On the other extreme are the *gerontophobes*, for whom life has always been a struggle. They inordinately dread aging, especially because some of these people have invested so heavily in preserving their bodies and their attractiveness. But attractiveness and physical integrity is transitory and if it remains the major modality in preserving self-esteem and connectedness, it is not surprising life's end-phases may carry unspeakable horrors.

In between are most ordinary people who, especially when in need, welcome our efforts to establish connections with their inner being. Resistance is minimal, for without external guidance and inspiration, they rarely feel creative. The main task of living long has become how to support and hold the self together in an empty, changing and depleting world. Unlike gerontocrats, most ordinary folk lack creative capacities to find new means to release tension and rationalize away their imperfections, failures and disappointments enough to reach inside to hidden reserves.

## Art and Connectedness

Art, in its protean forms, tends to span time and space, and in so doing assures humankind of its connectedness with the past, while seeming to promise an immutable and indefinite, rather than finite, future. It may well be that art does not communicate the same thing to different people. But I suggest that it may convey the same message to all: *it is a concrete, living expression of the lives which have created it* and thereby a connection to tomorrow. It is this connectedness revived which seems to define and affirm living, while it *defies destiny*.

In most people we can be certain there exists the wish not to be alone and the wish to reach out to others. The question is how to find the right key, how to find the door into which it will fit, and finally, if permitted to enter, how to make an empathic connection. For our purpose there must be time; we need to provide a place and create a method designed for the person or persons at hand. The creative artist intuitively opens doors to old reservoirs of hope and energizes hidden illusions.

With elderly people there is an additional facilitating factor. In the world of drama, dance, art, and music, familiarity and old illusions play pivotal roles. But so do the earliest of experiences, often the last memory to be lost in dementia. It is an amazing experience to witness a group sing in a nursing home when Alzheimer patients, who may seem without any past and are most inarticulate, join in group sing-a-longs. We may witness old, demented, as well as relatively intact people still able to play, sing, and act.

Admittedly, as psychiatrists we have made many assumptions about the sources of pathology. We now can point to genetic factors, emotional neglect, trauma, environmental toxins, etc., all combined with various forms of conflict between generations. Yet we are relatively ignorant of the true nature of wellness or disease. We still stand in awe of the power of art to sooth the agitated man or woman.

Teasing out all the important factors is impossible, but much depends on the capacity of the artist to discern the need for and impart a feeling of appreciation as she or he carries out a seductive re-engagement into the world of doing, playing, and accomplishing things.

In today's mismanaged care environment, many socio-economic forces sabotage all efforts by unrealistically limiting the time we can devote to

our work. From this negative perspective, we may indeed be imperiled by impersonal technologies outpacing our ability to understand them, and by families eroded by modern mobility and weakened by inappropriate stress upon independence.

From a more positive perspective, the creative artist may transcend all this because her or his work contains an international symbolic language, understood by all kinds of people of all ages, resonating with their past familiar anchorages. Many forms of isolation may yield as the veil of protective withdrawal is lifted, and old, almost forgotten sources of mastery and pleasure are revived.

Simultaneously the creative artist has consistently assured humankind of a way of expressing its connectedness to the past, of preserving narrative history, while still promising an immutable and indefinite (rather than finite) future.

That is what the authors in this book are trying to do. Not only do they bring the possibilities of a more fulfilling life to the long-lived, but also to all those who care for them. The family and all observers witness the power of art to awaken empathic connectedness. To become such a catalyst is the gift of the creative artist, a delicate art in itself, but highly gratifying.

*Stanley H. Cath, M.D.*

# Foreword

## Why some older persons disconnect
## 'Old age is no place for sissies'

So many troubled elders suffer from a pervasive feeling of being worthless and disconnected from the world around them. Many feel that they have lost all value and therefore have no claim on a health professional's time. No one modality of treatment is adequate in helping them; a range of options must be considered. Psychotherapy is only one of many tools that can be used to help this group *reconnect* and become participants in treatment to ease their suffering, prolong their lives, and add substantially to the quality of their lives.

The creative arts, because they rely largely upon nonverbal techniques, provide other tools that all clinicians ought to be aware of if the pervasiveness of depressive illness among the elderly is to be adequately addressed.

Without a doubt, 'old age is no place for sissies' (Bette Davis). And if it was true in 1985, when the first edition of this book appeared, then it is even more the case now, as the health care systems for caring for the elderly approach meltdown in the millennium. Stay healthy, or get really sick with a poor prognosis, and only then your health will not be a problem.

But if you should fall anywhere else on the need spectrum, expect to fight with your insurance carrier. And be grateful if you can afford a month's worth of the newer high-tech medications that are good, but may require a second mortgage to pay for. If old age is no place for sissies, then insurance is not for the sick. Prevention is a dinosaur, and outreach a concept that is no longer considered 'cost-effective.'

Today more, not fewer, older adults suffer from pervasive feelings of worthlessness. Fewer agencies are available to provide social services, especially in-home services, so many elders withdraw into an aloneness that reflects a feeling of being disconnected from the world.

The aged cobbler in *Dragon, Dragon*, a children's story by John Gardner, speaks for many of these older people when he convinces himself that the king made a big mistake by inviting him to a town meeting because he was 'nobody important.' To effect the analogy: many elderly share the cobbler's feelings that the invitation to meet with the king must be a mistake. Or, in our own terms, when approached by any type of health care provider, these elders are apt to feel that they do not deserve the help; the worker is certainly in the wrong place, or clearly wasting his or her time with them. Elderly patients troubled with emotional problems will attempt to convince the worker that this time can be spent elsewhere with more worthy and certainly more deserving patients. Now the cobbler must also worry whether he has the proper insurance coverage, whether he has a prior authorization and coverage for the wonderful but very expensive new medications.

In so many ways today, it is easy to feel like an outsider. Never mind an invitation to the king's court, many elders are thinking that the world might be a better place if they simply disappeared or failed to awaken the next morning.

## Ageism

Ageism, the subtle but pervasive attitude that defines the many ways the elderly are discriminated against, is a pernicious process that begins when people are young. Indeed, *Dragon, Dragon* is a children's story book. And, sadly, the negative attitude that many young people adopt toward the elderly persists even while people themselves age. In other words, as people age, they become members of the group they hold a prejudice against. *We all become the elderly.*

This ageism, practiced also by the elderly, will greet us all as we approach elderly patients. They will often try to discourage our interest in them, or assume that our task of evaluating them is odious to us. Many elderly, especially those with some emotional troubles, will assume that we too despise them as much as they despise themselves. Often they will treat a therapist with scorn as they project their low self-esteem and self-contempt. Even if they are friendly and compliant, they will share

very little in the interview, based on their conviction that there is little, if anything, to share.

When we are greeted this way by elderly patients who are referred to us for services, we can be easily sidetracked. Prompted by some of our own unsettled feelings about aging and the elderly, we are apt to maintain our own distance, to allow ourselves to be easily discouraged, or to rationalize a treatment approach that avoids intimate, probing contact.

We are likely to suggest that others implement a more supportive approach; at the same time we ourselves can agree to a course that precludes insight, and that may at times suggest countertransference, acting out of our own need to avoid a patient's pain.

## Losses and gains

Within a nursing home many patients isolate themselves and reject invitations to socialize and participate in milieu programs. Pain and suffering will be hidden and denied; patients withdraw into loneliness and isolation.

Many harbor bitterness and resentment at being old, so they refuse to let anything nice happen to them. For this reason they will not let the nursing home become a 'home,' and behave in a style that serves to maximize their own discomfort. Some will carry this to such lengths as to cause their own expulsion from the home. Many can provoke mistreatment that they believe they deserve. Many paranoid patients will assume that everyone hates them almost as much as they hate themselves. Many will more quietly and compliantly resign themselves to their fate, but put no energy (cathexis) into their situation.

### Case histories

Consider Mr X. He lives alone, has chronic obstructive lung disease, and rarely gets out of his apartment. The manager of the housing complex is concerned, and calls a local health agency for a mental health evaluation. (Today, housing programs rarely have their own funding for mental health services, but some did in 1985.) So the contacted agency has to find a worker able to make a home visit. Mr X is friendly, and seems to enjoy the company, but steadfastly denies an obvious depression, and politely

refuses services that the worker identifies as necessary. What should happen next? What happens to seniors who cling to independent living? Who pays to help independent elders in need of services?

Other patients enter older age having made a relatively comfortable adjustment, until a sudden loss, or even gain, is experienced. A loss of a friend, spouse, pet, relative, can serve as the precipitant for a sudden decline and death. Loss of hearing or sight can result in a sudden change in a patient's mental status. A move to a new locale can be very disturbing. Loss of a job, and/or retirement can, for some, be devastating. But a gain can also result in disruption.

Mrs R illustrates this in a revealing way:

> Mrs R had always functioned well, and had worked hard her whole life. Her earliest memories were of making sacrifices so that she could be helpful and available to her parents, and later to her children. Two years previously she had retired and adjusted to this gallantly, if not with complete satisfaction. Her religion continued to play a central role in her life. Now a widow, with grown children who were all busy in their own lives, she managed to keep active. She continued to drive, and filled her time doing volunteer work and attending a drop-in center for seniors.

> At the center, she met a man with whom she began to spend time. The more they saw one another, the closer they became. Paradoxically, she became depressed and agitated. When I met her for a consultation, she was in considerable distress. She acknowledged her loneliness. With mild resentment, she stated that her children were all taken up with their own lives and had little time for her. She said that she would like to live with one of them, but that was out of the question. Quite suddenly she had been overcome with a feeling that she could no longer take care of the family home where she had lived for years. She had decided that she must go into a nursing home. This decision, remember, was made by a woman who until one month before had done a superb job of taking care of herself and her home.

> She then began to talk about her new male acquaintance. She had kept him a secret from her children, and had trouble talking about

him and how nice it was to spend time with him. He suggested that they live together. Although she was surprised and pleased, she was also upset. She responded that this was out of the question, but that she would consider marriage. He tried to explain to her that their economics were less affected if they lived together.

She became very anxious, and consulted a parish priest, who reinforced her guilt by telling her it was sinful to live with a man, adding that he was too much of a burden, and that she ought not to see him. She severed the relationship, and then decided that she must give up her house and enter a nursing home. When reminded that her friend made her happy, she became more upset. When asked why she felt she did not deserve some happiness in her life, she became still more agitated.

The pleasure she gained from this new relationship precipitated a serious crisis in her life. The pleasure made her feel as if she must choose between being a lonely old lady, or one who deserved to have some happiness in her life. Her guilt at the prospect of enjoying herself was so severe that she became depressed.

The internal conflict was so intense that the easiest remedy for the immediate problem was to abandon the relationship, and to assuage her guilt by checking into the nursing home. Efforts at intervention, including a consultation with a more 'liberal' priest, were vigorously but not totally resisted. Her decision was tragic because everyone lost. Her quick decision to treat her own depression by removing herself totally from the conflictual situation substitutes symptom relief for a slower resolution of the conflict.

## Possibilities?

Since the first edition of this resource book, the problems referred to above have become much more pronounced. For seniors, the issues only increase shame and guilt when it comes to asking for and/or accepting an offer of service. And because shame and guilt are so operative, the clinician has to be especially sensitive to resistance. Even more today, precisely because of

the limitations of the health care system, we must have available a rich array of strategies and interventions that may help clients engage in services before they give in to helplessness and despair.

This new edition helps us tackle the unmet needs by challenging caregivers to try new and creative approaches in working with isolated and depressed elders. Knowing that shame and guilt are a factor in resisting help, clinicians will welcome the broad range of techniques that are brought into focus here, and which they can use with comfort and enthusiasm.

The antidote to burnout, cynicism and fantasies of career change is the challenge of being creative at a time when the human service industry is under assault. This is no time for sissies among caregivers!

We are inspired by the hope-filled, playful methods in this book to want to do better the work of engaging reluctant or resistant clients in the very creative process of a therapeutic intervention. The expressive arts reconnect clients with their creative selves in ways that bring them insight and pleasure. As practitioners and therapists, we have to learn again how to listen as we promote the sharing and interaction that we call therapy. Once this process takes hold, depression recedes and a more reasonable accommodation to the stress of older age is achieved. The elderly have stories to tell us, and their own way of telling them, but they may need our help.

Providing mental health services is the easy part; there are well-trained practitioners available to work with elders. But staffing programs to meet their needs, and having these programs adequately funded, are the greatest challenge. And in a perfect world, the creative art of treating seniors in need would be the major concern of clinicians. Unfortunately, for those who have not recently looked around, this is not a perfect world, and the challenge of financial problems that providers deal with daily only mirrors the daily struggle for survival that our patients/clients are forced to cope with. Sissies will have trouble navigating the treacherous channels that lead to survival; this is a sad fact of life.

The irony in all of this is a universal, growing awareness that treatment works. Creative arts, psychotherapy, expressive therapies, behavior therapies – they all work well when properly applied. The creative arts may be unique in the way they facilitate reconnectedness – the goal of any

successful intervention. They are 'strong medicine' that needs to be prescribed more often.

This book defines interventions that will better equip therapists of any and all persuasions to meet the challenge of providing relevant service to a growing number of troubled elders who now often receive inadequate service, or none. In other words, all practitioners must work toward the goal of helping people realize that cobblers and the elderly deserve an invitation to the king's court, as their presence there, or anywhere, is needed and valued.

*George S. Sigel, M.D.*

# Editors' introduction

In the early 1980s when we produced the first edition of this book, we looked at aging with compassion and concern, but from the outside *in*, as though looking through a one-way window. We were still relatively young. Fifteen years later, we're *in*side; we're part of that *in* group. We both wear 'granny' glasses, and 'ooph' a bit when we get up from our chairs. We know what it means to be patronized by some doctors who seem indifferent to our medical complaints: 'What do you expect, at your age?' with a little smile. Or embarrassed by the bus driver who exclaims rudely, 'That senior citizen ticket can't be used now.'

However, we continue to know at first hand the surge of empowerment that comes from purposefully creating something, whether it is this book, giving a course in a university, developing a creative arts workshop, planning and exchanging ideas with colleagues, or making up stories with the grandchildren.

Speaking for our age group now, we are lured by discounts at the supermarket 'on Tuesdays' and have no trouble at all accepting reduced fees at the movies, and on planes and trains. In many ways times have changed; society has begun to accept older age as a 'time of life' to be accorded some respect for its wisdom, experiences and special needs. A proliferation of books and articles attempt to interpret and pigeonhole 'members of the Third Age'. Some doctors are now specializing in geriatric medicine. Certainly more commercials for age-related products address us as a prime consumer market – more often than not with deceptive advertising.

We see a huge growth in educational programs attended by elders – Elderhostels, tours and cruises, college-level courses – for those who are well and able. There is no question, either, that the elderly today include

more professionals, more people who are educated and outspoken in their communities, proactive in their occupations and careers.

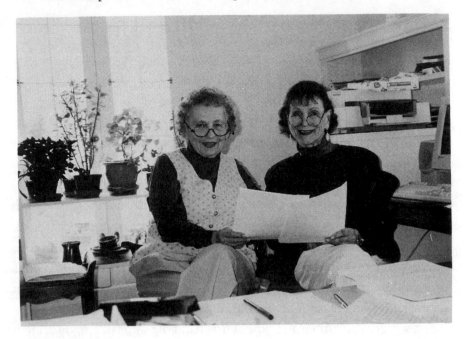

*Weisberg and Wilder at work*                                    *Al Weisberg*

Yes, there have been a few positive changes on our behalf in the last 15 years. The American Association of Retired Persons (AARP), a significant lobbying organization in Washington, is playing a strong role in mobilizing the 'over-55s' to be aware of their potential impact on legislation. We are voters to be reckoned with! We are even hired, often part-time, by businesses and corporations who admire our dependability, our work ethic. (See 'Gray power to the rescue,' in *Business Week*, 6 March 2000.)   But we also see Congress is still 'out' on some issues most important to us. For example, social security. Is it a handout or something we've paid into all our lives to sustain our older years? And Medicare, another 'political football'? Medications for chronic illnesses have improved generally, but are out of reach of too many budgets. Poor elders, or those living alone without savings and without insurance, cry for help, with excellent reason. Alas, responsibility for their care often falls to their

middle-aged children, frequently burdened with financial and family problems of their own. So, some progress, lots of problems, very few thoroughly satisfactory solutions.

Now, how can we help? To whom do we address our efforts? Despite marked changes for the better, and as Dr Stanley Cath writes in his foreword to our book, in life there are 'ordinary people, who, especially when in need, welcome our efforts to establish connections with their inner being… Without external guidance and inspiration, they rarely feel creative' as they age. Even more so, of course, can this be said for the lonely, the handicapped, the ill and impoverished. Cath goes on, 'For [them], the main task of living long has become mainly how to support and hold the self together…' These people, whom we may find in day-care centers, in retirement residences and in nursing homes, are the most in need of our services, the services of expressive arts leaders and expressive arts therapists. Throughout the United States and other parts of the world, it should be noted, we are also demonstrating the effectiveness of our work in contributing to the mental health of well elderly in our communities, with people who have previously enjoyed music, dance, art and theatre in their lives, or at least yearned to.

As the late Dr Robert A. Famighetti, Director of the Gerontology Center, at Kean University of New Jersey, observed years ago:

> Although the therapeutic value of Creative Arts programming must be underscored, we, as professionals in the field of gerontology, often neglect to realize the other perhaps more important values of the arts with older adults. For example, the arts can become the language of the aged, a language created over the course of a person's life. The arts can speak for all an older person has been, is, and can continue to become. As an expression of humanity, they are an inseparable tenet in the lives of older persons. Unfortunately, this has been a relatively unknown and neglected quality in the human services system which primarily focuses on the material needs of the aging. The creative arts can provide meaning as the link between the aging human and a society that needs to listen and understand.[1]

At this writing, too many of the dynamic, funded programs which serve life-enhancement, including those in the arts, are seriously threatened, if not already sacrificed, along with scores of other human services. The health care system in our country is openly acknowledged to be in jeopardy, and approximately 34 million persons over the age of 65 are among those in danger of the fall-out.

Therefore, in composing the second edition of this book, we are even more eager to share a commonality of ideas and purposes as expressed by diverse experts in gerontology and the expressive arts. We urge you to dig into and examine the many art forms they present here in order to discover how the arts overlap, interweave, and alternate in organic response to the special requirements of individuals and groups. For those of you who live and work with elders, we hope you will be inspired to prepare your own programs with a zestful combination of these ingredients.

You will find approaches and techniques that encourage people to think, initiate, do and communicate. Throughout the chapters are the kinds of connections our writers make with their groups. Listen for their excitement behind the methodology, the humor, the sharing, the spirit that can raise a smile even from the depressed or discouraged. They are not bound by a single theory or method. Each writer is a theorist who states a personal approach and objectives. They are all involved in process more than product and their approaches represent a multiplicity of training, backgrounds and experience. As Bernie Warren tells us, '…being involved in the process of artistic creation is every bit as important and in many cases more important than the end product…'[2]

Our contributors offer non-competitive programs to stimulate mind, body and spirit, and promote individual participation in a cooperative group setting. Each builds an atmosphere of acceptance and trust in which feelings are expressed and problems addressed on behalf of the healthy, normal facets of every individual. And as Dr Gene D. Cohen, the first director of the Center on Aging, Health, and Humanities at George Washington University, advises:

> The truth is that creativity is not just for geniuses… Creativity,
> which I define as our innate capacity for growth, is empowering.
> It is the energy that allows us to think a different thought, express

ourselves in a novel way. It enables us to view life as an opportu-
nity for exploration, discovery, and an expanding sense of self…
and it *knows* no age.[3]

Expressive arts services can make a measurable contribution by enabling
the aging adult to articulate desires, necessities and aspirations. We believe
– we know – the arts are potent resources for both the well and ill. Above
all, we know intimately the transcending power of humor, of laughter, in
so many arts experiences. We invite you to 'lose' yourselves in the art of
play. Use the magic stimuli of the arts in your own lives and infuse them
into the lives of those with whom you work.

Historically, the arts and creative expression have challenged indi-
viduals to articulate the substance of life and to reaffirm their existence. In
every culture, the arts have been integral to life. An octogenarian sculptor,
Edna Eckert, confined to her home, told us, 'I think creative people are
often long-lived because we are always re-inventing life; what we did
yesterday, we create anew tomorrow. Inherent in this process is HOPE.'

## NOTES

1.    Weisberg, N. and Wilder, R. (eds) (1985) *Creative Arts With Older Adults.* New York:
      Human Sciences Press, Inc., p.232.

2.    Warren, B., (ed.) (1984) *Using the Creative Arts in Therapy.* Cambridge: Brookline
      Books, p.4.

3.    Cohen, G. D., (2000) 'C=ME2: *Modern Maturity,* March-April, 32–37. Creativity
      Equation That Could Change Your Life.'

# TO YOU, CONNECTOR AND HEALER

You are artist, poet, dancer;
> singer of wind chimes,
writer of beginnings and dreams,
> actor of many faces.
You've tasted true feeling,
> moving from quick sand
> to soaring wing spread.

Your metaphors,
> drawn in shape, sound or image;
> line and word,
> resonate in awareness:
Your passion ...your source
> to inspire.
Your gift to the long-lived.

Formerly silenced; rarely beckoned,
> you encounter each
> as unique;
coax forth hidden voices.
> You beckon; you honor;
> you guide...

You give this with caring;
> helping each elder
> weave split threads of a life time.
With wonder
> transforming reality.
> Reclaiming significance;
> asserting their lives!

R.W.

PART I

# Art Experiences Accessible To All

*Figure 1.1 Ben Lieberman, aged 82*        *Dr Murray Greenberg*

The visual arts offer a range of materials through which older persons, experienced or inexperienced, can express their subjective visions. With guidance, they manipulate the clay, wood, paint, wire, paper, string – shaping, expressing and communicating their personal statements. Although the visual arts are generally considered to be nonverbal, the

authors of the two chapters which follow, as you will note, often use the silent arts as stimuli for the written and spoken word.

**Pearl Greenberg**, as an educator and gerontologist, speaks of the increasing number of well, idle, disabled, and isolated elderly who can be served through the visual arts. She points out the urgency for special training for arts educators who have never worked with the elderly, additional arts training for those who have been working with the elderly for years, and college programs which include elders or are specifically designed for them.

**Georgiana Jungels** is an art therapist whose clinical experiences enable her to assess the needs of her clients and prescribe programs for them. She presents us with methods for adapting media to the concerns of the individual. The symbiotic relationship of verbal and nonverbal language for improved group communication is evident in her work.

1.

# Approaches to training and curriculum design in the visual arts for the elderly

*Pearl Greenberg*

...while elder students may be thinking of the best way to use leisure hours, they may find themselves involved in an art medium to the extent that they become true practitioners – it can happen and does for some people.[1]

Every community has older adults looking for places where they can go to meet others, socialize, learn something new, or enhance knowledge gained earlier in their lives. Increasingly, many elderly want to learn to use time rather than just to fill it. Those exploring the visual arts desire opportunities to express themselves, and the skills needed to function adequately, not simply for leisure but for aesthetic experiences which can become part of their lives.

While we cannot assume that every older person with whom we come in contact is going to be interested in the arts, there are many who may not even be aware – who have never before had the free time to find out – that they have some latent talents in the arts. Unless given the opportunity for exposure in a setting offering quality-level opportunities, they will not realize their potential. Of course, among the geriatric population which is close to 40 million at this writing,[2] there must be as large a proportion of experienced painters, sculptors, weavers, potters, and printmakers as in

any other group of adults.[3] They are usually the self-actualizers who go on creating as long as their vigor allows. Imagine what we must do to be prepared for the number of Americans over age 85 which is expected to increase by 40 per cent by the year 2010.[4]

## College programs

More and more, people in the later phases of life are choosing to attend college and adult education programs in the visual arts. Many colleges invite them to sign up to fill vacant seats in courses, free of charge or at a minimal cost for registration. Thus no special program is planned; they join the regular students as members of the class...and often ensure that a class will run which might otherwise be closed for lack of students! Some enjoy this keenly, and become class members with ease, following the regular curriculum.

### Special programs for older people

Others prefer special programs, sometimes held elsewhere on a campus. When working with them we may use similar media, but teaching approaches differ. Most young college students seem willing to sit still in class and listen as professors spout this or that, whereas many elders want to take part in discussions rather than hearing a lecture for long periods of time. And they seek active involvement with art media as well as art history and art appreciation.[5] Other programs designed for elders are found at 'Y's, senior centers, religious centers, museums, retirement housing complexes (e.g. Leisure World) or offered with travel opportunities such as Elderhostel,[6] and other sites. As always, different people prefer different approaches to arts classes in terms of their comfort and attitudes toward working with their own age cohorts.

## Training leaders

With the growth of special programs for older adults, it is imperative that colleges and universities incorporate material on the arts and the elderly in methodology courses for future art teachers. New courses in the visual arts are needed, geared to those who are teaching or will teach the arts to this

growing population. In addition, materials and programs need to be made available for gerontologists and recreation directors, since both groups will be called upon to organize programs, as well as to hire the teachers.

There is still another group of practitioners whom we need to reach. They are the people who lack a formal arts background, but who have been leading the visual arts and/or crafts programs for years in senior centers, hospitals, nursing homes and other health-related facilities. Now that settings where the elderly congregate are gaining attention, these programs are being scrutinized and sometimes found wanting. We must attract these practitioners back to the college or some other in-service course work to enhance their experiences and allow some degree of re-tooling. We have much to learn from these leaders about working with elders, but they are themselves in need of learning which will permit them to set standards of excellence in their arts programs.

Many programs developed in recent years have been geared toward copy work or kits, or junk-made-into-more-junk, because employees had little or no visual arts background. This was due in part to lack of adequate funds; art supplies cost money, and professionals demand higher salaries. But there was also a lack of awareness on the part of administrators, such as activity directors, regarding the proper content of quality visual arts programs.

We must also address our program to college students in gerontology, as well as recreation and leisure studies, who desire background in the arts. They need course work which will assist them in running an art program, or at least to learn enough to hire the right people to do this, i.e. art educators with background in working with elders.

Add to this list art educators with years of background in working with children who are now ready and willing to switch to the older population as they retire, [7] and the new art educators who know at the start of their careers that they want to work with older people, teaching quality crafts as well as art.

You can see the tremendous task ahead of us. We need to question who should teach the arts: qualified artist/educators, recreation directors, aging practitioners or volunteers (who may or may not have the background in the arts, but are available at lower cost)? We agree that it is

the artist/educators who are the best qualified. We also know that artists can work until they die…and many who have been teachers want to continue doing some teaching once 'retired'. They could be available even at settings where money may be limited as they already have incomes from their prior years of teaching art.[8] Limited budgets more often than not decree how decisions are made.

## Methodology

### With the well elderly

The well elderly are not passive learners; they need and want to share in planning, organizing, and implementing their programs as well as evaluating them.[9] An art teacher working with them will need to identify the leisure patterns of the given group, their depth of previous arts involvement and preferences, and attitudes toward experimentation and toward the arts in general: Are they willing to take chances in a supportive atmosphere? What are the components of a supportive atmosphere? When is the best time for a program to be offered? How often, and how long should it be?[10]

Participants in an art center need to be assisted in seeing that what they are doing is worth doing. We must avoid trivia! When an artist works in a studio, it is serious business. Naturally, not everyone coming to such classes will develop this attitude of seriousness, but it should be in the air to avoid making it just another way to pass the time. Different kinds of art programs appeal to different people. In addition, different requirements must be met, such as adequate lighting for those who may have visual problems, clarity of presentation for those with hearing impairment, and adaptations of the tools needed to create, for those with physical limitations involving arms or hands.

People are often coaxed into taking part in different recreational activities prior to lunch or after it is served at nutrition centers. Here, opportunities to develop new skills, or pick up on old ones, are made available in settings where everyone feels 'at home.' And it is here that quality programs might inspire some to find a new approach to life through different creative opportunities.[11]

Although we tend to think of involvement in the arts as a socialization experience, specifically in the visual arts, it is likely that some may prefer

*Figure 1.2: Weaving is for anyone*                    *Dr Murray Greenberg*

working individually, away from the crowd. Many will work on a painting within the class or studio setting, but we need to allow for the possibility that once they have reached a certain degree of mastery of techniques, some will prefer working alone, off in a corner of the studio, with the art teacher offering advice as requested.

In crafts, people have tended to work in groups – a quilting bee is one example from the past, continued to this day. While knitting or crocheting, people who know what they are doing seem free to chat. Weavers can work alone or in a bustling studio, as can jewelers and sculptors. Many plan their designs or forms in advance and then follow that plan. The manner of working will depend on the medium used and the personalities of the people involved, as well as their degree of health and need for physical assistance.

Twenty-six per cent of those aged 65 now (2000) will survive to age 90, and by 2050 that number will jump to 42 per cent.[12] We need to be prepared for all of these people who will eventually show up in our classes!

Working with crafts materials sometimes seems easier to people who are new to the arts, or need additional assistance. But some crafts often come with 'crutches' in the form of kits. Kits offer very limited opportunities. These are someone's idea, requiring that one know how to follow directions, but allowing little personal creativity or thinking. This is perhaps why crafts appear as heavily as they do in programs for elders.

What we have been calling the fine arts require giving of oneself, and exposing oneself much more than may at first be comfortable. Therefore, I believe that it may be best to start people new to the arts with simple crafts experiences – aim for success, but with integrity. So often recreation programs at senior centers and 'Y's emphasize kits; people get bored and stop attending these classes, but some continue coming because they have little else to do and this occupies them for a time. Bad habits result. It is difficult to wean people away once they start to copy rather than create.[13]

*Practical considerations*

We must develop any number of different art curricula to meet the unique needs of various populations. But there are certain concerns that everyone working with the elderly must keep in mind. Although many in this last phase of life remain as able as ever, some cannot hear, see, or move as well as they used to. We must be certain that the area is well lighted. Write in a large, clear hand on the chalkboard, and when you speak, look directly at the students. When on a field trip, allow time to get from here to there, as it will probably take longer than when touring with either the very well elders, or younger students. Avoid a patronizing manner. Speak a little louder, but do not shout. Find out what the students think about in response to what they see. Offer good criticism but be supportive at the same time. It would seem that these teaching strategies are important no matter what the age of our students, but particularly important for the older student.[14]

Those preparing to teach art to older people must take a number of courses in addition to the art methodology being discussed here. They need background information in sociological, biological and physiological aspects of aging. To assume that this material will be included in an art course is to give it much less importance than it deserves; to assume

there is time in an art methodology course to do this, and include adequate art experiences and background as well, would be absurd.

Let us now clarify some of the settings and possible course content as they now exist in locations where elders can find arts courses available to them.

## College campus

As already noted, elders join the regular students in both studio, lecture and art history courses. There is no attempt to change courses in any way. The professor works with the entire class, also with individuals, in planning work for the semester; the elders become regular students and do the course work as required. (Available day and evening, often at a low fee, if space is available.)

## Adult Education

These classes, if held at a local high school, might have students ranging in age from sixteen to ninety-nine. Classes run in the evening might keep elders from attending, as daytime courses are often preferred. Once again, the teacher needs to introduce basic course content, then work with individuals who develop their own style, be it painting, sculpture, ceramics, jewelry, weaving, drawing, photography, or computer art. Night-school teachers have worked with this wide range of students for a long time, as it was for many years almost the only opportunity for people to study at low cost in a school setting with a qualified artist or art teacher. Students who opt for a given studio course tend to know by word-of-mouth what it will offer, such as a good teacher, or an interesting medium, or both. They do not expect a watered-down curriculum.

## Local 'Y'

These tend to be similar to night-school classes, but are available both day and night. There are two possible approaches of concern to us: segregated classes for elders, or mixed-age classes open to everyone. This depends on who is hired to run the arts and the crafts as well as other studio courses.

*Art centers*

Opportunities are similar, but emphasis would be more for those people
more serious about their art involvement and in-depth opportunities to
work. These students sometimes continue semester after semester,
working with an individual artist/teacher who becomes a serious mentor.

*Senior centers*

These may be located on a college campus, the local church or synagogue,
or some center-city buildings easily accessible via public transportation, if
at all possible. The community center is often arranged around a lunch
program, and called a nutrition site. Those attending often come to
socialize and eat. They play cards, crochet, and chat while awaiting lunch.
When art is available, such a program faces a lot of competition and
requires a very strong, well-qualified teacher to attract and involve people.

Other senior centers, where lunch is not the prime reason for their
existence, such as those on a college campus, can offer high-quality
programs with excellent course choices. There is often a lounge where
people can socialize, and this is one way to find out which courses and
teachers are considered good and there is an atmosphere conducive to
learning and working. Many students consider taking regular courses on
campus, once secure in their ability to function.

*In nursing homes, hospitals, and health-related facilities*

As people live longer, there is an increasing number of idle people with
limited mobility for whom programs must be developed. Add to them
those who are isolated, who may not be physically challenged, but yet
cannot get themselves out and involved with community programs. The
psychological mind-set of these people may be that they cannot learn. [15]
Over half are not interested in any kind of education until they dare to try.

We need to inspire them to become involved…to help them find out
what they can do, to continue to feel capable in at least some small ways for
a start. This often requires one-on-one learning, very costly, at least at the
start, and not often available. But many people do begin to feel better
when they are involved in cultural programs because it takes their mind

away from aches and pains and replaces these with other concerns. For example, when a group of nursing-home residents were given responsibility for matters such as decorating their rooms, they became more alert, active, and happier.[16] I am convinced that, given the right opportunities, these people can do quality art work as well. Those who have worked with them know this is possible. If you expect more of people, if you give them selected challenges and support, they will become happier participants, making their lives and those of their care-givers much easier.

Those in health-related facilities are mobile and can get around inside and outside of the facility. Some may be very interested in some phase of art, attend museums or galleries, and generally live as though they were still at home, with only some limitations due to physical problems.

Those in nursing homes and hospitals are often in wheelchairs, or need walkers which set limitations on how freely they can move around the facility to attend different activities. They are sometimes tranquilized and unable to become truly involved. However, given a quality program, rewarding things can happen: people snap out of their lethargy and function on a surprisingly competent level. They can use a number of different media and create satisfying work. This caliber of program is rarely available, since the tendency is to assume they cannot do anything and expectations are low. Once one has seen what is possible, it is shocking to realize how few people in these facilities have the chance to be creative. Yet we know many could be, if given the opportunity. One imperative is that qualified art educators must be hired as the teachers; they have the know-how to inspire people to function adequately.

I have visited all the types of sites noted here. There is one thing that was easily observable: wherever there were qualified people in charge of the program, with an adequate budget and schedule, quality work was going on and people were feeling good about themselves and their accomplishments. This was true even for the frail, ill elderly with limited mobility. A good art teacher knows how to work with each person to bring out his or her best. An activities director who has an art background can offer in-service experiences to the staff and this makes for better quality programming as well.

## Approaches to programming

Many settings could offer in-depth exposure in one or another specific art medium. A beginners' ceramics class introduces students to working with clay, and an advanced class allows them to work at their own pace, once they have learned techniques. But in some settings both advanced and beginning students work together, learning from each other. Whether this works depends on the number of interested students, space availability, and adequate funding to pay a teacher for more than the one class.

Some organizations like to start people with a general arts and crafts class in which they can try a number of different media. From this experience, they can decide which area they want to work with in depth. The next group of courses should offer those media the students found to be of greatest interest, so that they can continue to work in their chosen medium. Once they gain necessary skills and know-how, these students should be given the opportunity to work individually. Thus a workshop atmosphere exists in the art studio, allowing for individual advancement and a wide range of possible choices that attracts people who do not want to be kept waiting in a step-by-step approach. This makes it possible for those with different levels of functioning to be in the same course, assisting each other, as needed.

Those of us who have been involved with the arts in these varied settings have seen the positive responses of our students when given opportunities to function creatively. We know it is not always easy, but if we keep trying, we can have some degree of success. It would be useful to clarify that while elder students may be thinking of the best way to use leisure hours, they may find themselves involved in an art medium to the extent that they become true practitioners – it can happen and does, for some people. After moving into a retirement community Mr B, now 80, took up sculpture when his wife suggested he try an art class. It was free, so he thought, 'I would never have paid for it. I did not think I was talented.' Well, as soon as he handled the first ball of clay, he was hooked. Now, almost twenty years later, his home is filled with his works, resulting from using a hammer and chisel on stone, as well as clay.[17]

At first you may want to show slides with a range of styles in drawing, painting, construction (clay, wood) and crafts (jewelry, fibers, ceramics).

Choose work that ranges from quite realistic to primitive and non-objective, showing successful works in a variety of styles. This helps people feel more comfortable regarding what they believe they can or cannot accomplish with art materials. Showing only realistic works will cause some to feel inadequate. They cannot possibly do that kind of work, or so they think; therefore it is not for them. Showing only primitive works will lead others to assume you think little of their abilities, as they don't understand how to look at and respond to such works. Try to include some slides of older professional artists, as well as those who have recently become involved with art. We know that artists need never retire – they just keep on creating as long as they live! Use this as a way to inspire potential art students.

Present more than one way of working and more than one medium. For example, crafts, as noted earlier, seem less threatening as a starting point for some. If you choose fibers as one of your media, include ways of working that will attract men as well as women. Avoid sex-segregated classes, as those that attract only women begin to be less valued by the women than those that attract men as well.

People are sometimes motivated to create works which can become gifts. While this should not be the only reason for holding such classes, it may be one way of getting started. Both men and women could weave belts or guitar straps. Placemats are not only the province of women. Nor are wall-hangings or bookmarks. Such practical weaving basics are only one example, but get people involved. They can work at home, using small weaving frames, as well as in the art studio. They can make color and design decisions once they learn the simple skills. After these introductory sessions, students with an interest in weaving can begin to think about this medium and develop their own unique forms.

A class in which a variety of media have been introduced allows students to choose the area of greatest interest. Some may opt for involvement in drawing, painting, clay work, and woodwork. A qualified teacher can shift from area to area, medium to medium, with ease, within limitations. The limitations could be space, class time, availability of supplies, and number of interested students. Some elders say 'What am I going to do with it? What do I need it for?' They need to realize that it is the process of creating that is important, not always the final product.

When the product happens to be a satisfactory piece of work, that is an additional bonus. In many programs, emphasis is only on the product. We need to move beyond this. After a few weeks of working, it is important to look over what has been produced and discuss with each student some new directions.

Exhibitions of works completed – displayed with taste – will attract new students and enhance the reputations of those already involved. For students to begin to function as artists, they must realize that not everything they make will be worth exhibiting, nor possibly worth keeping. A portfolio for each student is the best way to save works, with dates on each piece. This allows both the teacher and the student to begin to see growth and development. Art entails introspection, and students, once they realize this is for themselves, will begin to work at their own pace, no longer in need of constant teacher attention at each step. This attracts people who do not like to be kept waiting for the slower students to catch up. Once we discover their interests, overcome fears, inspire confidence in taking risks, we can develop programs to meet those interests.

We are working with a diverse population which cannot be served by one simple curriculum. Rather, we have to study people's needs and build a curriculum based on them. It must be constantly changed, and grow to suit our elder students wherever we meet them.

## Notes

1.    Atchley, R. C. *The Social Forces in Later Life.* Conference speech. Wadsworth, California.

2.    Anon 'No longer an age but an expanding Stage of Mind.' In *New York Times,* 21 March 1999, p.15.

3.    Kaplan, M. 'The arts in an aging population', from the conference *The Aging of America,* University of Delaware, November 1977.

4.    DiLorenzo, J. 'The Older Americans Act.' In *New York Teacher,* 7 April 1999, p.18.

5.    Covington, J. P. 'Toward a philosophical base for community arts – the museum's role.' In Hoffman, D., Greenberg, P. and Fitzner, K. *Lifelong Learning and the Visual Arts..* Reston, Virginia: National Art Education Association, 1980.

6.    Sack, K. 'Older students bring new life to campuses.' In *New York Times,* 21 March 1999, p.6.

7.   Kaplan, M. 'The arts in an aging population.' From the conference *The Aging of America*, University of Delaware, November 1977.

8.   Grumbach, 'When do artists pack it in? Never!' In *New York Times* 21 March, 1999.

9.   Hoffman, D. 'Training personnel for work with the elderly.' In Hoffman, D., Greenberg, P. and Fitzner, K. (eds) *Lifelong Learning and the Visual Arts*. Reston, Virginia: National Art Education Association, 1980.

10.  Barnes, C. 'Geragogy, The education of older adults.' Speech to National Art Education Association, San Francisco, CA, April 1979.

11.  Hoffman, D. 'The elderly and the arts.' Unpublished manuscript, 1977.

12.  Greenberg, P. *Visual Arts and Older People; Developing Quality Program*. Springfield, IL: Programs, 1987.

13.  Barnes, C. 'Geragogy, The education of older adults.' Speech to National Art Education Association, San Francisco, CA, April 1979.

14.  Berghorn, F. H., Shafer, D. E., Steere, G. H. and Wiseman, R. F. (1978) *The Urban Elderly – A Study of Life Satisfaction!* New York: Landmark Studies, Allanheld Osmun/Universe Books, 1978.

15.  Rimer, S. 'Forget golf, there are masterpieces to make.' In *New York Times*, 21 March 1999, p.12.

## Suggested readings

Barret, D. 'Art programming for older adults: what's out there?' *Studies in Art Education 34,* 3, Spring, 1993, pp.133–140.

Comfort, A. *A Good Age*. New York: Simon and Schuster, 1976.

Fitzner, D.H. and Rugh, M.M. *Crossroads: The Challenge of Lifelong Learning*. Wahington, DC: National Art Education Association, 1998.

Greenberg, P. 'Senior citizens and art education.' In *School Arts*, 1984, pp.38–40.

Hoffman, D. *Arts for Older Adults: An Enhancement of Life*. Engelwood Cliffs, NJ: Prentice Hall, 1992.

Hoffman, D., Greenberg, P., and Fitzner, D. *Lifelong Learning and the Visual Arts*. Washington, DC: National Art Education Association, 1980.

Jones, J. E. 'On teaching art to the elderly: research and practice.' National Art Education Association Convention paper, San Francisco, April 1979.

Newman, T. R. *Contemporary African Arts and Crafts*. New York: Crown Publishers, 1974.

Sunderland, J. T. *Older Americans and the Arts: A Human Equation*. Washington, DC: National Council on Aging, 1976.

## 2.

# 'To be remembered…'

### *Georgiana Jungels*

> Between the moment in which a person whispers a single word about an art expression and the time in which members of the group openly share their comments and responses, there occur many progressive experiences upon which client and therapist can build communication.

I always learn so much from the older people I meet through shared art experiences. I have worked with older adults in different settings: community centers, senior centers, colleges, hospitals, and nursing homes. I have had varying job titles and roles: art specialist, artist, art educator, art therapist. The common element is art. Art-as-art, art-as-activity, art-as-vocation, art-as-education, art-as-therapy. In the following paragraphs, I would like to share some of these experiences with you. They illustrate to some extent what I have learned from the older people in my geriatric art therapy groups, and give an overview of some of the structures I have found helpful in encouraging and fostering increased communication skills among institutionalized older people, many of whom begin in art therapy with limited communication skills. Some are almost nonverbal because of physical handicaps, retardation, apprehension, and/or long-term institutionalization. Often their visual communication skills are as limited as their verbal skills.

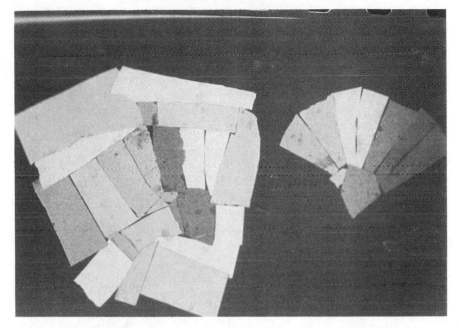

*Figure 2.1 An array of colors and a fan*

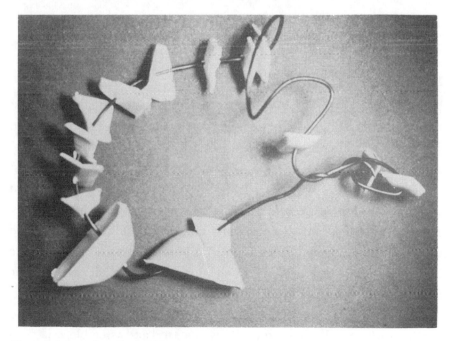

*Figure 2.2 A scenic railway with seats*

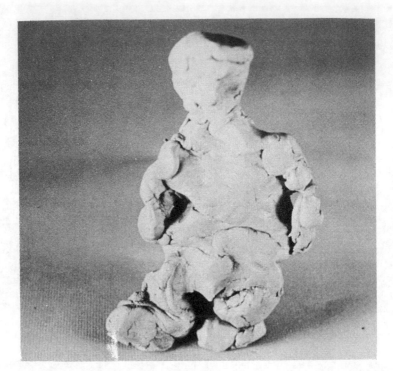

*Figure 2.3 A man thinking about his neighbor*

## How to begin

Initially I search for ways in which the older person can begin to express thoughts and feelings. I offer each person as many choices as possible to stimulate their interest; for example, one may select a particular color, some paint, or a piece of paper, wood, wire. The color might suggest subject matter; paint can be touched to a paper to make 'dots' or moved with a sponge for 'just colors;' a piece of paper can be torn into 'raindrops' or cut and arranged into 'an array of colors and a fan' (Figure 1); wood pieces can be arranged into 'a village' or 'a chip pile on a farm in the state of Virginia;' wire can be twisted and turned into a 'circle' or 'a scenic railway with seats to sit on' (Figure 2). After selecting a particular size/shape/color/feel/smell of a piece of clay, a person may squeeze and pinch a 'rock,' or roll and balance a 'tower,' or roll and assemble a clay coil 'bell,' or make 'a man thinking about his neighbor' (Figure 3).

*Basic language*

During these beginning experiences, I try to use basic human language rather than 'art language.' I have found that words like 'draw' often prompt people to respond 'I can't'…'I don't know how'…'I never could do that.' Perhaps this is because the older person may have developed certain standards for a 'drawing' and therefore may feel that he or she cannot meet them. Instead of asking a person to draw, I might say, 'Move the pencil… move it however it feels comfortable…move the pencil the way you like to move your hand.'

*Different responses*

Each of these beginnings in art therapy communicates to the therapist information about the maker. People work at different paces because of preference, attention span, physical abilities, and environmental circumstances such as medication, scheduling, and mealtimes. Some people use many media; others use only one. Some express variety within one medium; others repeat shapes and subject-matter so frequently that interpretation might range from symbolic content, to organic brain damage.

Some people can work in media which involve multi-step skills, e.g. painting with cake watercolors, which requires taking a brush, dipping the brush in water, rubbing the wet brush on the chosen color, and applying the wet paintbrush to the paper. Other people can work only in media which involve one-step skills, e.g. painting with a brush which has previously been immersed in liquid, nontoxic paint and requires only that the painter lift the paint-filled brush and place it on the paper.

*Building personal strengths*

In working with needy older persons I have found it necessary to analyze each art medium according to: skills required, safety, and developmental stages of complexity. There are hundreds of ways of painting, modeling, printing, drawing, assembling. Each older person has personal strengths to build upon. But often these strengths can be discovered only by very close observation. When an older person seemingly cannot work in an art process, it may be because the particular medium offered for the art

process requires complex sequencing, or produces glaring reflections, or irritates the skin and lungs, or exposes the person's weaknesses rather than strengths.

### Adult language

Often, a media analysis suggests using basic art materials such as tempera paint, chalks, wood pieces, crayons, and clay. Inasmuch as these materials are often considered in our culture as 'kindergarten' materials, I have found it important to use accepted 'adult language' such as 'wood sculpture' instead of 'wooden blocks.' Crayons in the No. 8 Crayola box are immediately associated with kindergarten by my clients; but crayons in a long, flat, compartmental artist's box are not. Reproductions, slides, and books of contemporary sculpture also offer acceptability to the basic shape wood sculptures that an older adult may make with available wood pieces.

### Offering stimuli

Because many of the older people with whom I work are not living in rich sensory environments, it is important to offer stimuli – a group happening – in the art therapy sessions. These shared experiences seem to help each person's responses to 'awaken' and are often followed by increased participation and communication. Ideally, stimuli offer opportunities to respond from many different personal sources: memory, reality, imagination, association. Sometimes this stimulus is a book, a film, slides, movements, exhibits, or the art materials. Usually group or individual needs, questions and discussion, or the qualities of a particular art medium suggest appropriate stimuli.

For example, an 18-inch piece of plastic-coated wire can be identified and discussed on many levels: physical qualities, uses, associations. In each person's hands this 18-inch piece of plastic-coated wire may be turned and connected to be 'a mirror,' 'a perfect circle,' 'a wreath' – or made into a pair of 'glasses' by a partially sighted woman who months before broke her glasses in an outburst of anger at a staff member and now expresses the desire to have a new pair; or it may be described by an often-angry woman as 'telephone wire – you can call someone you love;' or described by a man

with total blindness 'it feels like a tidal wave;' or made into an untitled piece, which later during group discussion is described as:

'Looks like a pig being held by its tail.'

'Looks like a donkey.'

'The little ones look like the caps of the waves of the ocean: you see them when you stand by the shore.'

'Looks like an Indian.'

'Looks like John with his headgear.'

Each of these descriptions is a personal contribution to the group inter-action and shared individual thought processes, language skills, and image association. The last example leads into a more detailed discussion of art therapy experiences which seem to heighten communication within the group.

The most basic principle, perhaps already obvious, is a group envi-ronment based on acceptance and encouragement of each individual's expression of feelings, interests, memories, concerns, and abilities. Each older person's progression is unique. At the same time there are often similar experiences, though not necessarily sequential, which are part of this process toward increased communication.

## 'I'll just watch'

Many times an older person will participate initially in a group by watching what other people are doing until he or she sees what is happening and feels comfortable with the therapist, the group members, and the activity. One seventy-five-year-old woman watched intently as some of the people in the group were doing crayon rubbings of room surfaces and/or arranged paper pieces. Whenever I had invited her previously to participate in an art activity, she would smile and say in very slow, broken English, 'Oh, I'm too old; I'll just watch.' Noticing her interest in the rubbings, I brought her some string and asked her to take it and drop it on the table in front of her. After she did, I placed a piece of paper over the string and demonstrated how to rub the crayon. She began

slowly to rub across the paper. I then explained that the crayon, paper, and string were for her to use as much as she wanted and I would be back in a few minutes. When I returned, she had written what appeared to be many names diagonally across the left side of the paper. I asked her about the names and she said they were 'messages.' I asked her to whom the messages would go. She said, 'To Emma.' I said, 'Why, that's you! Why are you sending messages to yourself?' She replied, 'To be remembered.' After a moment, I told her I would remember her wavy silver hair, her soft speaking voice, her dark eyes, and her smile. She smiled and squeezed my hand.

## Common art materials

In the personal expression of each older person's use of the same art materials there are unlimited variations. If it is accepted that there are different ways of doing things with one art material, an older person may be less hesitant to share his or her own particular style and subject matter. Several rolls of wallpaper may prompt conversations about the interiors of homes, techniques for hanging wallpaper, and the appropriateness of each pattern for particular rooms. The artwork following one such discussion was derived from each person's prior experiences. This in turn stimulated further verbalization:

> This house is in the coal mining region in Scranton, Pa. We had lace curtains at the windows, straight down. When we washed them, we washed them in Lux and put them on stretchers.

> Those look like chimneys. Our curtains were yellow and white. Flowers, I think. We lived in New York. Some houses were white and pink. I never noticed where the door handle is – it was always open.

Or a box of small varied wooden pieces may be arranged and described differently by each person. For example:

> Looks like the starting of a house.

> Born and raised in Shenandoah, Pa.

Population 7500

Our backyard was the coal mine

And we lived by the railroad

It was a coal mining town

with six mines quite a few homes

quite a few people

The woman kept house

and went out to pick coal

and the men went to the mines

the people played cards and

had all kinds of games.

These shared variations of expression can lead to group discussions of common feelings, varied life-styles, and multiple ways of responding to crisis situations.

Sharing is important, for it increases the older person's communication skills. Many older people begin to share their art expression first with the therapist and then through the therapist, and gradually may extend this sharing to include other group members.

Because this provides the impetus of increased communication, I offer participants the ongoing opportunity to exhibit their work in the art therapy room. If the art work is also accompanied by typed descriptions written or dictated by the maker, the exhibits provide both visual/tactile and verbal stimulation for conversation. It appears to be easier to look at a picture, touch a sculpture, and read a description than it is to go up to another person and initiate a conversation. I've noticed that people who rarely get up out of their chairs will spontaneously walk over to see an exhibit area; people who never ask questions in the group or rarely respond verbally to the comments of other group members will stand and carefully read descriptions accompanying exhibited art work.

One seventy-eight-year-old woman with a severe speech impediment initially resisted participation in the art therapy discussions. After she had

completed a sequence of four drawings, she wrote descriptions of them which she read to us. In this context we were able to train our ears to understand her. Here are her statements.

Milkweed

Buttercups and trees

A Creek. The log cabin was up above the creek.

Wild flowers blooming among the wild hay near roadway which in Colorado went up into the hills.   We went up and got a wagonload of poles to make a cowshed.

These written descriptions are like small stories.

## Shadow show

Cut-paper images can be used to make a shadow show by simply holding the paper pieces up to a rear-projection screen or stretched sheet with a light source behind the paper pieces. Occasionally a group story develops out of the art work of each group member. For example, cut-out paper images of a fence, bird, mammoth, small dog, mountains, and moon can be elaborated and related by the group into a shadow show with a story like: 'When the moon came up over the Colorado Mountains, a small dog and a mammoth-like animal watched a bird fly over the fence.' I have noticed an increase in group conversation about each person's art work whenever work was shared via a shadow show or slides. Perhaps this is because shadow and slide shows offer older persons in a group – especially the older person with limited eyesight – the opportunity to see intensified colors and enlarged shapes and to share experiences.

## The exhibit

As group members increase their communication skills, it becomes essential to provide a link to people outside the group. One way to do this is to invite the people in the group to participate in an exhibit beyond the walls of the geriatric art therapy rooms. Even the preparations for an exhibit offer many therapeutic possibilities. There are many choices to be

made: which art work to display; whether or not to be identified in this more 'public' exhibit; the possibility of 'selective' framing in which a person shows only what he or she likes about a particular picture. Just trimming and mounting a picture makes it special and may raise a person's estimation of the value of the work. As one woman said when she handed me a drawing, 'This is to put on the wall.'

## Cultural considerations

Cultural and historical backgrounds are revealed in our work in many ways. I first began to be aware of this when one of my female geriatric clients expressed surprise at the fact that I was married and had three children and still worked. She told me that her husband 'made her quit her job as a nurse' as soon as they were married, in the 1920s. There are significantly different individual and cultural attitudes toward women combining marriage, children, and employment today; and as a result, I have taken a closer look at some of these different attitudes in my geriatric clients and in myself.

For example, how can a young, female art therapist living in the center of a large urban community adequately communicate with clients who are over sixty-five years of age and reside in a rural institutional community? I must know about historical events, familial structures, sexual roles, religious beliefs, occupations, labor patterns, trends in mental health treatment, and the activities, objects, events, living styles and peoples of the past hundred years. How else can I communicate with a person about blackouts, food rationing, flexaphones, eisenglas, Lux, magic lanterns, grits, farina, and God in the electricity? My resources are books, newspapers, films, stories, interviews, antique shops, garage sales, grandparents, aunts and uncles, and each older person with whom I work.

As an art therapist in geriatrics, I need to know about the turn-of-the-century, the Twenties, the Thirties, the Forties, the Fifties in terms of events, roles, history, and styles, but I also need to learn about current experiments, observations, clinical studies, and models of human memory.

Art therapists need to examine the very subtle nuances of their interactions with geriatric clients. I would also suggest that we look at cultural

influences on the field of art therapy itself. How is the history of art therapy and the current 'body of knowledge' affected by recent work in perception? What information in the future will suggest that we re-examine our present attitudes?

# Addendum

## Thoughts of the Millennium

The technology developed in the twentieth century has changed how artists, educators and health care professionals will work in the twenty-first century. Yet, impressive as all of this new technology is, those who work with people in educational and therapeutic settings must continue to plan services based on individual needs. For some, the latest technology may meet therapeutic needs. For example, a 'talking' computer is a very appropriate assistive device for someone with a physical disability; on the other hand, it could be very confusing to an older person with a dementia, or contraindicated for a person who hears 'voices,' or feel overwhelming to a patient with a traumatic brain injury.[1]

What we know in the present from our past and what we can learn is the foundation for problem-solving and the basis for new knowledge in the future. For example, while doing research in Egypt with Professor Mostafa El-Razzaz and Professor Saria Sidky, I found images documenting the fact that artists and scientists often worked together thousands of years ago, and many of the images painted on the stone walls of the rooms and hallways deep beneath the blowing sandy surface raised significant questions about some of our written histories.[2] For example, what role did persons with disabilities have in ancient societies? Many written reports on the history of disability services around the world suggest the 'inclusion' model is a contemporary action primarily in the Western world when, in fact, there are clear images on the stone walls of ancient Egyptian buildings that workers with obvious physical disabilities were doing some of the same work as workers without disabilities. Further research comparing what we know, to date, from our verbal vs. visual recorded histories remains to be done.[3]

While past and present procedures may appear sometimes to be quite different, there are numerous similarities between the past and our present.

For example, Herodotus (484–425 B.C.) in his Histories 1.197, (in Odyssey, Spring, 1998) reported:

> The Babylonians have no physicians, but when a man is ill, they lay him in the public square, and the passers-by come up to him. If they have ever had his disease themselves or have known anyone who has suffered from it, they give him advice; and no one is allowed to pass the sick man in silence without asking him what his ailment is.

In the year 2000 A.D., patients and health care providers continue to search for information in the public square. It is now called 'the net.' We review the latest clinical reports on-line and we communicate electronically with others and join 'lists' to find answers for health questions.

Twentieth-century forced-choice diagnostic dichotomies (e.g. 'nature or nurture' and 'physical or mental illness') will presumably be eliminated in the twenty-first century, based on the latest findings reported by the United States Office of the Surgeon General. In a 1999 National Public Radio report, Dr Satcher summarized the findings as follows: 'Brain chemistry affects behavior and behavior affects brain chemistry.'[4]

What are these brain chemistry changes and behavioral changes? Do we have a way of recording these changes? There are now objective tests for measuring both brain chemistry changes and behavioral changes. Is art therapy a possible testing procedure for the future? Could patients who now report vivid neural 'images' during migraine headaches, or myofascial pain flare-ups, illustrate these images in some electronic form? Is there a method for scanning these images from 'mind' images to 'out-of-the-body' images?

In the past seventy years (1929-1999), the field of art therapy has changed from a proposed projective procedure to a nationally recognized profession. Art Therapists are Board Certified (ATR/BC) by a national credentialing board. The work of numerous pioneers in the twentieth century will continue to develop in the twenty-first century. New ideas will emerge and researchers will be working individually and collectively

with colleagues in other health-related disciplines in artists' studios, offices, universities, laboratories and hospitals.[5]

For the first time in the history of art therapy, it is possible for researchers to collect and store enormous amounts of visual and verbal data electronically. If all the current art therapy information in books, articles, videotapes, audiotapes, films, archives and/or private art therapy collections were collected and stored electronically (e.g. on a CD-ROM or a Web Page), there would be a world-wide collection of significant data for further study.[6]

## Notes

1.  Jungels, Georgiana 'Communicating from One Room to Another and across the world.' Presentation to the 18th Annual Network on Ageing of Western New York, Inc., Buffalo, NY, 14 October 1998.

2.  Jungels, Georgiana 'International Research in Art Education.' In *Newsletter International*, Vol. II No. 1, State University of New York, College at Buffalo Office of International Student Affairs, 1992.

3.  Jungels, Georgiana 'Over the Fence or across the Americas or around the World: Three Examples of Working Together Illustrated in Art and Imagery.' Lecture presentation to first National Conference on Urban Issues, Buffalo, NY, November 11–13, 1994.

4.  Satcher, David (U.S. Surgeon General), National Public Radio Interview, 13 December 1999.

5.  American Art Therapy Association. 'Art Therapy Research Initiative.' (Research Task Force, coordinator: Marcia L. Rosal, Ph.D., ATR-BC.) Available on AATA Web Page: http://www.artherapy.org

6.  Jungels, Georgiana 'Is a Picture Worth 10,000 Words?' Lecture, Adamson Collection Exhibit, International Conference on Mental Health and Technology, Vancouver, BC, Canada. 9–13 June, 1986.

## Suggested readings

American Art Therapy, Inc. *American Journal of Art Therapy*. American Art Therapy Association, Two Skyline Place, Suite 400, 5203 Leesburg Pike, Falls Church, VA 22041.

Jungels, G. *To be Remembered, Art and the Older Adult in Therapeutic Settings*. Buffalo, NY: Potentials Development, Inc., 1982.

Schonewolf, H. *Play with Light and Shadow, the Art and Techniques for Shadow Theater.* New York: Reinhold Book Corp., 1968.

Terkel, S. *Working.* New York: Pantheon Books, 1972, 1974.

Zwerling, I. 'The creative arts therapies as real therapies.' *Hospital and Community Psychiatry 30,* 12, pp.841–847, December 1979.

# PART II

# Dance and movement: A primary art expression

Dance and movement represent the earliest and most basic expression of human emotion. They reveal the universal symbols and rituals of our primitive selves. Our authors in this section discuss the effectiveness of their art form with seniors as it evokes active participation in community and institutional settings.

**Jocelyn Helm** is a dance therapist and educator whose experiences as the director of a Senior Resource Center give her a special perspective on the total needs of the elderly. She traces the development of a program she conceptualized for the community and she shares innumerable ideas for working on specific physical problems with individuals in her movement workshops.

**Dorothy Jungels** and **John Belcher** worked together as a dance and music team who also called on art and poetry in their relationships with elderly in a mental institution. Lively anecdotes illustrate how their contrapuntal use of the arts can affect change even when it is most unexpected.

3.

# 'Can you grab a star?'

## Dance and movement in a senior resource center

### *Jocelyn Helm*

There is strong evidence that half an hour of exercise can have the same calming effect as a typical dose of a tranquilizer.

Our dance/movement group at the Senior Resource Center has been described as 'just a little bit crazy' by those who peek in the door or happen to overhear little bits of conversation:

Float your arms sl-o-o-w-ly up to the sky. Can you stretch up and grab a star? Now pull – pull that star down – harder, now!

or

Let's make some funny faces.

*Answer:* You don't need to – You already have one!

or

Give yourself a big hug.

*Answer:* I'd rather hug you than hug myself.

or

You own all the space you can reach – pull it all in around you and shape it into anything you would like – can we explore some of that space behind us?

*Answer (from a 90-year-old group member)*: I'll be exploring that space soon enough without this!

The students, who range to ninety-nine years of age, are urged to bend, stretch, clap, flick, punch, shake, pull, and toss imaginary, but also some real, objects. They begin to loosen up and respond to their bodies. Feelings and memories are freed; repressed anger and sorrow begin to emerge and they become involved in the life around them. Contact is being made with both their emotions and their physical bodies as the group progresses through movements designed to reawaken the 'child' in them and shake out the rust of body disuse. One has only to survey the scene and note the intensity of the self-expression and communication taking place to see the well-nigh universal myths and stereotypes about our elderly dissolving.

Why is it that those things which we think of as antique are cherished and revered, while the word 'old' renders an entirely different connotation? If you ask a group of people to respond to the word 'old', what you hear is 'discarded, used, fragile, worn out.' These meanings are commonly applied to today's rapidly growing population of elderly and thus we can understand why there is so little motivation on their part to change their second-rate status in society. Many seniors have been receiving the message for the past fifty years, and they believe it.

When my work began as an intern in dance therapy at a New York Hospital in 1973, I focused on the elderly. Most of the participants in my sessions were over sixty. Many of these people didn't seem too different from what I term the 'normal neurotic,' but they were not young and they had fallen into a semi-dependent state and there was nowhere for them to go. My interest was aroused, and I decided that I would devote my energies and insights as a dance therapist to developing a better understanding of movement as a resource for the elderly. This is an area which holds great fascination for me, since I was, and am, faced daily with the reality that many older people refuse to accept the responsibility for their own physical and mental well-being. Many of them who do have aches and pains use these discomforts as an excuse to sit back and do nothing. Society then reinforces the 'don't overdo' attitude and gradually the message reads 'sit down and take it easy.'

Why not attempt a different program of physical activity which would combine within a community setting my training in physical education, movement rehabilitation and dance therapy? Most exercise programs which have been developed for the elderly have focused on the cardiovascular and respiratory systems. Research does support the observation that exercise increases cardiac and vascular fitness, and, significantly, that this improvement does not depend on having trained vigorously in youth. It has been substantiated that exercise, especially proper breathing exercises, can strengthen the respiratory muscles, provide better ventilation, and increase the vital capacity of the lungs.

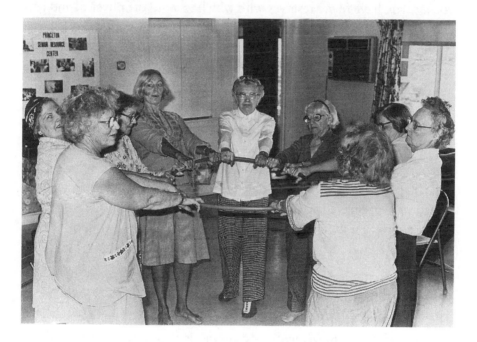

*Figure 3.1 A dance therapy session at the Senior Resource Center, Princeton, NJ.*
*Steve Mervish.*

In the past a new approach, 'gerokinesiatrics,' defined as the use of movement or exercise in the treatment of diseases of aging, has emerged. Many physicians and health educators have become interested and involved in helping people function within the confines of debilitating illnesses. Diseases which accompany old age, such as emphysema, Parkin-

son's disease, osteoporosis, arthritis, other joint diseases, and depression, have become the target. Health professionals are beginning to view the older person holistically – as one who is alive, rather than one who is dying from a disease called old age!

In a paper presented at a meeting of the Gerontological Society of New Jersey, Dr Stanley J. Brody of the Department of Physical Medicine and Rehabilitation, University of Pennsylvania, stated that perhaps one-third of the sixty-five-plus population suffers from depression at one time or another, with perhaps 5 to 6 per cent suffering from senile dementia. This is not such an astounding figure when you become aware of the fact that as you age you have fewer reserves with which to ward off physical and psychological insults. Depression, then, is a natural consequence. There is strong evidence that half an hour of exercise can have the same calming effect as a typical dose of a tranquilizer. With growing widespread drug abuse among the elderly, why not try some different approaches?

The beneficial impact of exercise and movement on preserving bone density is now beginning to be understood. Many studies have been documenting the effects of high-intensity weight-training in counteracting osteoporosis, which now affects more than 25 million elders aged 65 and over, 80 per cent of whom are women. As a result of these studies, many of which were pioneered at Tufts University, exercise programs which incorporate strength training, balance and flexibility are now being offered by federal, state, and local coalitions.[1]

## Movement as a holistic tool

The question most often asked of me is, 'What is so different about your program of dance/movement?' My answer is that movement is used as a tool to involve the whole person so that older people can use their bodies as instruments for release and joy. Where is the child in us which we have repressed for so many years? A sense of fun and companionship seems to be missing in many of the national programs.

I am convinced that you cannot persuade a person of considerable years to take part in a program simply because it is 'good for you.' As children we never bought into that rationale and certainly very few older adults will respond to this approach.

The late Dr James Sheehan, a cardiologist who had become the 'guru' of runners on the East Coast, often spoke of the 'child' in us and the benefits of allowing that part (the creative part) to be released through movement. 'Play is where life lives,' he claimed, and 'fitness has to be fun. If it is not play, there will be no fitness. Play, you see, is the process. Fitness is merely the product.' At a 75th Anniversary Symposium held at Carrier Foundation in New Jersey, Ashley Montague, a renowned anthropologist who was the keynote speaker, talked about the importance of laughter and play in the process of living. 'Physically, the benefits of play are enormous. We are designed to grow and develop as children.' Through dance/movement, the group can provide a safe, supportive, non-threatening atmosphere where people can be playful and alive and experience validation through sharing personal insights.

There is little to prepare us for the experience of growing old. When we discuss this in the group, most of the clients speak of feeling the same as they did when they were in their twenties, except that their bodies do not function as well. We try to expand their body-movement range in order to restore self-awareness.

Older people are beginning to realize that aging and chronic disease are not synonymous. Dance is one of the tools that sustains life – a tool by which withdrawal, loneliness, and the depression of old age can be dispelled. When we know our feelings, we know who we are; when we accept our feelings, we accept ourselves. When we think of ourselves as 'our body,' we can move through life with grace and dignity.

The following are some thoughts on dance/movement by a seventy-eight-year-old woman who participated in our program for over five years:

> When I do the dance/movements which are quite varied, I experience feelings of release and pleasure. I know while doing them that they are good for the functioning of my body and keep it moving more easily, and I also receive good feelings that I am keeping my mind active in a certain way! Plus the knowledge that I am part of a community effort.

She had very limited and bound patterns of movement when she first joined the group. She gradually expanded her 'movement vocabulary'

through the use of tasks, themes and imagery, to the point where her whole spectrum of movement was greater and she began to rediscover her full potential.

## Setting up dance/movement programs

In order to set up a community dance/movement program, there are many questions to be considered. The five most important challenges which I faced when I began were:

- funding: local, state, and federal sources
- location: a central location which can be reached easily by public transportation, if any. (During the first 2 years of my program there was no public transportation in our town.)
- publicity: publicizing the program and attracting members
- group composition: selecting the specific population
- community support: involving other agencies in the community so that they work with the program rather than compete with it.

### Funding and location

Funding was the most immediate concern, and after investigating several private and state institutions I found that they were not interested in programs such as this unless they were time-fillers and I would work as a volunteer. I received advice such as 'perhaps if you give us your time for a while, you can work into a part-time position.' My focus then moved toward funding possibilities from the state and federal government. A request for a proposal was being circulated by the State Division on Aging, Department of Community Affairs, to involve public housing authorities which had empty community rooms (no funds having been provided to staff them) to develop programs for their elderly residents. What an opportunity to solve both the problem of funding and location! Imagine having a 'captive' audience to form a stable core group. The proposal was approved. It was one of the twelve housing authorities (Department of Housing and Urban Development) in 1972 to be funded by the New Jersey State Department of Community Affairs for a demonstration

program. However, the grant ran out after a year and we had to look elsewhere for further funding. The program continues, now in its twenty-seventh year, and we constantly seek other forms of private funds. Small grants from state and county arts councils were helpful during the 1980s but now most of the support comes from the general public.

## Publicity

With the problems of funding and location out of the way, I could then focus on publicizing and trying to attract members to the group. Program information can be disseminated in many ways but the most effective way is to interest a few people and have them act as your publicity agents – word of mouth is by far the easiest and most efficient method.

However, you can not rely on this alone. All forms of media can be helpful. Newspapers, radio and TV usually have weekly senior calendars and are willing to include pertinent information. Demonstrations can be given in the community, especially to groups which cater to senior citizens' activities (AARP, YWCA, senior citizens' clubs, business and professional women's clubs, Jewish centers and other religious organizations). After a successful demonstration there are always enthusiastic promises, but with the dawning of a new day plagued by bad weather, poor transportation and chronic disorders, the good intentions can dissolve.

## Group composition

For many years the medical profession tended to lump all the elderly into one category. It has been a difficult lesson which programmers in the aging network have had to unlearn. More and more literature is now being written on the wide individuality of the elderly population which has received few, if any, services. I began by focusing on the older, less active group but at the same time emphasizing the adaptability of dance/movement, which can allow for individuals to participate at their own levels and could therefore encompass any age range. Our group has maintained a similar composition over the past 27 years with approximately 20 members. Anywhere from 8 to 18 show up for each session. Of these 20 members, only two remain from the original core group (many

have moved away). The make-up of the group is varied but always seems to include participants with bursitis, and arthritis or stiffness in the joints, and often two or three are recovering from hip or knee surgery. Currently an eighty-six-year-old blind woman attends and enjoys the sociability and group support. 'I come here to satisfy my skin hunger,' she exclaimed one morning. What a wonderfully insightful, feeling statement. Ashley Montague, the anthropologist, speaks of our culture as a nation of untouchables unable to express affection or understand the language of touch. Maggie Kuhn, founder of the Gray Panthers, called herself 'the wrinkled radical' and berated people by saying, 'Touch me – wrinkles aren't contagious!'

One member, ninety-nine years old, found that she could not come during the winter months, and is now too debilitated by osteoporosis. I visit her often and she confesses to tapping her feet and moving her fingers and hands so that she will not just 'molder away like some people around here.' Another member, who was a visitor for two years from Great Britain, had suffered a stroke. She was greatly excited by our program and felt it was instrumental in helping her regain some of her functioning. She was intent on getting back to her home town to spread the word of what wonders had occurred. One member says that she has substantially reduced her 'widow's hump' through a series of back exercises. A third member, eighty-four, describes her feelings: 'I love to close my eyes, listen to the music and get the rhythm going in my body – like the trees swaying outside. One gets that floating feeling with no worry or care. The music is good today. I'd like to get up and dance the way I used to at the Rochester Exposition.'

*Scheduling*

Our group meets for one hour twice a week in mid-morning. Although the elderly have more time for leisure and the pursuit of expressive roles, they tend to spend little time actively engaged in creative and intellectual pursuits. One of the first things I learned was to schedule around the soap operas, for out of an average of five daytime leisure hours, many seniors spend at least half this time watching TV. Regular meeting times are established and group members are encouraged to make a real commitment of

time to the program so that the sessions become an integral part of their lives. I find that even those members with problems of memory and confusion manage to attend on a regular basis.

## Community support

In order to involve other agencies in the community and convince them of the benefits of a dance/movement program, I had to do a great deal of consciousness-raising and advocacy. My presentations concentrated on the importance of physical activity throughout the entire lifespan, not as a stop-gap measure when you reach sixty years. Somehow much of the value of physical exercise is lost as we enter the middle years; we become spectators. Educating the public to the value of any kind of commitment to a lifelong program of movement and exercise is a very difficult task. The health service industry has never focused on prevention. We must continue to emphasize and promote programs of exercise as a process by which we can maintain a healthy, alert and independently active life. Too many older people follow their physician's advice to the letter. When a doctor or a family member says 'Take it easy,' it doesn't mean to vegetate and become stagnant. The term 'hypokinetic disease' has been coined by Kraus and Raab and is defined as the whole spectrum of somatic and mental derangements caused by inactivity.[2]

## Considerations for early sessions

The dance therapist must be constantly alert to the fears, frustrations and limitations of his or her population. When moving hurts, one moves less. There is loss in motility and a resultant loss in muscle tone. Obesity with fat encasing the muscles makes movement even more difficult. Fears of falling, heart attack and pain are all realities. Many elderly who are physically inactive often have a very distorted body image. They think of themselves as being broader and heavier, and often feel the activity to be more strenuous than it is in reality. This can lead to a clumsiness which in turn completes the cycle by increasing fears.

Dr Robert Havighurst, Professor of Education and Human Development at the University of Chicago, has stated that the three needs of the

elderly are for stimulation, identity and security. I find that this is an excellent foundation for dance/movement sessions. The definition of dance therapy as 'the psychotherapeutic use of movement as a process which furthers the emotional and physical integration of the individual,' spells out the concerns of the movement therapist. Stimulation and identity are my prime target.

Yes, I use that lost language of touch as much as possible to show that the group cares. Although the tactile sense is the most important of the senses (skin being the largest organ of the body), the elderly rarely experience the warmth of a gentle hug or caress. Often, as we are stretching, I encourage each one to reach out and feel the touch of the neighbor's hand. Is it soft? Is it warm? Is it strong? I also try to inspire creativity in every possible way. How moving it is to see the smiles of pure enjoyment as we form imaginary shapes which conjure up memories of the past. These in turn are designed to stimulate and increase the blood flow and also to activate mental processes. A healthy mix of both verbal and nonverbal communication takes place spontaneously and often leads to some fascinating reminiscences.

When dealing with individual identities, it is essential to provide a congruent and accepting atmosphere in which the group members can express both positive and negative feelings. Even though we use the group as support, each person's individuality is respected. Their own movements are important. No one is judged on performance or endurance. Virtuosity is not the aim.

## Screening individuals

The proper screening of all individuals is extremely important. The type of exercise appropriate for the elderly person varies greatly according to age, physical condition, and personal preferences. Factors that should be known about participants include:

1.  risk factor assessment – information received from a doctor; results from an electrocardiogram; ongoing medical assessment

2.  past athletic participation

3.  present amount of physical activity

4.  presence of heart disease in family

5.  weight problems

6.  existence of hypertension

7.  personal habits, e.g. smoking, drinking

The geriatric dance/movement sessions which I lead are based upon knowledge of the biological changes which take place during the aging process. There is a general slowing down in the human organism. The body gradually loses its ability to renew itself, and there are marked changes in the sensory processes. Some particulars of the aging process are as follows:

1.  increase in connective tissues

2.  disappearance of the cellular elements in the nervous system. The neuron fails to reproduce itself and there is a reduction in the number of normally functioning cells

3.  increase in intercellular 'sludge' which impairs cell functions

4.  increase in fat accumulation – more fat stored in the muscles

5.  decrease in hormonal output

6.  decrease in muscle strength

7.  decrease in cardiac output at rest, particularly in the cerebral blood flow

8.  slowing of reaction time

9.  some memory loss – especially short-term memory

10. decrease in breathing capacity of the lungs and thus a marked decrease in oxygen utilization

11. greater water retention at the expense of solid elements

12. the autoimmune response mechanism appears to turn against itself and often treats other parts of the body as foreign invaders

13.  there is a shift in the center of gravity, particularly in women, which often causes problems with balance. Falls are the sixth largest cause of death in the elderly

14.  decrease in calcium so that the bones become brittle and porous. Often the bones become compressed and deformed as with osteoporosis

15.  there is a different reaction to drugs and to combinations of drugs. Because drugs are stored in the fat cells and there is an increase in those cells, there is a different drug management problem.

In light of these many changes, I find myself consciously using certain group leadership techniques:

- speaking and articulating carefully and slowly
- maintaining as much eye contact as possible
- demonstrating clearly so that everyone can see. If the member is blind it is important to translate the movement into familiar terms or pictures
- repeating a comment made by one group member so that each person hears it
- making each member aware of the other members' disabilities so that each is sensitive to the others' needs
- interspersing the session with plenty of relaxation and breathing exercises
- using sequences of movements which stimulate use of the memory
- using series of movements which require concentration and coordination.

## A typical geriatric dance therapy session

*Participants*

- men and women sixty years or older, in wheelchairs or ambulatory
- ideal number: ten to twelve

*Location*

A large room. This gives an atmosphere of freedom. Space and good ventilation are essential. Often the elderly experience temperature changes acutely. If the space is too big, a room divider can be used. Good lighting and good acoustics are very important. I learned this by trying to run a group in a section of a large gym – the sound was disastrous, the music and our voices bounced off the walls!

*Equipment*

- tape deck and tapes. Ethnic music, such as Greek, Polish, Israeli, etc. Ragtime and jazz (especially Dixieland) have a strong rhythmic beat and are very popular with this age group
- folding chairs with straight backs, placed in a circle
- mats for those who are willing to get down on the floor
- piano. We are lucky to have an old-fashioned player piano and also someone who is willing to get her exercise by pumping it. Whenever possible live music is preferable. Sometimes you can draw upon the senior population for a piano player.

*Props*

- scarves, hoops, ropes, balloons, masks, and mirrors can be used to explore space. Feather boas are always a big hit.
- rhythm instruments, such as maracas, bongos, tambourines, sticks. Homemade instruments made out of plastic jars, or cans filled with dry beans, or coffee cans made into drums. Often

when participants don't want to move, they are willing to involve themselves by keeping time with the instruments.

- three-foot smooth sticks can often be used in exercising the limbs and are very helpful with stretching and twisting.

- balls, both large and small. Small foam balls are excellent for limbering the fingers, wrists, and hands. The largest balls are good for practicing coordination. I like wool balls the best, and they are easily made by the seniors. They are so soft that no one can get hurt.

- a parachute for all the participants to hold and wave in unison; or, if you can't afford a parachute, two double sheets sewn together.

- objects such as seashells, fur, velvet cloth, soft pillow, stuffed animals or polished stones, often evoke reminiscences.

- hand weights – varied according to the individual. We start small and then add poundage as they progress. Each person is responsible for his/her own weights.

## Methods and sequence

1.  Explanation of our contract:

    They work to their own capacity and within their limitations. They can stop anytime. No one is judging, so they don't have to worry about how they look. They must make a commitment to the group. Anyone can join at any time but we ask them to attend at least three sessions. Then, if they don't feel comfortable, they can drop out. Members are encouraged to exercise and walk on days when the group doesn't meet.

2.  Begin by socializing and getting acquainted. Memory games with names are fun and help to break the ice.

3.  Warming up: experience the different body parts – where they are and how they feel.

    - listen to the music

- feel the beat or pulse
- start by tapping or wiggling different parts of the feet: toes, balls, heels
- travel up body, using each part alone: shoulders, elbows, arms, wrists, hands, fingers; eye exercises, making faces, neck rolls, etc.
- slap different areas of the body while identifying them, working up from toes and feet to include head, face and neck massage to wake up the different parts.

4. Stretches: more exploration and experiencing; active and passive manipulation.

- pushing head up to ceiling – centering
- articulating vertebrae by curling and uncurling
- stretching arms up to ceiling, one side then the other
- twisting through the torso
- opening and closing rib-cage stretches
- reaching out across the circle to one another and pulling. Group interaction, using props and visual imagery.

5. Breathing: one or two of the following exercises when participants need to slow down and relax. Intersperse them throughout the session.

- opening and closing – inhale as you open, exhale through the mouth as you close. Slowly hiss the air out of the body, then float with eyes closed by slowly pulling air in through the nose and mouth, filling the stomach like a balloon. Then hiss it out twice as slowly through the mouth
- uncurling – start in a curled position with the head and shoulders dropped forward and slowly uncurl, pushing the back toward the back of the chair.

6. Discovering and experiencing feelings.

- stimulate all parts of the body by mimicking movements suggested by each member of the group. At first suggest

movements which are familiar, so they begin to reminisce, e.g. 'How did you churn the butter? Can we all try churning?'

- help them improvise a dance to which they can relate, e.g. Charleston, Alley Cat, square dances

- encourage movements which incorporate some of these efforts, e.g. strong, light, quick, punching, flicking, dabbing, slashing, kicking, floating – all movements which they can do with feeling.[3]

7. Weight training – at least ten minutes of each session is now spent working with the muscles of the upper body, using hand weights. (Information concerning the correct regimen for weight training is now being offered in several eastern states through programs developed originally at Tufts University.[4])

8. Winding down – pulling the session together. Let the group experience mutual support:

- rock up and out of the chairs

- swaying together

- holding hands and swinging

- balancing on toes – holding onto each other

- reaching upwards as high as possible

- knee bends (slight) and balancing on one foot

- swinging legs gently and moving in close to form a small circle

- touching, hugging, patting, kissing, are the way we say good-bye

- everyone is urged to take these exercises and techniques home with them. They can do many of them while watching TV or lying in their beds.

## Conclusions

Services provided for the elderly usually focus only on the most basic physical needs. Most therapeutic efforts are directed toward curing

specific conditions, and not toward the overall needs of the individual. The aged lose their identity and become medical management problems. Often they adopt the 'sick role' in order to live up to the expectations of society. This depersonalizing atmosphere offers no gratification and serves only to reinforce the isolation and the separation that is often the cause for institutionalization.

It is important for dance therapists to be knowledgeable about these problems of the elderly if we are actively to advocate and promote the development and funding of new programs in our communities. We can add a major dimension to the field of dance therapy through the development of specific new programs of movement which will help integrate the individual both physically and psychologically. Senior centers, nutrition sites, rehabilitation centers, nursing homes, adult day-care centers and community-based psychiatric facilities can benefit from these programs, which are geared to meet the individual needs of the elderly.

We, as creative arts therapists, are convinced that such programs, if effectively supported, can have a significant preventive effect and reduce the cost of health care by reducing the resident population in our mental institutions, as well as improving the quality of life for the elderly. 'The tragedy of old age in America is that we have made absurdity all but inevitable. We have cheated ourselves. But we still have the possibility of making life a work of art.'[5]

## Notes

1. Nelson, Miriam E. and Wernick, S. *Strong Women Stay Young*. New York: Bantam Books, 1998.

2. Woodruff, D. S., and Birren, J. E. *Aging. Scientific Perspectives and Social Issues*. New York: D. Van Nostrand Co., 1975.

3. Effort-Shape – a system of organic movement designed by Rudolph Laban.

4. Project Healthy Bones. An osteoporosis prevention, exercise and education program for older adults. NJ Department of Health and Senior Services wellness and family support program in coordination with the Saint Barnabas Health Care System.

5. Butler, R. N. *Why Survive? Being Old in America*. New York: Harper and Row, 1975.

# Suggested readings

Curtain, S. R. *Nobody ever Died of Old Age.* Boston, MA: G. K. Hall and Co, 1973.

de Beauvior, S. *The Coming of Age.* New York: G. P. Putnam's Sons, 1972.

DeVries, H. 'Physiological effects of an exercise training regimen upon men aged 52–88. In *Journal of Gerontology 25*, 1970, 325–336.

Dychtwald, K. *Age Wave. The Challenges and Opportunities of an Aging America.* Los Angeles: Jeremy P. Tarcher, Inc., 1989.

Helm, J. B., and Gill, K. L. 'An essential resource for the aging: dance therapy. In *Dance Research Journal.* Committee on Research in Dance. vii:L fall–winter 1974–75.

Laban, R. *The Mastery of Movement* (3rd ed.). Boston: Plays, Inc., 1971.

Porcino, J. *Growing Older, Getting Better. A Handbook for Women in the Second Half of Life.* Reading, MA: Addison-Wesley, 1983.

President's Council on Aging: *Fitness in the Later Years.* Washington, DC: Department of Health, Education and Welfare, 1968. Microfilm.

Press, K. *Life Time, a New Image of Aging.* Santa Cruz, California: Unity Press, 1978.

Rosenberg, M. *Sixty-plus and Fit Again. Exercises for Older Men and Women.* Boston, MA: G.K. Hall and Co., 1978.

# 'My cheeks are rosy anyway: I can't be dead'

## A multi-arts program at a mental institution

*Dorothy Jungels with John Belcher*

In nature a tiny particle is as beautiful and important as a star.
Man was the first who presumed to judge what was beautiful
and what was ugly. (Hans Arp.)

The Arts and the Aging program of the Rhode Island State Council on the
Arts was continually searching for ways to bring artists and the arts to
older people in the community. We artists were inspired, delighted, and
touched by the opportunity to be with the older people. We found that no
matter at what age, they responded to the arts and the opportunities to
express themselves. John, a musician, and I were hired at first to lead music
and dance classes; eventually we included art and writing. We were sent all
over the state to nursing homes, lunch sites, senior citizen clubs and
housing, and even to choreograph for a group of ladies in their seventies
called 'The Gingham Girls.'

## A mental hospital

Our program director, Margot Honig, found that the state mental hospital
was filled with elderly people, and that there were not many art programs
available to them. We were asked to lead sessions on the wards.

As we discovered, mental institutions are usually large, off by themselves somewhere, a place to be hidden, lost, and forgotten. Many old people survived shock treatments, lobotomies and, in some places, mistreatment, such as being dressed in nothing but hospital johnnies and left to defecate in floor drains.

We had had no previous exposure to the bleakness of a locked ward. When John and I entered the room filled with old women in cotton housedresses, it was frightening. Maybe a big factor was the missing teeth and straight hair that at first sight made them look like witches. One large lady, who scared us initially, in time became our close friend. She insisted on carrying John's heavy drum to the door at the end of each class and giving us enormous hugs. After a while it seemed unimaginable that this affectionate, childlike lady had once frightened us.

We made music with these ladies. We marched, walked, held parades, waltzed or simply sat and rocked back and forth in our chairs as many of them did. We generally tried to find what was pleasurable and meaningful to them, and when we did, no matter how simple the activity was, it also became truly pleasurable and meaningful to us.

### We meet Roger

In another class we met Roger. He was dressed in baggy, gray wash pants and shirt. His head was down, the typical stance of so many in the institution. We discovered that he had been in the alcoholic ward for ten years. Formerly he had been a tap dancer in clubs all over the Boston area. We asked Roger to dance, with John filling in a bass line on his drums.

With the critical ear of the drummer, John was surprised by the rhythms coming from Roger's feet. The steps were intricate and unpredictable, steps reminiscent of Bojangles, the Nicholas Brothers and Sandman Simms, from a time when tap dance was experiencing its greatest popularity.

Part of the Arts and the Aging plan was to create a touring show of entertainment by older people with arts skills. We mentioned to our program director the possibility of having Roger perform at a senior lunch site. She had strong reservations about using a patient from a mental institution. However, after a trial visit by Roger at one site she agreed to his

coming regularly. Later, she even aspired to get him on the payroll as a performer.

We were so naive about institutions that we didn't know how unrealistic it was to daydream about Roger dancing in fancy clothes, performing again as he once did in clubs; Roger having his own apartment again; Roger leading a real life once more.

After working together for a number of months, we inquired about getting Roger out of the hospital. We found out that after ten years there are in-between steps such as half-way houses. A patient doesn't just leave an institution and get an apartment. We were warned also that few people make it 'outside' after a long stay in the hospital. Roger's social worker, with an overload of cases, didn't know Roger was a dancer. He was very helpful when we talked to him. Within a week after our request, Roger was moved to a half-way house.

From there, Roger went back to his Narragansett Indian community in South County, and to its senior citizen club activities. He had his own apartment five-and-a-half years later. He continued with our show, which travelled to nursing homes, lunch sites, prisons, schools, housing projects, parks and even vacant lots. It was exciting not only to watch Roger recall his old tricks as his dancing became clearer, louder, and livelier, but also to watch his independence return.

In the beginning we picked him up for every show. Then he took a bus halfway across the state to meet us. If the bus from downtown was late, he would walk the mile to my house. And he walked quickly. When we hauled a portable stage, he surprised us by pitching in and lifting equipment right along with us. He treated us all to lemonade after the show, and over the holidays he gave us each an Indian beaded tie to wear for performances. These changes were dramatic and they began in an institution where 'change' is not a common word, and at an age when 'people don't change.'

## Natural creativity

Although few patients have been professional artists, we are often struck by the talent among patients in general. Sometimes they create with the direct, free, bold approach of a child. Other times, the complexity of their

life experiences reveals expressions of personal history and fantasy all in one.

We are accustomed to a kind of poetry spoken in the wards. During one dance class we were moving our arms up and down and I thought Helen was saying, 'like a bird.' But when I came closer, she was really saying, 'like a bride running to her husband!'

Jean from K Building said to me one day, 'The wind makes the colors in the sky. I taught you, now you must teach me.' There are people who have lines that they repeat time after time. 'My name is Betty. My husband left me after the war. The hell with him.' 'Bondy,' a lady in her nineties, told me, 'I'm a Boston baked bean. Give me thirteen dandelions for my grave. Roses are too expensive.' And there was the small Frenchman who would continually ask, 'Will I be cured? Will I be happy?'

Art programs encourage these expressions, allow a time for them to happen, media for them to happen through, space for them to be arranged, re-arranged, expanded or modified, and present an ear, an audience. Even in the locked ward there is hope, and through art, change is possible. When we went to RA4, we saw a large room with two long rows of chairs on which men sat, looking off into space. A television was on but no one was watching it. A few men paced back and forth. No one spoke. Our first 'conversations' with these men were wordless. We volleyed a balloon to them. Soon almost everyone began to hit it back to us. We sat next to them with a drum and asked each to hit it. We tossed a bean bag around and played music. We squatted on the floor and offered each one a marker and paper to write on.

The first move to return the volley, the first bang on the drum, the first mark on the paper gave us information about these men. No matter how 'institutionalized' they had become, locked in a ward in lethargy, dullness, and obedience, each of them still revealed a unique personality. Through music, movement, drawing, and writing we were getting to know each other.

## Transformations

Rick had been there probably longer than anyone. He would hit the drum hard, and when he drew he would use long, parallel strokes, sometimes

drawn with such force that the paper would tear. When Hal drew, he floated little lines on the paper and then crossed them till the paper was filled with X's. His drum playing was light, also, and if you shook his hand it was so soft you would have to prompt him to squeeze.

John and I would set up our chairs at opposite ends of the long rectangle of men and try to modify the group into a circular form. John would play the drums at one end and I would lead movement from mine. The moves had to be kept simple and we might do one move for ten minutes at a time. We began chanting as we lifted our arms up and down, 'Up, up, up, up' and 'Down, down, down, down.' A third of the men were participating on and off. Some would forget and just leave their arms up in the air; some would need to be called by name because they would fall back into their dreams, but even this was progress compared to the first weeks.

As the sessions went on, we introduced time for solo dances. Different men would take turns in the center of the floor, playing and dancing with a tambourine while John played the drums. Bobby, who spoke no more than a 'yes' or 'no' if you tried to talk with him, would take long solos. He became almost totally transformed: brightening up, raising his head, and stepping lightly. As we continued over the weeks, more and more men were willing to take a turn and many days we were surprised by a burst of spirit from a man who was ordinarily withdrawn.

We also set up tables for drawing. This was usually after moving and making music. At first we had to bring the drawing materials over to Hal where he was lying or squatting on the floor. After a few weeks we were able to get him to come over to the table. Hal was sixty-six and had been at the medical center since he was fourteen. His records said he was a bright boy who loved to read. He was brought to the hospital because he was hearing voices. In his medical report he was described by the doctor as 'a hundred per cent uncommunicative' and 'mute'. No one had heard him talk except when he hallucinated. He compressed his lips tightly when asked a question.

It was at the drawing table that we discovered Hal was rational, and even romantic, and quite willing to communicate – but in his own unique way. While the other men drew, Hal preferred to write. He would write

phrases like 'great Scott,' 'Gulliver's Travels,' or the names of birds. We brought in a bird chart, and for the first time we heard his voice 'Thrush! – Jay, a bluejay.' Eventually he would read off the names of all the birds clearly. I began writing words next to his words to stimulate him more. Sometimes he would copy the word, sometimes write the opposite word, or sometimes make a slogan. For instance, I wrote 'hard' and he wrote, 'It's hard to beat Skippy.' I wrote 'fight,' and he wrote 'tuberculosis.' Then I began writing parts of sentences that he might finish. 'I wish I could…' He added 'see a poem lovelier than a tree.'

I wrote, 'I wish I were…' Hal added, 'dead.'

'My favorite color is…' He added, 'black.'

'Black is the color of…' He added, 'screech owl.'

'I want to be…' He added, 'free.'

'Dear mother…' He added, 'I love you.'

One day an attendant came in a bit drunk and was creating a disruption in our class. We looked down at Hal's paper; he had written 'this man is?' We all cracked up laughing.

Hal not only read things aloud now, but he answered more and more. Since we had been writing together, the nurse in charge took an interest in him and brought him to the canteen for ice cream. She was delighted when she asked him to tell us where they went, and what kind of ice cream he had, and he answered. We noticed the attendant on the floor gave him a special invitation to go down to bingo and offered to help him play. We continued to write our poems together. This is one we wrote. I tried to follow his lead. We each used a different color marker.

The best literature is written by a *baby*

The child knows *heaven*

I sit by the brook and think of *you*

I wait for the monarch butterfly to *fly*

I look at the moon and the *shepherd and the sheep*

I feel the wind and wish for *the lover*

My heart is *broke*

I cannot find my *lover*

I watch the sheep and console myself with *soda*.

Toward the end of the drawing time, John took a few of the men off to a corner to play the drums. They sat in a small circle with the drum between them. They took turns hitting it or at times all played it together. Initially Phil would play the drum with one hand, striking it with his hand cupped – just a steady beating. Phil's playing progressed through a number of stages – from playing with one cupped hand to two hands playing simultaneously; to two hands alternately (more sophisticated and difficult for many mental patients); to playing with two hands alternately, the hands flattened so that the palm strikes the drum in a more controlled, forceful fashion. Originally, if John asked Phil to strike the drum the same number of times he did, Phil could not do it. Later he could, most of the time. John got Phil to imitate things he did on the drum after they had their free exchange. He was capable of doing this quite well and picking up on the subtleties, which showed he was concentrating and aware.

## Kinesthetic rewards

It is impossible to separate the pleasures in making art, music, dance, and words. There is a lot of overlapping. When the men play the drum, as well as enjoy their sounds, they enjoy the feel of the drum skin and the movement of the hands and wrists coordinating themselves on top of the drum. When they work with clay, the hands are again moving – going through a whole gamut of possibilities, twisting, squeezing, poking, pulling. When they move the hands to music, or squeeze and throw a foam rubber ball around, they also enjoy the sound of the music, and the shapes the hands and ball are drawing in the air. The enjoyment of all this hand movement can have a practical side; the hand–eye coordination and flexibility developed can increase some of the skills now lacking, like tying shoes, shaving, buttoning shirts.

## Overcoming small budgets

Working in institutions for five and a half years we also learned to tackle other practical problems. We found ways to overcome small budgets. John discovered that metal dustpans make wonderful gongs and collected different tone dustpans from a number of places where we have worked – with permission, of course. When we ran out of drawing paper, we discovered the rolls of paper for the doctor's examining table. Also, paper towels and cups seem abundant and can be drawn on and decorated.

One summer we discovered that kitchens of institutions can offer materials when there is no more money left for art supplies. We used a large pan of dried beans that made a pleasurable, sensual experience when we sifted them through our fingers. We have yet to request salt and flour from the kitchen for a good self-hardening clay, but that's next. Large hospitals often have their own wood shop too, and different shaped odds and ends of wood make good blocks. Some of the men enjoy sanding the blocks, which incorporates movement, sound, sight, smell, touch, and the satisfaction of turning something rough into something smooth. George made a cross with the blocks and then placed other blocks around it.

'That's St. Lucia and Martha,' he explained. I thought, the Martha of the biblical Mary and Martha, but he added 'Raye.' Then he pointed to 'Betty Grable and Errol Flynn' next to the cross.

'What are they saying?' I asked.

'They're singing "Buttons and Bows".'

We sang "Buttons and Bows" together.

## Fantasy world and reality

Many of the men opened up a great deal. We shared openly with them in ways we sometimes don't achieve even with close friends. The mundane matters that usually concerned us were put aside and we partook of rich fantasy worlds. Even in a fantasy world there is organizing, decision-making and reality.

## Gerald communicates

A striking visual example of this is a series of drawings made by Gerald. He never spoke but always took part in the movement session. Then he would draw, or rather scribble, for the rest of the time. After six months, I heard an attendant standing behind him say, 'That's a nice horse, Gerald.' I did a double-take because Gerald had never drawn any recognizable form. There on his paper was a horse! And even more striking, we looked at his older pictures which were still hanging on the wall. The vague shape of a horse with a saddle, generous mane and tail was forming, as if making its way out of a cocoon, becoming more recognizable with each drawing till this day when the horse emerged (see Figures 4.1–4.4).

*Figure 4.1*

*Figure 4.2*

*Figure 4.3*

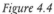
*Figure 4.4*

## Art programs can revive human spirit

Age, obviously, is not the barrier to growth, change and healing. Age may be the very reason that healing can take place. The body naturally heals itself. 'Time heals.' 'He's gotten mellow in his old age.' It is very possible that older persons in an institution can overcome their problems and

return again to a life. For a population so institutionalized and so neglected, these people still have potential spirit, life, and humor. Art programs can offer ways to uncover and revive these qualities. As Hal said laughingly to us one day: 'My cheeks are rosy anyway: I can't be dead!'

## Suggested readings

Bertherat, T., Bernstein, C. *The Body has its Reasons: Anti-exercises and Self-awareness.* New York: Avon Books, 1976.

Greefeld, J. *A Child called Noah.* New York: Pocket Books, 1970.

Hoper, C., Kutzleb, U., Stobbe, A., and Weber, B. *Awareness Games. Personal Growth through Group Interaction.* New York: St. Martins Press, 1974.

Pesso, A. *Movement in Psychotherapy. Psychomotor Techniques and Training.* New York: New York University Press, 1969.

Polster, E., and Polster, M. *Gestalt Therapy Integrated: Contours of Theory and Practice.* New York: Vintage Books, 1973.

PART III

# The drama in our lives

Drama is intrinsic to all of us as we play different roles throughout our lives. In this section, the writers give us myriad examples of the revelatory power of theatre as art and as therapy to express feelings, disclose problems, rediscover self-value, and pull together the threads of a long life — always with elements of playfulness.

**Naida Weisberg** and **Rosilyn Wilder**, the co-editors of this book, are seasoned creative arts leaders and therapists when they meet their first groups of older adults. But greater demands are never put on their abilities than when they try to engage men and women who question the value of play and imagination at this stage in their lives.

**Don Laffoon, Victoria Bryan** and **Sherry Diamond** of the STOP-GAP Institute employ their STOP-GAP method to address specific issues of aging through dramatic script performed by trained actors, and improvisation to involve members of their older audiences. This unique approach introduces us to many new ideas and possibilities using inter-active theatre as an educational and therapeutic tool.

**Rose Pavlow,** as a creative drama specialist and drama therapist, inspires participation and self-renewal among handicapped elderly in senior centers and nursing homes. She offers a range of techniques and activities that are infused with humor and playfulness, including folk tales and poetry as the basis for dramatic improvisation.

**Bernice Bronson,** a well-known playwright and theatre director, set out to develop a script derived from interviews with diverse older adults in senior housing. She weaves the personal stories she collects into a performance piece that covers many of life's milestones.

5.

# First encounters

*Naida Weisberg and Rosilyn Wilder*

## Choices

Will it be a Scott Joplin tape, a 'wedding' hat, a bouquet of herbs, or a folder of old photographs today?

Shall I wear the red caftan and the shell necklace and shall I be carrying an unusual looking box tied with ribbons?

It may depend on the season,

Or the anniversary of an important date,

Or what's going on in the community or the world at large –

But wherever I go, to turn on the troops, my wish, my aim, is to stir, surprise, entice and lift the spirits of my participants.

## In a senior center

'Who's going to pretend? Old people like us?' asked one of the senior men at the community center. He stood in the doorway for several minutes surveying the room I had just rearranged. Prior to the arrival of my first drama class with seniors, I had moved the folding chairs from their rows into a circle.

'Pretend! You mean "make believe"? That's what kids do!' said a heavily rouged woman. She eyed me with suspicion as she picked out a chair nearest the door.

I regretted my decision to let the senior adult director explain my program before I arrived, because creative arts processes are not easy to define; they require experiencing. And my years of working with every other age group should have warned me that elderly persons in particular would feel threatened by the words 'drama', and 'pretend' – a child's word, after all.

I was now facing a group of fifteen elderly citizens I had never met before, who were picked up at home by the senior bus on one to five days a week for the midday meal at the center and for the program that would occasionally follow. I was uneasy, and so were they.

After introductions, without another word I cupped my hands as though I were holding something small, fragile, and alive. I patted 'it' and passed it to Louis on my right. He grinned and said that by the size of it, it was a baby bird that should still be with its mother. When he, in turn, placed the imaginary bird into Joe's hands, Joe looked at me with embarrassment. 'What should I do with it?' he asked. 'Anything you want,' I answered gently. 'Turn it into something else, something you'd like to be holding right now.' As though he had played this way many times in the past, Joe inhaled the fragrance from a bouquet of flowers and presented them with a zestful flourish to the woman on his right.

The atmosphere in the room that had been filled with apprehension and discomfort now felt friendly and relaxed – even after this very brief period of time.

Then the woman, whose name was Angie, unwrapped an imaginary shawl and placed it carefully around the shoulders of her neighbor. Mrs Miller was a woman of great physical dignity but she was disoriented and repeated herself. Now she spoke with deliberation. 'This is beautiful and warm, Angie. Thank you. Do you know that I used to crochet sweaters and hats and afghans for everyone in the family, even shawls like this. They used to say I must crochet in my sleep, I was so fast.' The group was astounded. They were unprepared for Mrs Miller's clarity, for this sudden sign of wellness. And Angie, who had precipitated this response, beamed with an awareness of her own contribution.

It was apparent that the group was unaccustomed to sharing, remembering, and making connections with one another. Even after a few other

playful exercises which they obviously enjoyed, they were not convinced they deserved such pleasure.

'This is what actors and actresses do, isn't it?' asked the woman in the chair nearest the door. 'So why are we…we're not actors and actresses.'

'Do you enjoy pretending?' I asked, trusting the process, but holding my breath just the same. 'Oh yes, I do, I do,' she answered. 'I just can't believe that we're doing this here. It's fun. I didn't think folks like us could have such fun.'

When we said our goodbyes until the next week, I found myself surrounded by friends who were eager to know about my 'plans' for next week's workshop.

At a later date, in another senior center, a wheelchair skeptic startled me by asking what the 'bottom line' was in 'this drama class.' I had never heard the expression 'bottom line' applied to drama before and stammered over my reply. I knew that if I had said 'to have a good time,' he would have fled the room. 'Self-discovery,' I suggested. 'Fresh insights.' 'Increased perception.' 'Development of creative potential.' His dissatisfied look did not melt. But then I had a hunch.

'What do you think of work?' I asked.

'Work is good,' he said. 'Work is important.'

'Work gives you a reason to live,' someone else chimed in. 'If you don't work, you have no reason to be proud of yourself.'

'How about play?' I asked. 'Is it any good?'

'Oh yes, play is very important. It's good for you.'

'What's so good about it?' I was beginning to feel a little bit better.

'Play is like recreation.'

'Play relaxes you.' Now they were all talking at once.

'You get a lift from play.'

'You learn a lot from it.'

'Play is work, too,' from a gentleman who had not spoken before. He quickly added, ' We used to be told 'no more play' when we got to school, and I don't think I've played since then!'

There was chuckling all around after this remark, with everyone sharing memories of strict classrooms. Then finally came the clincher from my 'bottom line' challenger: 'If you forget how to play, you forget about living!'

## In an institution

Although many long-term facilities – including those mentioned in this book – offer fine programs for residents, many continue to be like remote caves in which there is little to do but wait. Residents sit facing large television screens seeing neither the images nor each other. There is a prevailing sense of hopelessness and remoteness from the light of the outside world. 'It's a place you check into, knowing you will never check out,' one resident explained to me.

I have found that the creative arts can stimulate happy participation, shared experiences, and moments of optimism even in the bleakest environments. The first time we – you or I – enter a facility can be the most difficult. But once we have experienced how our creative interventions cause eyes to brighten, or the release of unaccustomed laughter from even a few, our commitment is made.

I vividly remember the first all-day workshop I led in a state nursing home – one of the better ones, as I was to learn. In the morning I trained administrators, nurses, and other professionals. As I told them, my objective was to demonstrate how – in a group effort – drama, movement, images, words, sounds and songs can help spark aliveness, involvement, memory, sharing and laughter; how they can, with sensitive guidance, gradually restimulate residents' interaction and spontaneous self-expression.

After the first session, ten non-ambulatory patient-volunteers were brought in to participate with us. I was particularly aware of one resident, a Mrs Garnett, as an aide wheeled her through the door, erect and expressionless behind the writing tray of her wheelchair. She recoiled from the animation of the large group, mostly strangers. Her look was of someone who had been forced suddenly out into the light. She broke into sobs. A young physical therapist swiftly crossed to sit beside her, grasping her hands in his. I froze. 'I can't do this!' These words sounded in my head. Yet I heard my voice begin the session; years of experience leading other age groups supported me.

I reached into my large bag-on-wheels to pull out a brightly striped two-inch-wide elastic sewn into a circle large enough for all to grasp. With rhythmic music on the tape recorder, I queried, 'How many ways can we

move this elastic, all together?' 'Up, down,' contributed a nurse. 'Let's row a boat,' said an old gentleman. We rowed together; we pulled, stretched, waved, undulated; we breathed in unison. Faces flushed with the activity; smiles appeared.

My gaze returned to Mrs Garnett's face. She had stopped crying; her hands still firmly clasped those of the physical therapist. Later, I saw her raise her eyes to listen solemnly as feisty Mrs Atkinds, one hundred years old, shared a pantomime, and then described the early morning routine in the nursing home. She mimicked faces and voices of nurses and aides dashing in and out of her room. Others, professionals as well as residents, added details from their own experiences.

Then Mrs Atkinds sobered us, 'Except for this hour with all of you, I'm getting dopey sitting in this place...no one to talk to. I'll forget who I am...'

By the end of that hour, everyone knew each other's names. In many facilities even this small measure of identity is overlooked. Each person had shared something of his or her life, verbally or nonverbally. A man who had been a 'high-class waiter' left his walker to enact an hilarious dinner scene in which he advised three diners not to order the soup. A woman instructed us how to make a pie she had not made in thirty-five years – with gestures.

And then, from her wheelchair, came Mrs Garnett's response to my question, 'What does this shade of green remind you of?' She said, 'A drive – a drive through the Vermont mountains – about forty years ago.' She spoke haltingly of the remembered greens of the forest reflected in the wet pavements from a summer rain. I noticed others close their eyes, the better to relish the scene.

After the residents had left, the professionals analyzed the session. One social worker labeled my approach 'similar to reality therapy.' And in a way it is. Also like sensitivity, remotivation, rehabilitation, and others. We all aim to stimulate individual aliveness. But note a difference: six sessions later, the same person said, 'We work mainly from set, prescribed activities. It seems to me the expressive arts leader offers a range of choices. You listen and take cues from the participants. You aren't afraid to give them autonomy...to let them express themselves in their own ways.'

As creative arts specialists and drama therapists, we do work with a play process that seems to breathe energy and spontaneity into groups of individuals, no matter what their age or problems. It evokes their gut reactions.

One reason is that this process, as the social worker observed, welcomes many different kinds of responses from the participants – which is exciting. For another, it unclouds the senses, releasing the imagination, body, and spirit.

'Children must play in order to grow up normally', most of us accept as fact. When we are young, it is the natural way to understand and express very basic feelings about our lives. As we mature and grow older, however, most of us 'forget how to play,' as the gentleman at the senior center signaled. We need other methods and means to recapture our powers of spontaneity and creation – so we do not 'forget about living.' Drama and dance, music, visual art, and writing – all of these art forms can provide outlets similar to those of play when they strengthen our capacities for self-expression. Actually, we might call them non-prescriptive 'medicines', because they can heal; they can treat lethargy and depression with only the most positive side-effects. Individually or in combination, the expressive arts are guaranteed to induce alertness, enthusiasm, a sense of fulfillment and joy – especially when taken in large doses!

## Suggested readings

Jennings, S., Cattanach, A., Mitchell, S., Chesner, A., and Meldrum, B. *The Handbook of Drama Therapy*. London: Routledge, 1994.

Sandel, S. and Johnson, D. R. *Waiting at the Gate*. New York: The Haworth Press, 1987.

Warren, B. (ed) *Using the Creative Arts in Therapy*. Cambridge: Brookline Books, 1984.

Wilder, R. *The Lifestory Re-Play Circle*. Pennsylvania: Venture Publishing, Inc., 1996.

# Life journeys

## The STOP-GAP method with elders

*Don R. Laffoon, Victoria Bryan and Sherry Diamond*

We acknowledge that the participants are themselves the experts. Only an elderly person fully grasps the elderly experience.

*What do you see, nurses, what do you see?*

*Are you thinking when you are looking at me*

*A crabbit old woman, not very wise*

*Uncertain of habit with faraway eyes…*

*Open your eyes nurses, open and see*

*Not a crabbit old woman, look closer…see me!*

The inspiration for 'I'm Still Here!', one of STOP-GAP's touring plays for seniors, this poem was found in the bedside table of a convalescent hospital resident after her death.

In 1978 the headlines across magazines and newspapers proclaimed the graying of America. Those headlines focused our thoughts for the beginning of a theatre company – a theatre company that was to address issues of growth, aging, and life circumstances for elders, their families and communities.

Our name, STOP-GAP, began as an acronym: Senior Theatre Outreach Program for Growth and Aging Problems. An apt description for a

company with our mission, until the success of our workshops prompted requests from other age groups for similar programs to address issues specific to those groups. Twenty years later, our work has grown to include all ages and target populations. In a single year, we provided over 1,300 interactive touring plays and 600 drama therapy workshops, along with many conference, seminar and training presentations.

The STOP-GAP Institute is a professional, non-profit-making theatre company dedicated to the use of interactive theatre as an educational and therapeutic tool to positively impact individual lives. Our vision of helping individuals explore their range of roles, choices and alternatives is realized through the institute's two primary program components: inter-active touring plays serving youth, and drama therapy workshops serving a variety of special populations. This chapter will focus on the STOP-GAP method as applied in programs serving the needs of well and frail elderly people.

In our early days we explored several different formats involving the use of theatre to address the needs of seniors, including script-in-hand plays and set-building through visual art and formalized discussion, before solidifying and refining what has become known as our method. While our techniques have evolved considerably since 1978, our work continues to be guided by the same fundamental principles and values. Today, the Institute collaborates with a variety of community organiza-tions serving older adults, designing customized one-time interactive theatre pieces to meet specific goals, offering a repertory of interactive plays exploring issues faced by older adults as well as providing on-going drama therapy programs in day treatment settings.

While the groups of elders with whom we work vary greatly in terms of their health, interests, socio-economic status, ethnicity and age, we find there are more shared concerns than there are differences. We have found that our method affords these individuals the opportunity to build bridges for communication, not only between generations but amongst themselves as well. It gives participants an opportunity to view situations similar to their own, safely and anonymously.

The advantage of this is increased clarity and objectivity. Participants can consider and reflect upon what they see and hear without making definite commitments to a course of action and/or to its consequences.

This dramatic distance, and the opportunity to identify with a character, has a liberating impact on older adults. In addition, we provide older adults with an opportunity to explore their creative potential and actually improve impaired physical, mental, emotional and social functioning.

Reflecting on our work at a senior center, one psychologist observed what those of us who use creative arts with older adults have known all along: 'The beauty of theatre is that with all its drama and humor, it allows participants to really look at the issues affecting them and relate to them without closing down.'

## Philosophy

The STOP-GAP Method is guided by a philosophy that is participant-centered, interactive and grounded in mutual respect. The elders in our communities have come to feel patronized, devalued and dehumanized. Through theatre, we can offer these individuals a voice, an opportunity to be acknowledged and appreciated for their wisdom and experience. Theatre provides the means for them to impart their vast knowledge and keen insights in a way that is safe, non-threatening and fun. In fact, one of the most important aspects of our interactive approach is the platform it provides for older frail and disabled persons to speak and be heard, a feature that is all too often lacking in their lives.

Our leadership team relies entirely upon the seniors' input, their opinions and, most importantly, their feelings about the characters and situations developed for the improvisations. In every program each participant is involved up to the level of his or her ability. That could mean stepping into a role-play with us, but could also include giving us direction for what will happen next in a scene or identifying what was really going on in the scene; that is, what the characters were feeling and thinking. That the participants themselves build the scenes enables them to contribute to the fullest extent that is possible and comfortable for them. If the participant is too frail to come up to the 'stage area' (we never use an actual stage) – the role-play will come to the participant. It is the involvement of the participants that is key. This interactive quality is integral to our philosophy.

*Figure 6.1 STOP-GAP actor/therapist Robert Knapp presents 'script-in-hand' play with participant in a senior day care center, Garden Grove, California*

Another component of our philosophy is to 'listen to the experts.' We acknowledge that the participants are themselves the experts. Only an elderly person fully grasps the elderly experience. It would be inappropriate, indeed disrespectful, for us to presume to understand how important issues affect older adults. We talk to the participants and, more importantly, we *listen* to what they have to say and incorporate those feelings into the scenes.

Our philosophy does not impose value systems and ideas, but rather elicits them. We never judge. We are not there to 'fix' anyone. Instead, we use theatre to stimulate dialogue about relevant issues and explore options. Many of the seniors we work with feel victimized and without choices. The STOP-GAP method identifies and explores just what alternatives there might be. We believe there is power in choice. We urge each partic-

ipant to consider his or her own choices rather than what choices she or he would like others to make.

And finally, an extremely important part of our philosophy is the fundamental belief that we cannot change others; we can only change ourselves. Dignity, respect and personal empowerment are at the heart of our philosophy in working with older adults.

## Methodology

The STOP-GAP Method of Interactive Theatre involves a specific style of improvisation involving five distinct components:

- make the menu
- focus on feelings
- cut to the chase
- swing the pendulum
- hit the bull's eye

Whether a scripted touring play, a one-time special presentation or a drama therapy workshop, we utilize two to four professional actors (members of STOP-GAP's repertory company), who, under the guidance of a trained facilitator or drama therapist, role-play scenes based on the participants' input implementing these five components:

### Make the menu

In 'make the menu', a facilitator leads the participants as they suggest characters, lines, situations, reasons for the situation, how each of the characters is feeling (see 'focus on feelings') and a first line for a character to say. This process lays the foundation for participant involvement. It is through making the menu that participants become actively involved in the development of the improvisations that will ultimately tell their story. The more the participants have invested in the process, the more engaged they remain throughout the workshop and the more interested they are in the outcome. More importantly, making the menu introduces the concept of choice for the participants.

The facilitator will guide the participants through making the menu but the actors must listen to, and act on, the responses of the participants. STOP-GAP Institute trains its actors to listen to the responses, the names, places and relationships and repeat them if they are unclear. If the facilitator asks for a first line, the actor must repeat that line exactly as it was spoken. Hearing their thoughts, their views, indeed their exact words validates and affirms elders whose experience it has been to be ignored or patronized. Again, we are not there to judge or teach, but to stimulate thought-provoking dialogue that elicits healthful alternatives.

## Focus on feelings

We believe there is a universal language of feelings – joy, sadness, fear, loneliness, compassion, etc. The question is, what do we do with those feelings? By creating scenes that focus on characters who either keep their feelings inside or behave inappropriately, participants are able to recognize their own feelings and the feelings of others. Many older adults have become habituated to minimizing their feelings or discounting them altogether, often for the sake of others. This 'focus on feelings' of the characters creates an opportunity for participants to express their personal feelings through the characters.

Body language, of course, helps to establish the character, but we carefully avoid playing stereotyped mannerisms or behaviors. For example, the actor playing a frail elderly person will not slow his/her gait or change his/her pattern of speech. We emphasize the importance of playing feelings and emotions, not the external stereotype.

## Cut to the chase

To 'cut to the chase' refers to the use of shortcuts to explain what the participants already know about the situation being role-played. For example, 'You know the trouble I'm having with my daughter-in-law,' sums up what has been established and gets immediately to the issue. In our method of improvisation, a lengthy build-up is not necessary – we know the characters, we know the situation – these were established

during 'making the menu' and 'focus on feelings.' We want to find out where the scene is going!

If the actors need more information about their character or the situation, we find out before we start by asking very direct questions such as, 'What is my character feeling?' or 'Has this happened before?' Getting information from the participants can help to focus their attention; getting to the point quickly helps to maintain it.

## Swing the pendulum

To take the opposing point of view best defines 'swing the pendulum.' Strong conflict lies at the heart of drama. Two characters in agreement will never make a good dramatic scene. The best scene will come from two characters having strongly opposing or contradictory views, or between a character who is absolutely certain and one who is uncertain. Provocative questions or statements such as, 'You never bring the grandchildren to visit!' establishes conflict and moves a scene forward quickly. The scenes should run like a well-wound clock, not grind to a halt as everyone takes more or less the same position. Instead, our actors are trained to swing the pendulum (take opposing positions) to get a strong response not only from the other character in the scene, but from the participants.

## Hit the bull's eye

'Hit the bull's eye' is another essential component. Sometimes referred to as the 'It,' the 'bull's eye' is the point of the play or the scene. What is it really about? Is the scene about not seeing the grandchildren often enough, or is it about feeling left out or isolated? In our scripted plays for older adults, the bull's eye is pre-determined and known to the actors and facilitator. Improvised scenes, on the other hand, involve a bull's eye that is determined by our team working from the needs of the participants and input from the staff. It is imperative that 'hit the bull's eye' remains the focus of every performance. Otherwise, participants may view the program as entertainment and be less likely to become involved.

The responsibility for hitting the bull's eye is held by the team and involves the actors and facilitator working closely together, listening and

responding to the input of the participants. Each improvisation should help to make the bull's eye of the piece much clearer. By the end of the show, the participants should have a clear understanding of what the bull's eye of the piece is.

## Tools

Regardless of whether we are presenting a scripted play, a drama therapy workshop or a one-time special presentation, we will employ certain devices to further engage the participants in active contribution to the scenes. The most significant of these devices is the *pause*.

At key moments or critical junctures in an improvisation, the facilitator will say, 'Pause.' This stops all action and dialogue immediately. The facilitator then engages the participants in a dialogue about the feelings of the characters at this point and asks for input as to what the options for a particular character might be. Strong phrases such as, 'Well, what can I do?' or 'It's all my fault isn't it?' gives the facilitator prime opportunities to stimulate dialogue and gather input from the participants. Also, if an actor is uncertain about what to say in an improvisation, 'I don't know what to say to you,' is a perfect line. The facilitator will pause the scene and turn to the participants for their ideas, e.g. 'What *can* he say?'

The dialogue, between paused scenes, among participants, the facilitator and often the actors responding in-role to the participants is most lively, insightful and meaningful. Here, the actors glean even more information for their characters and, more importantly, choices for the characters, and ultimately for the participants, begin to emerge. Choices involve effective communication, healthful living and increased understanding of roles, behaviors and emotions. The pause is a powerful tool for gaining perspective, objectivity and clarity.

Other tools inherent in the method and most important in working with older adults include being clear and direct with actions and speech. For some participants, cognition may be somewhat compromised and rapid rates of speech will cause much of the scene to be lost. Also, many elders have hearing impairments, making it extremely important to speak loud enough to be heard. We avoid the use of inappropriate language, such

as slang and profanity, as not only might it offend older adults, but it de-focuses the attention from the scene.

Although humor can be valuable in helping participants become more comfortable, especially with a subject that is difficult to talk about, 'getting laughs' is never the point of any scene. We require our actors to embody the voice of the participants and, essentially, act at their direction.

Participant involvement lies at the crux of our method. Clearly, the more we can dialogue with seniors about the issues most affecting them, the more truthful the improvisations will ring and the more meaningful they will be.  But never is this more effective than when a participating senior is en-roled in an improvisation. Here, elders have an opportunity to speak their mind, have their say and experience the sense of validation and empowerment that is inherent in the role of advisor, helpful friend or family member.

Any participant en-roling in a scene must take on a role that is powerful, confident and wise. It is our intent to remove the sense of victimization by eliminating 'victim' as a role option. The actors will always play the part of a character who is behaving inappropriately, being taken advantage of, or in need of advice.

Additionally, older adults value this chance to develop their creativity while enjoying the support of their peers. In an adult day health center visited weekly, one of the participants revealed she had always longed to be an actress. It was soon apparent that she not only had a tremendous sense of humor but was quite gifted at improvisation. The participants so enjoyed her characterizations that they soon came to look forward to her contributions to the scenes, calling for her participation. She has been completely gratified by this experience.

Another woman in a different senior center went on to get an agent and head-shots and pursue a professional acting career at age seventy-six! To date, she has appeared in numerous commercials and print ads.

## Drama therapy workshops

STOP-GAP Institute's drama therapy programs for older adults work to achieve specific therapeutic goals and objectives identified by agency staff, families, or the participants themselves. These objectives may include

self-awareness, awareness of others, social interaction, communication skills, motor skills, and so on.

In day treatment settings, such as adult health care centers and senior centers, we work in close partnership with the staff to remain informed about on-going issues faced by participants in their homes, the community or within the center itself. These workshops are purely improvisational and conducted by a registered drama therapist (RDT), accompanied by two actors (one male and one female, of differing ethnic backgrounds) from the repertory company. The seniors are asked to choose names for the actors, their ages and sometimes their relationship ('Make the menu'). The situation or what the scene is about is set up according to the needs of the participants, the goals of the center, etc.

Situations role-played vary extensively. Some of the issues we address include: autonomy and independence, health concerns, accessibility, diversity, transportation, parenting and grandparenting, social and romantic relationships, safeguarding assets, and so on.

## Addressing specific incidents

Although many of the issues that staff, families and seniors tell us about are the same as those that informed our earliest workshops, there are others which reflect our changing communities. For example, in a planned community in Orange County, California, we were asked to explore diversity at an adult day care center. Once a homogeneous program, the center now serves many ethnic groups, including Iranian, Russian, Afghani and Asian refugees and immigrants, as well as Latino, African-American, Caucasian and Asian citizens and long-term residents. Language barriers, unfamiliarity with customs and even hearing loss had contributed to particularly upsetting incidents. Hurt feelings and resentments were interfering with the center's ability to meet its goals. By developing characters that had difficulty adjusting to change, participants began to recognize and dialogue about change in their own communities. By experiencing the characters' feelings and points of view, the participants determined the need of every individual to have respect and kindness. ('Bull's eye!')

At another day care center, the director came out to greet us one morning as we arrived. She said she didn't know whether we would be able to hold our group that day because two of the participants were fighting once more over who would sit in a specific chair. By transferring the situation into a scene, with our actors playing two characters who were battling over what each saw as an infringement of their rights, we were able to create a forum for the seniors to identify and address the issues that were underlying the fight about the chair. A newcomer's nervousness and a long-term participant's comfort with an established routine had collided, but each was able to see the other's point of view through the role-play.

### Interactive touring plays

Although our method is utilized in both touring plays and drama therapy, the tone of the touring plays designed for older adults differs greatly from that of the drama therapy programs serving elders. The touring plays are designed to elucidate the ideas, opinions and reminiscences of older adults, not with a therapeutic objective but rather with the intent to affirm and validate the feelings, thoughts and experiences of the participants.

The touring plays utilize at least two and as many as four (depending upon the play) actors from the repertory company. Again, the aim is to provide a gender- and ethnically-balanced cast. Because the plays are not therapeutically intended, the facilitator need not be a drama therapist but is, however, carefully trained through the institute.

Scripted plays are kept very brief, with 'cutting to the chase' and 'swing the pendulum' reflected within the scripted dialogue. Once the scripted portion of the play is complete, the facilitator leads the participants through the 'focus on feelings,' improvising new scenes that follow the stories of the characters in the play, while gently guiding the participants to ultimately recognize the 'bull's eye.' By keeping the plays brief, the participants are afforded more time to be actively involved and engaged in their own improvisations and dialogue.

Among our most popular touring plays for older adults are:

- *Life Journeys.* This play explores life lessons and provides opportunities for reminiscence, using the highway and road signs along the way as metaphors for life's decisions and turning

points. The bull's eye of the play is: to look at our past and future as a journey, to identify what is most useful to take along, and to recognize what we can learn from each curve or apparent dead-end.

- *Shared Housing.* This play looked at Maggie Kuhn and the Gray Panthers' promotion of the idea of shared housing as a way for elders to remain in their own homes. The bull's eye of the play is: to present the concept of house sharing as a viable option for some seniors to maintain independence.

- *I'm Still Here!* This play explores the life-story of an elderly woman in a convalescent home. The bull's eye of the play is: to focus on the stages of our lives – youth, middle-age and older adult; to recognize that feelings are ageless.

- *Every Part of Me.* Most often presented for support groups, this play is about coping with life-threatening illness, specifically breast cancer. The play gets to know three women: one married in her twenties, one single in her forties and one widow in her sixties, each coping in very different ways. The bull's eye of the play is: to explore how to stay open to possibilities and to establish support systems.

A glance at the bulls' eyes for these touring plays illustrates best the importance of reaching out to older adults with messages of affirmation, acknowledgement, empowerment and choice.

## One-time special presentations

The STOP-GAP Institute is often commissioned to design plays focused on a central idea or issue for a specific group or purpose. These plays often become part of the repertory, according to the needs of the community. *Shared Housing* was created in this way, as was *Every Part of Me*. The most recent example of this has been our participation in a program designed to alert elders to the prevalence of fraud against older adults by both family members and con artists and to provide the tools to prevent it. We are

currently developing a play addressing this issue for inclusion in our repertory for older adults.

## The journey

Throughout our journey with older adults, we have found one thing to be profoundly clear: our elders have something to say. As we listen and reflect not only on their life journeys but our own, we are humbled by the wisdom of our elders. We are warmed by their compassion, delighted by their stories and good humor. We recognize the significance of their contributions and believe that age does not negate them. Working through the STOP-GAP method, elders share this experience with us, recognizing and internalizing the message that they are valued members of the community, our families and our lives.

Bull's eye!

## Suggested readings

Fleshman, B. and Fryear, J. L. *The Arts in Therapy*. Chicago: Nelson Hall Publishers, 1981.

Johnson, D.R. and Lewis, P. *Current Approaches to Dramatherapy*. Springfield, IL: Charles C. Thomas Publishers Ltd., 2000.

Moreno, J. L. *Psychodrama* (Vol. I). New York: Beacon House, 1946.

Moreno, J. L. *Sociodrama: A Method for the Analysis of Social Conflicts* (Psychodrama Monographs, No. 1). New York: Beacon House, 1944.

Slade, P. *Experiences of Spontaneity*. London: Longman, 1968.

Spolin, V. *Improvisation for the Theatre*. Evanston, IL: Northwestern University Press, 1963.

Sternberg, P. and Garcia, A. *Sociodrama*. New York: Praeger, 1989.

Way, B. *Development Through Drama*. London: Longman, 1967 Humanities Press.

# 7.

# '… Secrets I never told before…'

## Creative drama and drama therapy
## with handicapped elders

### *Rose Pavlow*

I decided to assume the role of 'March' to give them an antagonist against whom they could direct their anger. By taking on this role, I could guide the improvisation while defending my actions as 'March.' The technique of becoming the antagonist creates an atmosphere of excitement and controversy that gives the group focus.

*Figure 7.1 A drama warm-up at Warwick Geriatric Day Care Center, Warwick, RI. Reprinted by permission of the Providence Journal bulletin.*

## Beginnings

It was really because of my mother that I considered initiating a program in creative drama with the elderly. I had already been actively teaching drama to children in educational and community settings for thirteen years. I believed that a similar program would be equally effective for the elderly.

My mother was quite vigorous for her age, with many outside interests, and even though she lived in a housing complex for the elderly, she was always a close, integral part of our family and friends, and an eager participant in all our activities. She frequently spoke of the loneliness of many people her own age, how tiresome some of them were, and how she hoped that she would not become 'tiresome' as time went on, and repeat the same stories over and over again.

I thought about the needs of these elderly people, frequently infirm or handicapped, and isolated within their own age group. I knew it was vitally important to instill in them the feeling that they were still an important part of the community, with valuable resources to share.

Initially, I worked as a volunteer at an urban senior day care center. We met several days in succession over a period of several weeks, which gave me the opportunity to assess interests and needs quickly. I could carry over ideas and activities from one day to the next without losing momentum and enthusiasm. The disadvantage of the usual once-a-week session, particularly with a new group, is that much of the continuity and accomplishments of the previous sessions are lost.

I recognized that a creative program could provide a structure for sharing life experiences. Folk tales, poetry, music and the other arts could provide the stimuli and the backdrop for unfolding the color and excitement as well as the sorrows and frustrations of their lives. They could share their stories now with an appreciative peer group and a responsive leader.

However, I was apprehensive. Would people who had spent their lives in a pattern of work and family life, suppressing the desire to 'play,' to be imaginative – would they come to a creative drama program? Could I help them loosen up mentally and physically? I knew I had to respect their reluctance to let go, and I would have to give them leeway and time, and

assure them that their presence was important to the group even if they did not wish to participate in active ways.

## The space

At this particular center there were only two spaces available, a dining room with rows of long tables, or a small, cluttered room filled with materials for arts and crafts. I chose the latter, although it barely gave us room to move. We were crowded together with two wheelchairs and six folding chairs. No one could escape or even nod off, because we were packed in so solidly. I did not want a new group scattered throughout a large area; I wanted eye-contact with everyone. I wanted to be able to reach out and touch those who were already partially blind, and to repeat what others had said to those who were hard of hearing. With this arrangement, we grew close and comfortable with each other.

## Tape-recording the scene

A tape-recorder often encourages responsiveness among even the habitually withdrawn, and Connie provided a classic example of this. Sitting and mumbling to herself, she seldom talked to others. She may have been trying to contribute to the group, but no one could understand her.

At one session, the group was excited about an accident en route to the center on the senior citizen bus. I felt this was a good opportunity for an improvisation. I suggested that we re-enact the incident, with different members of the group as passengers, driver, policeman, driver of the other car, and bystanders. I recorded all of this on the tape-recorder. Our policeman interrogated everyone at the scene, including Connie, who was one of the bystanders. When the tape was played back, everyone was surprised. They could hear Connie, and understand everything she said. She was delighted with herself, and after this breakthrough there was a distinct change in her attitude toward the group. She smiled, laughed, and participated in our activities more frequently.

## Other stimuli

I also found that an 'instant camera' was an excellent stimulus; its revelations never fail to initiate laughter and banter.

Our improvisations were often inspired by sounds made with 'junk' objects and simple instruments. One favorite sound-story was the dramatization of a day at an amusement park: barkers competing with each other, food vendors enticing customers, parents looking for lost children, and children begging for rides and goodies. The group made the hoots and roars of the spook house, and the shrieks for people on the roller coaster. They whispered endearments in the tunnel of love, and chattered happily about all the fun they were having.

## My techniques develop

In the following months, I began a second program at another senior day care center. This is the longest program I have led, and I feel that this center provides a strong base for the consistent development of my techniques with the elderly. My own growth has evolved from searching, selecting, and trying out varied ideas for improvisations and activities to draw out and motivate the group.

In comparison with the first center, this one has a much larger working space, and there are more men in the group. During their first few sessions, the men were not as enthusiastic as the women about participating in the program, but not one walked out on me!

This center was specifically for the handicapped. There were stroke victims with speech and movement difficulties, some were nearly blind and/or deaf, and several were in wheelchairs because of other infirmities. I did not necessarily plan the programs around their handicaps. But I did tell the group they should participate as long as they were comfortable. Actually, as the sessions continued, many found themselves moving and talking far beyond their self-assessed limits without consciously being aware of the progress they were making.

*Our sparkplug: Oma*

It is always helpful to have someone who is lively and spirited to animate the group. Oma (German for 'grandmother', which she insisted on being called) is our sparkplug. She is in her late eighties, tiny, vivacious, and speaks German interspersed with English.

Oma has severe arthritis in her knees, but she is always willing to take part. Before coming to the center, she had been very depressed, and resisted any attempts by her family to help her. Getting her out of the house and involved in the center's activities was the key to restoring her vitality. She responds spontaneously to any stimulus with a story, a song, or an old German country dance. She is often amusing, sometimes sadly nostalgic, and frequently earthy and hilarious.

For warm-ups one day we were swinging and stretching, and Oma was reminded of playing on a swing as a child. I recorded her memories:

When I was young,

I liked to swing

  high! high! high!

And when I was high up,

I liked to look in the first

  room of the house.

I was a sneaky girl.

Everytime I went high,

I thought

  what can I do?

I turned my head

  and looked at the mill

where they make the furniture.

The feeling of the moving around;

the feeling of the jumping around;

and playing with the boys;

    more! more! more!

Then the others contributed:

When I was swinging

I wanted to swing

    as high as I could.

It was a cool feeling.

Swinging is like flying –

    free as a bird.

And sometimes you

    fall on the grass.

You don't get hurt

    when you fall;

you don't see anything.

## Music was the key to Gil

Gil was the youngest member of the group. His personality was the opposite of Oma's; it was difficult to get him involved in group activities. At our fifth session I put on a recording of George Gershwin's *Rhapsody in Blue* and asked the group to listen and think about how it made them feel. Did it remind them of any people or places? Were any special, past circumstances brought to mind? Gil responded with emotion, 'How did you know that song was one of my favorites?' He continued, 'The music has got me! Secrets I never told before – I see young people dancing: I am on

stage playing my saxophone. There were changes in the spotlight from red to green, to blue and yellow!'

He had opened up and was talking about his feelings. 'Secrets I never told before' – Gil said it for everyone, everyone who achieves a peak experience through the creative arts.

There is a greater frequency of death among this age group, yet I rarely heard mention of those who had died or had left the nursing home. Just prior to one of my sessions I learned that Gil had died unexpectedly. I was extremely distressed, and wanted all of us to express and share our feelings about him, and what we had learned from him. I played his favorite melodies to help us understand him a little better. We even danced to music he loved so much. Some of the impressions each of us received from Gil, his feeling about music, what he liked or disliked, his concern for others and what he liked to do, are set down here.

> *Rhapsody in Blue* brought back old memories for Gil when he was in the orchestra – he never forgot the people dancing. Gil must have been a pretty good musician to be able to play the *Sabre Dance.*

> Maybe he was longing to be young and able like he used to be before he became sick. He liked to bring the young who had gone astray back to the fold. He mentioned a young girl he had helped out when she was sixteen years old.

> He told me his dearest wish was to go to New York to see the girl he had helped out. She was married. She called him and wrote to him.

> Gil liked to work with his hands – I tried to 'burn him up' by telling him he did good work but not much of it. It made him laugh.

## I am March!

In late March I read them 'Blow March Winds Blow' from *Poems* by Minerva Maloon Simpson, a nonagenarian poet and native of Rhode Island.

Come March and sing your mad wild songs of power,

The world is list'ning but for a sweeter note,

The wasted land emerges from its slumber

And trembles at the joy from robin's throat...

I also read a few lines by William Shakespeare:

...daffodils,

That come before the swallow dare, and take

The winds of March with beauty...

It happened to be a day of cruel, blustery, bone-chilling winds that aggravate painful conditions, and arouse strong feelings of frustration.

I decided to assume the role of 'March' to give them an antagonist against whom they could direct their anger. By taking on this role, I could guide the improvisation while defending my actions as 'March.' The technique of becoming the antagonist creates an atmosphere of excitement and controversy that gives the group focus. My initial problem was to convince them that I was not Rose, but actually a very aggressive character called March. I introduced myself:

'I am March! You think you have it hard? What about my problems? I have to listen to all of your complaints. Speak to me and tell me why you are all complaining about me. I am a perfectly wonderful month! Why are you so impatient with me? What do you want to happen?'

*Amelia*: 'March, I think you had better get out of our way because we can't stand your winds, especially when they're strong. Stop your winds blowing which we can't stand with our aches and pains.'

*Doris*: 'The winds are blowing; they shake my windows and I can't sleep at night.'

*Marie* (to Doris): 'Well, can't you fix the windows?' [Laughter from the group. Marie takes on the role of defending March at this point.]

*Mike*: 'I'd like to punch March. It's not any good.' [Mike is a stroke victim who has difficulty with speech. It is unusual for him to offer any comments.]

*Tom*: 'March, you're a stinker!' [Tom is almost always reticent. I am not sure whether his comment was motivated by the spirit of the improvisation or an effort to get back at me for drawing him into the group.]

*March*: 'Why am I a stinker?'

*Tom*: 'Too many storms!'

*March* (to Mary Agnes – she is a ninety-four year old woman with a sharp, quick wit, but she is quite deaf and I must get close to her so she can understand me.): 'Do you like March?'

*Mary Agnes*: 'I didn't say I didn't like you. I enjoy March because you are so lively.'

*Laura* (to Mary Agnes): 'What's so lively about it?'

*Mary Agnes* (to March): 'You are talking all the time and giving all your energy, while some of us are only sitting here and listening.'

*March*: 'How do the rest of you feel about me? Everyone who has spoken so far, except for Mary Agnes, who likes March's energy, is complaining. You told me to scram; you want to punch me, push me away, or make me blow away. I think I am a very energetic month with lots of excitement. If I didn't have strong winds, how would you fly kites; what would blow the smoke away; what would clear the air?'

*Gail*: 'March, you are costing me too much money for kites. I have a fortune in kites on roofs, trees, and telephone wires.' [Gail is director of the center. She is an enthusiastic participant in the activities of the group when she has some time away from her administrative duties. She enjoys the opportunity to interact with her clients.]

We get into March birthdays, holidays, clothing, and the problems of bringing up children. All the personal stories are shared with zest and

mutual appreciation, a most important aspect of the work. We have created a sincere family atmosphere with bonds of affection and caring.

The subject of March started out with everyone expressing their weariness with the long winter months, and loud complaints about the changeable weather. Gradually, as the result of our humorous exchanges and anecdotes, the mood changed to one of lightness and laughter. I felt it was now time to leave March and explore the promise of spring.

## Building a group poem

I selected another one of Minerva Simpson's poems, 'Springtime.' The first two lines are:

I love the glorious Spring when it is unfolding

Like an old time peddler showing his filled pack...

'What else do you see in the springtime peddler's pack besides what is mentioned in the poem?' I asked. These are some of the responses:

Summer underwear

Crocuses

Forsythia looks like

the shape of a small bird.

Pussywillows, like a kitten's paw.

Spring hats.

But who wears spring hats now?

My aunt had one that had a nest with little eggs in it.

Sulphur and molasses

puts hair on our chest.

After dealing with March,

you need sulphur and molasses

to build you up.

When I typed these responses – their own group poem – and distributed them at our next meeting, they were delighted with themselves.

## How significant is staff support?

The uniqueness of the center where I work is that there is regular participation by the staff in my program. Even the administrator joins in the activities whenever her duties permit. For this reason I always consider the staff in my choice of material, because if they find a workshop sufficiently appealing they will be more supportive of the program. Staff members also will be more inclined to adopt these techniques in their own work with elderly. After all, they are the ones who can provide and maintain a continuity of relationships and respect for individual capacities between my sessions. This was recognized by the center director, who invited me to lead a number of in-service workshops that showed positive results.

The administration at this center has changed several times; many new people have joined us, and a number of the original drama group are dead. But a legacy of affection and acceptance has survived and expanded through the years. Because of this sustained flow of trust, and bonds of mutual support, I have had the confidence to experiment and try new ideas. Our group of seniors has grown; the connectedness between members of the group has strengthened; and the general understanding of the possible benefits of a program of drama for seniors is, happily, fully acknowledged.

## Suggested readings

Anderson, W. (ed.). *Therapy and the Arts.* New York: Harper Colophon, 1977.
Caplow-Lindner, E., Harpaz, L., and Samberg, S. *Therapeutic Dance-Movement.* New York: Human Sciences Press, 1979.
Emunah, R. *Acting for Real: Drama Therapy, Process, Technique and Performance.* New York: Brunner/Mazel Publishers, 1994.
Koch, K. *I Never Told Anybody.* New York: Random House, 1977.
Maslow, A. H. *The Farther Reaches of Human Nature.* New York: The Viking Press, 1971.
Mettler, B. *Materials of Dance as a Creative Art Activity.* Tucson, AZ: Mettler Studios, 1960.

Sandburg, C. *The Complete Poems of Carl Sandburg.* New York: Harcourt Brace Jovanovich, Inc., 1969.

Schattner, G. and Courtney, R. *Drama Therapy* (Vols. I, II). New York: Drama Book Publishers, 1981.

Simpson, M. M. *Poems.* Virginia: Young Publications, 1968.

Thurman, A. H., and Piggins, C. A. *Drama Activities for Elders: A Handbook for Leaders.* New York: Haworth Press, Inc., 1982.

# A tapestry of voices

## From interview to script

*Bernice Bronson*

> It took a few minutes for the person to locate a memory of youth.
> Youth was now a long way off, but finally a story came. And then
> the dam broke and all the other stories began to come.

I pressed the button in the entry and a voice on the intercom asked whom I wanted to see. Satisfied, she buzzed me in. I was on my way to interview residents at Charlesgate, a high rise for seniors.

NewGate, the theatre I had been working with in Providence (actress, board member), had received a grant for an outreach program. Knowing that I had just written a piece for the Jewish Home for the Aged, and, years before, had written many plays for Looking Glass Theatre, NewGate commissioned me to write and produce a show for/by the elderly. Well, what elderly, I wondered? Elderly are everywhere. I am elderly. A friend steered me to the building where she lived, which had a number of subsidized apartments and, therefore, a good cross-section of tenants. Good idea. So I contacted the director of daily living, who suggested a number of people for the project and prepared them for what was to come.

Those I was to interview were notified by intercom of my arrival and let me in according to how they viewed the visit: perhaps cordially, perhaps hesitantly, or suspiciously, or curiously, and sometimes warmly. A little chit-chat to get going. Then I explained that the show I was writing would

be based on the lives of people living at Charlesgate. I wanted to know their memories of childhood, youth, work, love and marriage (if any), World War II and other important experiences. And then I wanted to know how they would evaluate this in retrospect and what they felt they learned about life.

It took a few minutes for the person to locate a memory of youth. Youth was now a long way off, but finally a story came. And then the dam broke and all the other stories began to come. For my part, I listened very closely, quietly – unless there was some shock or joke to be shared – and followed up on as many points as I could. In essence, that close kind of listening, recognizing, made us friends. Actually, many hoped I would be dropping in from time to time just to see how they were getting along, but that is how they gained the courage to remember so many stories and share them. I taped everything.

The people I spoke to included:

**Ben**, a tall, gracious, whitehaired man about 80. Admired. In his youth he had been an actor.

**Marianne**, a tiny energetic woman with huge eyes that could hardly see any more. She was in her middle 80s and did line dancing every week.

**Richard**, way up in his 80s, somewhat formal, called things as he saw them.

**Athelina**, an African American artist/art teacher, creative, small, intense, beginning to wander. She solved her storage problem with white satin covers placed over piles of newspaper articles about her achievements. Other stories were piled on top.

**Henry**, a tall, thin, elegant man; wore an ascot; a terribly fast talker and thus difficult to understand; in his 80s, a painter, still painting and selling. At one point he had taught painting in a mental hospital. His motto: 'Follow your instinct. Do as you please. But keep your eye on the cop on the corner.'

**Lawrence**, about 95, somewhat slowed down, but still with a sense of humor. Many books and photos around. Had held an

incredible number of jobs, but finally settled down as a photographer.

**Marion**, life consisted of visiting friends at Charlesgate, food shopping and going to the theatre. (Local theatres donated tickets to Charlesgate residents.)

**Gersh**, a Russian immigrant, about 65, came here with his children and grandchildren who lived nearby. In Russia had been a designer of automobiles; now he was an auto mechanic. Had trouble speaking English.

**Louise**, a Cape Verdean woman, had the authority and warmth of someone who is at the center of things. Indeed, she was the chair of the senior center that met in the building. She had been the chef of a chic restaurant that I loved.

**June**, my friend, had lived in Hell's Kitchen in New York City, in a fascinating settlement house where she taught neighborhood children. Ultimately, she taught in other places and then made a career change to become a research librarian.

The responses were terrific. They all took great pleasure in relating their experiences; well, of course, they were the ultimate authorities on these subjects. Here are a few:

## Memories of childhood and youth

Marion recalled, or perhaps had been told, that at age four she had boarded a freight train expecting to get to Grandma's. She knew Grandma would say 'yes', whereas Mother had said 'no'. Little Marion was noticed by a lady, who took her home, put her hair into banana curls, fed her cookies, and called the police.

Ben and his younger brother were putting on a play in their basement. It was war and his brother had the line, 'I want to die with my boots on,' whereupon Ben immediately got boots and put them on him. The audience roared. After that the boys began charging admission.

Gersh: 'I'm not sure I remember this. Maybe my mother told me. I was about four years old. War had just begun and my father was soldier. Our family moved from Kishinev, from the Germans. I remember a big field. The airplanes, they shot, and our mother covered us, me and my brother, with a blanket. She tried to hide us. She was not under blanket; she had not time, the planes go so fast.'

Marianne talked about growing up in a fundamentalist Protestant home. 'Nothing worldly in the house on Sunday other than we'd sing classical and hymns. There was no card playing and, of course, no television. We didn't even have a radio. Often I think I didn't have the kind of childhood I would have liked. It lacked the closeness and the sharing.' Marianne thought that, because of the lack of affection, 'you're always seeking out someone, even if they're not the best person in the world, if only they're affectionate.'

Louise: 'Most of my childhood is vague, which is often the way with orphans. I grew up as a ward of the state and I don't remember anything about my foster families. But I do remember Cape Verdean life, especially the food… At holidays there was a lot of interchanging of dishes, and they were all-day cooking affairs for the adults. If the kids were interested, they just hung around and learned. I later became a chef, you know.'

Henry's father had died, and his mother was a traveling saleswoman. Consequently, he was placed in an orphanage. 'All my life, I'll remember the screaming of children having their teeth extracted without novocaine. They were pulling one out here, one out there. That's a shock you go through. Another shock was, if you didn't eat your meal, you had it the next day. They kept it on a cold shelf, and you had to eat it. If you didn't, they'd whip you. I ran away twice, went back twice, but at twelve I was on my own. I lived in a rooming house, and learned the ABCs of shacking up right away.'

*Young adulthood*

Athelina: 'I graduated from the Rhode Island School of Design ready to be an art teacher in the school system. But apparently they felt it wasn't going to be. They said, 'You're very good, but we have nothing for you.' Well, a rejection is a blessing. I felt I had something that was needed; if it was not going to be useful here, I'd go elsewhere. I wanted to get on with life's activities. So I packed my suitcase and moved in at the New York YWCA and asked God to open doors. And you know what? He did just that. I went to teach at the Abyssian Baptist Church where Adam Clayton Powell was minister, under the WPA.'

Louise: 'I started work as a maid. I did cleaning. Cleaning was wonderful. After a while I went to work for one of the richest ladies in town.' Louise did so well that she was promoted from maid to cook, and was taught by her employer the art of Jewish cooking: how to clean a fish, cook a fish, clean a chicken, and so forth. When she had mastered these skills, 'I became a professional chef and went into business with two ladies. They put up the money and invited me to join them because of my experience.'

Richard told of his professors at Harvard, especially George Lyman Kittredge, who taught Shakespeare. This story will be demonstrated as a scene later.

## Love and marriage

Ben: 'When I was in high school, and the best-looking girl was going with the best-looking boy, I managed to steal her away. I don't know how. I would hang around her place, walk her home... We eloped. It was...not good.'

Athelina told a delightful story about how she and her husband got together. A dramatized scene of it will be shown later.

Henry: 'This was after I retired and was living here. It was pouring. She was standing outside waiting for a bus. I said, 'You wait inside. I'll let you

know when the bus is coming.' I was going to the library to return a book on the French Impressionists. On the bus, I kept opening the book and she kept looking at it, and we became friends. When we got off, she gave me her apartment number. I became her guide, her lover, her travel agent. We had a wonderful relationship for six years... Then she died. But those six years were the best time, the only time in my life when I was in love.'

## World War II

June: 'My brother, Harry, informed us that he was going to ship out soon, and asked us to meet him in New York. My mother and I went down. My father was away on business and would join us later. We all got together at the Taft Grill where Vincent Lopez was playing – his theme song was 'Nola' – and dined and danced all night until Harry took us back to the hotel. The last thing we saw of him, he was heading for the elevator. The saddest thing was that my father came the next night and went to the Astor bar to meet him. The poor man waited all night. Harry never showed up; he had shipped out. A few weeks later we received a telegram. A French aircraft carrier with mechanical difficulties had rammed the Number One hold. All those kids were washed out to sea. Drowned.'

Ben: 'I had been in training in Wales and Britain for the invasion of Normandy. We took the first men to land, the Rangers. Oh, they got the hell beaten out of them, floating around on the shore. It was appalling. After we dropped them off, we converted to a hospital ship for the dead and wounded. It was my job to go out in a boat, pick up the dead and wounded and bring them back. My best buddy had to receive them, tag them and tell the ship's personnel where they should go. For some reason, our jobs were switched. Now, as receiver... I had to tag my own buddy. I couldn't make sense of it. Why him and not me.' Ben could never tell this story without tears.

Henry: 'Some people don't believe there ever was a Holocaust. They should. I was there. We freaked some of the victims, running our trucks right through the wall. One thing that struck me that I really felt was the

sight of all the clothing carefully stacked in different sizes. All the little dresses, the glasses, the trousers. They were stacked up by size. That gets to you. But when the men were loosed – now this was never written, but I saw it – there was a cow out in the field. And, as they ran out, they picked up stones, stoned it to death, and ate it just the way it was. Now these were human beings, but they were starving. It shows you something. When man loses everything but the need to survive, he reverts back to an animal and anything goes.'

## Other important things

Marianne: 'My friend, Dr Nancy, invited me to go to the medical school and talk to some of the students. I told them how I thought a doctor should behave. I said, 'If a doctor has a patient that doesn't talk so well, the doctor should do the talking and get the patient to open up and feel free. AND DON'T LOOK AT YOUR WATCH. That's one of the things not to do.' And I says, 'Don't get up and get your hand on the doorknob because your patient will think, "He's too busy. I can't ask him for this; I can't ask him for that." And, if there's a patient in the bed when you come to visit me, pull the curtain. Give me the privacy. And NO WAY are you going to call me by my first name unless I ask you. And no way are you going to use the word "pee." This doctor I had the gall bladder operation, he come in with some students one time, and he was half way across the room and he called out, 'When did you pee?' Well that just drove me up a wall. I said to him, 'Doctor, could you dress that up a little?' He turned beet red.'

Mary: 'I was a nurse's aide and was trying to move a patient but just couldn't. It was 95 degrees outside and the air conditioner was broken and I couldn't breathe. My doctor had told me back in '83, "You have a touch of emphysema. I strongly advise you to stop smoking." I couldn't wait to get out of his office to get a cigarette. And now I couldn't even call the charge nurse to give me oxygen. I prayed, "If I ever get out of this room, dear Lord, I'll never smoke a cigarette again." Yet, when the feeling passed a few hours later, I took another cigarette and smoked it. I kept this up for three more days. Then I remembered that my mother used to tell me that a

promise is a debt. I had promised the Lord, hadn't I? These thoughts kept battling in me. I even said the words, "This is the end of my life," on my way to buy another package of cigarettes. But I never did buy another pack. Never. I won. The Lord has been kind to me. He gave me a second chance.'

## What if you could do it again?

Marion: 'I'd do everything different. My life has been one big inferiority complex brought on by things my mother told me.'

Mary: 'I wouldn't marry that fool.'

Marianne: 'I never cry in my beer. Whatever I did is what I wanted. But I would have loved to have done ballet dancing.'

June: 'I would not have been so cautious. When I worked at a newspaper one summer, I had an interest in reporting. But I was intimidated by the newsroom, especially the men. That was foolish. A couple of the girls who were with me went straight ahead.'

Gersh: 'What would be different? I don't know. I would have to be born again. But no. When I look back, it seems to me it was wonderful. I don't feel sorry about my life. It's the one that could be done and it couldn't be different.'

June: 'One of the downsides of old age is that you're never satisfied with what your life has accomplished. It suddenly hits you: this is it; this is what I am; this is what I have accomplished.'

Henry: 'When I was sixty-two I said to myself, "The most precious thing in the world is time to yourself, twenty-four hours a day, time to yourself." I retired. These days I have time to paint, time to read, time to go anywhere I want. It's the greatest feeling in the world.'

By the time the interviews had ended, we had bonded and usually we were satisfied. In retrospect, I think some of the end-of-life statements were happier than they might have been at another time. Perhaps it is because we so enjoyed talking about their lives. Marianne's daughter, a psychologist, told me later on that the entire process had validated her mother's life for her.

In converting the stories to a script, I used the material in terms of themes rather than sequential life presentations. Some of the stories stood well by themselves and could be narrations. For others, additional voices, not characters, added some dimension. For example, in Mary's story about giving up smoking, a doctor's voice spoke the line about emphysema, a mother's voice spoke about the meaning of a promise and someone else's voice represented Mary making a promise to God.

Here is Richard's description of Professor Kittredge:

*Richard/Kittredge:* He had certain idiosyncrasies. For example: If he were giving a lecture scheduled for, say, ten in the morning,

| | |
|---|---|
| *Student:* | whoever was to attend would file into the room, |
| *Another student:* | find a seat, |
| *Third student:* | and wait for him. |
| *Kittredge:* | Once he came in, the door would be locked. |
| *Student:* | So if you were late getting there, |
| *Another student:* | you did not hear the lecture. |
| *Third student:* | You couldn't get in. |
| *Kittredge:* | As he was finishing the lecture, he would start up the aisle. The door would be opened for him and he would go out. |
| *All students:* | Only then could you exit. |

In the dramatization of Athelina's courtship, there were actual roles:

| | |
|---|---|
| *Athelina:* | *One evening I was taking dictation from Miss Malone in the kitchen when the doorbell rang. And who was at the* |

*door, but the pastor of the church. Now Miss Malone was a*
*trustee, so I thought Reverend Latham had come to call on*
*her about church business:*

Wait a minute. I'll go tell Miss Malone you're here.

| | |
|---|---|
| *Reverend Latham:* | I didn't come to see Miss Malone. |
| *Athelina:* | You didn't? |
| *Latham:* | I came to see you. |
| *Athelina:* | *Now I was a New England Girl, an old fashioned girl. I didn't have lipstick or nail polish and I was married to my art, you know what I mean.* |
| *Latham:* | I came to see you and I brought some ice cream. |
| *Athelina:* | Miss Malone, Reverend Latham has brought us some ice cream. |
| *Miss Malone:* | I don't want any, dear. You all have it. |
| *Athelina:* | *We sat down and had some ice cream. I was so steeped in my art, I couldn't see through it. But God knew I needed a partner now. The Lord knows and he'll give it to you when it's time.* |
| *Latham:* | …an appointment for lunch… |
| *Athelina:* | An appointment for lunch? |
| *Latham:* | Next Wednesday at noon? |

This goes on for a while, involving Reverend Latham's grown daughter.
Then:

| | |
|---|---|
| *Athelina:* | *And you know, it happened. We were married on the 28th of April, 1943 in a church wedding with 1,200 people. The balcony was jammed, and the staircase to the balcony, and all down the aisles. My mother came from Rhode Island and spent a month getting me ready.* |

The stories provided material for a successful script, *I Do Remember*. Many of the transitions were accomplished through songs that everyone would remember and that also gave focus to the script, such as '*Dearie*'; '*This Is The Army Mr Jones*'; '*My Buddy*'; and '*Let Me Call You Sweetheart*'.

Keeping costs down, our acting company consisted of three seniors from Charlesgate, our accompanist (with violin) and me. Our last performance of twenty at senior centers was at our high rise; a smash of course, and everyone in the audience joined in the singing. We were theirs! In many of the centers, they stayed around to talk to us and tell us their own stories.

To complete the requirements of the grant, we had to collect written feedback from our audiences. These forms indicated that they had enjoyed the performance because 'It was about real lives.'

## Suggested readings

Basting, A. D. *Stages of Age*. Ann Arbor, MI: University of Michigan Press, 1998.
McDonough, A. *The Golden Stage: Drama Activities for Older Adults*. Dubuque, IA: Kendall-Hunt, 1994.
Terkel, S. *Working*. New York: Pantheon Books, 1974.

PART IV

# Intergenerational: Youth and elders come together

The perfect world could be one in which all people are connected by respect for each other, regardless of age, race, religion, cultural heritage or status. A world in which people are sustained with pride in origins and an awareness of their mutual significance on the lifeline of their times. To look for this nirvana in either the near or far distant future would be naïve and unrealistic on our part, of course. But we *are* capable of helping to bring people of all ages together to understand and accept some of their differences and acknowledge their similarities.

One easily accessible way of achieving this is through the arts: story-telling, dramatic improvisation, poetry, movement, visual arts, and music. When we pair these with strategies for better interpersonal and intrapersonal communication with the leadership of well-trained practitioners in a safe, non-threatening environment, a heightened awareness often occurs, as in an epiphany.

The following articles describe dramatic process as the primary route to connecting people of mixed ages to one another. Today many individuals think of drama as a passive form of entertainment, as when one sits and watches a 'product.' When the curtain opens, when the TV remote is pressed, young and older become spectators to the lives of others unfolding before them. But they are not *actively* involved.

In past times active, creative expression was an integral part of most cultures. It was the way communities coalesced to express identity in work and play, in ceremony and ritual. Young and old chanted together, danced, played instruments, painted their bodies, put on masks to become 'the

other'. Creativity was part of living, not a special word in many languages. Perhaps it was their therapy as well.

Drama is an active part of life review as older people remember and re-play moments of their long lives. For most young people, pretending is natural and helps them try on a variety of life roles, behaviors and attitudes. Both age groups embark on an adventure; and, together, 'playing' connects them to one another.

# Youth and elders inter-act

*Rosilyn Wilder*

The following is adapted from *Come, Step Into My Life: Youth and Elders Inter-Act* (New Plays-Books, Inc., VA, 1996) to introduce our intergenerational program as it evolved. A multicultural program which lived for seven years, it was built on dramatized life stories. It catalyzed many thousands of middle- and high-school students to collaborate with elders at schools, senior centers, and nursing homes throughout New Jersey and Northwest Massachusetts, and at state and national conferences.

## A Beginning...

It's the first intergenerational workshop of our eight-month pilot series. Picture a large multi-purpose room in an urban Middle School. Forty-eight chairs are arranged in a large square. The room is empty. Suddenly thirty 7th grade students swarm in like locusts. I call out, 'Please leave a seat between each of you for the elders!' They ignore me. Instead they crowd, two to a chair, at one side of the room. The elders arrive slowly and take empty seats facing them. Some look uncomfortable; others cast warm looks at the unresponsive youngsters. Can we really change this within a two-hour workshop?

I pull out a long rope and hand one end to a tall gentleman, the other end to a student. Man and boy pull the rope taut. Instantly, we have everyone's attention. 'This end of the rope is the year 1900,' I begin. 'What does the opposite end represent?'

Several voices chant: '2000.'

I continue. 'When I signal you, place yourself at the point on the rope where your birth year belongs.'

Thirty young hands are wagging at me. I select six students and an equal number of the older people. Two girls place themselves at mid-point on the rope. Others scream, 'You're not that old.' And they edge up closer to the far end. Three of the elders, a bit self-consciously, identify their birth dates close to the starting point. There's a gasp; nobody can be that old.

'What is this line?' I question.

'It's a time line,' says a student. An elder adds quietly, 'Maybe a lifeline.'

'How about a century-line?' suggests another youth.

'What's the main difference between all the people standing along the line?'

'They were born in different years,' sounds a thin voice.

'Do you think they have anything in common?'

There's a pause. What am I after?

'They're all standing,' chimes one boy.

'They're all people,' from his friend. The students all giggle.

'We're all part of the same century,' booms out an older voice.

'Then again, what is really different between us?'

'I guess we've just had different experiences,' starts a girl. 'We know different things...different times...'

And so we begin.

*Some history:*

Ideas often germinate in our minds without our full awareness. And suddenly, full bloom, they spring forth. Without a plan, I announced to my staff one day, 'How about starting intergenerational programming for next year?'

I knew I didn't want a mentoring program, useful as that can be, or an oral history program with youth interviewing elders for historic material. I dreamed of a program based on collaboration and interaction in which people wouldn't merely talk about their lives. Through dramatic improvisation they would replay them. By contrasting past and present, youth and elders could begin to understand and enjoy each other better.

I dreamed of a program in which youth and elders, and maybe members of the in-between generations, could feel connected by their similarities. They also could learn to accept and respect their differences. They would be able to replay the good experiences as well as the hurtful, and not be faulted for what they wished they had never done or what was not known or understood; the program would contain at its base a seriousness of intent, but with lots of room for playfulness and shared laughter.

I coined the term 'life drama' to describe our work with all age groups: a hybrid which includes many art forms.

### The preparation

On an open office wall we nailed up a production board with many columns. Column one: a list of our objectives and goals; next, our operational plan for a pilot time-line, and details we needed to get started. Then, staffing needs and how to fill them, followed by several slim columns of projected expenses with a budget for fundraising. The last column enumerated whom we would approach for both financial and material support.

A professional fundraiser helped us. This preparation was essential before we met with selected school districts or approached potential grantors. To request funding for an untried pilot program required that we be persuasive: why did we fit within their guidelines for giving? Our non-traditional approaches through the arts and life stories also needed justification.

Our timing was good. Nationally, organizations had formed about this time with similar goals. Three non-profits had effective programs in place using forms of drama, some of them scripted, others presenting contemporary problems between the age groups. Ours would be one of the first based on shared life stories, dramatized spontaneously. This was reworded for easy consumption, as 'experiential learning.'

With receipt of the first grant from the Geraldine R. Dodge Foundation, we approached six schools in three contrasting school districts, representative of the multicultural, multi-economic character of our area.

Simultaneously we started the search for capable creative drama leaders experienced with youth or with elders; we found few who had combined the two. We found ten men and women representing racial and ethnic diversity, artist-educators sensitive to our purpose and goals. A more eager, enthusiastic team of players one could rarely find.

## At the schools

We presented our program in each school district. The superintendents and principals were eager to be part of the eight-month pilot. Middle- and high-school classes were assigned with their home room teachers. We met with these teachers immediately to orient them to our purposes and ways of working. Then, elders were recruited by our educational coordinator, men and women who lived within each school district. She met them at church luncheons, senior citizen gatherings, or activity centers. It often took a lot of coaching for many elders to try something new.

For a pilot program, evaluation was necessary. Therefore we built a volunteer group of twelve professionals as our evaluation team. They included a middle school principal, a college teacher in education, a gerontologist, the director of a state arts organization, a social worker, retired teacher and a division on aging director.

Questionnaires were the 'opening wedge;' one for students 5th thru 10th grades; one for the elders to be filled out at the first workshop. Here is a sampling:

'This sounds so boring, working with a group of old people,' from a twelve-year-old girl who later became attached to one of the women.

An older woman wrote: 'Will kids accept me? I don't speak English very good. Will they laugh at me like my grandson does?'

A fifth-grader: 'They probably have a lot to teach us, but most of them are too weak like my grandmother. She forgets who I am most of the time.'

One older man wrote, 'My grandchildren are well-behaved. But other kids…they're such pack animals. What in the world can we say to each other?'

One teacher wrote us: 'Do you really expect these kids to listen to a group of old people? They think all history started today. I don't think this will work with my class.'

Only a few students thought well of elders, 'My grandfather is smart; he can fix anything and even helps me with my homework,' from a thirteen-year-old girl.

In the following months, not only did these responses change but long-lasting friendships were developed. The year after the pilot ended, one school invited all the elders to the graduation. At another, as reported to us proudly by the principal, several youths and elders became phone buddies. But I am getting ahead of the story...

## The pilot takes shape

In late September, with excitement and some trepidation, I called a supper meeting with the artist-leaders and our educational coordinator. I wondered, were my goals attainable? How should I play my role as 'artistic director?' In my journal I wrote:

> It was an intense and spirited evening. The energy that vibrated around our square table was almost visible. We agreed to hold monthly meetings as a time to exchange ideas and hear each other's experiences, even to replicate moments from a class so we could see what worked, what did not, and why.

Orientation Sessions were scheduled separately with students and with elders.

AN ORIENTATION SESSION WITH 9TH-GRADERS HELD IN A CITY SCHOOL
UNDER SECURITY SURVEILLANCE

Led by Carmine Tabone and Lisa Dennet, they outlined this session:

*Purpose:*     Introduce our new program. Introduce dramatic improvisation. Introduce the idea of working with active older people; make it attractive to them.

*Procedure:*    1) Get acquainted. Introduce ourselves. 2) Set ground rules of respect for each other's life stories. 3) Demonstrate the kinds of activities we will do. 4) Test out their stereotypes of older people. Allow lots of laughter. 5) What is

expected of their stereotypes of youth? 6) Fill out quest-
ionnaires. 7) Positive closure.

*Comments*:  This is a challenge. Students warmed up with the stereo-
types. We listened hard, kept changing our ground plan to
include their ideas. Most kids seemed enthusiastic by the
end.

### AN ORIENTATION SESSION WITH ELDERS, HELD IN A LOCAL CHURCH

*Purpose*:  Explain the pilot program, purpose and format. Explain
the realities of young people's lives today, choices they
face, and the support they need; how they, as ersatz grand-
parents, can help. Introduce improvisation.

*Procedure*:  1) Brief intro of myself. Then of pilot's purpose and
format. 2) In twos they interview each other; then share
gathered information with all. 3) Discussion of preferred
titles: Mr, Mrs, Ms, First names, etc. 4) Discuss games they
used to play, other memories of their youth. 5) Set up easy
improvisations. 6) Fill out questionnaires. 7) Closure: Sign
them up; give dates, hours, and location.

*Comments*:  Overall, they seem willing to meet with youngsters in an
unusual way. A few were confused that this isn't oral
history.

### A FIRST WORKSHOP WITH 25 6TH-GRADERS AND 11 ELDERS IN A SUBURBAN MIDDLE SCHOOL, LED BY JEAN PRALL

*Theme*:  Discovering each other as individuals.

*Purpose*:  Make generations comfortable with each other. Find some
topic(s) of mutual interest.

*Procedure*:  1) Introductions: each person's name, 'One thing I like...',
'One thing I'm good at,' 'One thing you'd never guess

about me.' Group guesses.

Play out stereotypes of each other's generation. Set up first interactive improvisations.

*Closure:*    In circle: What will you remember of our first meeting together?

*Comments:*    Introduction worked well. One student sparked the improvs by saying, 'I'm good at talking on the telephone.' Discussion contrasting today's cordless and cell phones with early party lines led into improv phone calls of past and present. Students enjoyed playing party lines. Having tangible props helped too. (My prop bag had toy phones.) Stereotypes avoided being insulting, just very funny. Each age group really listened to each other. Closing comments showed interest had been sparked.

### Realities, pleasant and otherwise

It didn't flow like this in all the classes. It took several weeks for student resistance in one school to fully surface. In the same school, five elders revealed a different kind of resistance. Despite our orientation session, there was confusion between words and interpretations. They still expected life drama to be oral history, focusing on their stories alone.

One man spoke with irritation: 'I thought this would be like a program I did at the senior center. Students came there to ask us questions about our lives.' Another man, a retired engineer, added that he didn't think there could be anything he'd learn from 'these kids.' These were expected – and unexpected – snags.

With some of the students, as with the five elders, reconciliation was impossible. Students had enrolled for an acting class, and improvisation – considered vital in professional acting workshops – was not something this teacher was comfortable with. The teacher was not happy with us; the students were torn between pleasing her, and pleasing our leaders, and the five elders did 'walk out.'

One out of six didn't spell failure. The school principal assigned another class to work with us. We located replacement elders for the dissidents, and moved on.

## Diversity was important

I was concerned about our ability to be adequately sensitive to the heterogeneous character of our groups. A number of our classes consisted largely of African-American youth and elders as well as recent arrivals from Latin America and Eastern Europe. The elders represented a broad range of education, work, and personal struggle. English was a second language to many. With our artist-leaders, we inspected themes and their presentation to check for appropriateness. No one must feel left out or patronized.

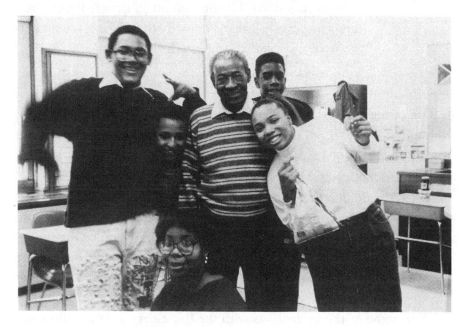

*Figure 9.1 We can really enjoy each other.*
*Public Service Electricity and Gas Company, NJ.*

At our monthly meetings we discussed unintended small slights, such as a white student telling about her family's vacation in Bermuda; she told it as though everyone had an intact family who lived this way. But some of our students and some of the elders lived in crowded urban apartments; and

many had only one parent. One boy in that group shared his bed with three siblings.

In another group, a child spoke of the death of five members of her family during the Holocaust. A few others snickered that such a time hadn't happened; one had heard his father say that.

Another time a white woman, running in from the rain, commented her curly hair was as kinky as [...] Either she wasn't thinking, or she was revealing deep-seated prejudice.

Such moments needed to be confronted, and quickly, to hold the group together. Several leaders felt inadequate in handling them. We helped each other recognize that, through drama and use of metaphor, we had perfect tools to confront painful issues without lecturing or moralizing. We added this reality to our list of goals: deal with another aspect of our society which separates people – prejudice.

Here is how one leader introduced deeper awareness of a racially-split society which needs mending. It was the fifth month of the program, the education professor of our evaluation team wrote of her visit to a high-school workshop:

> The artist-leader reviewed the previous session regarding the bus ride and trial of Rosa Parks in Montgomery, Alabama in the 50s. He called on elder and younger to move into two equal groups. He became the judge. A student-lawyer for segregation made an opening statement. Then the elder-lawyer made opening statements against segregation. The judge read the accusation against Mrs Parks, who had taken a seat in the front of the bus on her way home from a long work day.
>
> The artist-leader stopped the trial to question what each person knew of discrimination. Everyone was attentive. Elders spoke out of their own experiences in the South, or on arriving in this country knowing little English. Gradually students spoke from their own experiences with discrimination in a northern city. Everyone listened intently to each other. They resumed the trial. Arguments were presented: Pro-Jim Crow[1] whites (played in all but one case by African-Americans and Latinos) felt that blacks should not vote because they did not pay taxes, have steady jobs,

keep up property values. (No one laughed.) A student in role as a white police officer talked about merchants feeling uneasy when young black people look in store windows.

Witnesses against Jim Crow were questioned by the student-lawyer.

They spoke movingly about exclusion from restaurants and clean restrooms. They also spoke of rudeness of merchants and of their segregated schools without books or enough seats. Two elders added that good jobs were denied them, and job training.

When the bell rang, everyone wanted to continue. All students appeared alert and challenged; each was smiling at the elders as they held a closing exercise in a circle, standing by each other. Had the lone white woman in the group taken in the meanings?

*Eight months later...*

The pilot ended on a high note. The final questionnaires proved that most of our objectives had been achieved. Elders wrote that they'd gained respect for the choices young people must make today and the difficult realities in many homes. The students discovered that elders can be 'playful buddies and that they were once young, too.'

The pilot program came to an end, but the project itself went on in new places and new shapes for the next seven years. Sometimes funding allowed us to hold six to twelve weeks of workshops. Sometimes it was only a one-time, three-hour session. Our themes expanded. Often Autumn Stages, Older Adult Lifestory Theatre, an award-winning, touring improvisational troupe I directed, were the elders of a one-time workshop; other times elders were corralled from the community by a school. Certain themes were most popular, such as 'In My Mother's House,' which included family relationships, squabbles between siblings, punishment, responsibilities (or lack thereof), dreams; mother's roles; often grandmother's too.

Other themes included:

- Insult, injury and peer pressure

- 'I won't narc on them!' – why kids won't tell on peers, and how elders handled this in their youth

- 'Does anyone listen to ME?'

- Good times/hard times

- Mischief, teasing, and conspiracy

- What *we* did/do for *fun*

- A time capsule, then and now (symbolic ideas, experiences and things)

- Hitting out without hurting (conflict in which violence is replayed for negotiation)

- 'Moments which make me stand tall'

- When I say 'No' in order to say 'Yes' to myself

### *The usual shape of a life drama workshop: a summation*

1. *The start-up*:   Greeting and a variety of name games. (Elders often need refreshers each week.)

2. *The warm-up*:   An activity to ready mind, body and spirit and attitude for day's theme.

3. *Storytelling*:   Leader introduces the theme. Uses questions to stimulate ideas, e.g. 'Have you ever...?' 'Do you remember doing...?' 'How do you react when...?'

Lifestories gradually emerge, either from personal experience, hearsay, sometimes literature, sometimes 'made up' to maintain anonymity... stories which tell of how people live with each other, ways people handle a variety of situations, ideas of fun and adventure. Sometimes a single object will set us off, like the telephone, a letter, a school grade report, or a special possession like a skateboard or a jump rope, a gift or even an animal (stuffed, of course). Food can be a great stimulus for recall.

4. *Group planning*:   Within small groups of three or four, stories relating to the discussed theme are shared, group selects which story to improvise. They outline the story, but do not rehearse the dialogue or the ending. Group members

have been briefed about questions to direct their
planning. The following are just a few:

- What is happening in the story?
- Who are the characters?
- What is each one doing? Why?
- Where does the story take place?
- What is the conflict in the scene?

Each person selects a role to play and discusses briefly what kind of person
she/he is in the lifestory. About 15 minutes for planning.

5. *The improvisation:* The transformation of a lifestory scenario into action
using narration, pantomime, role-play and dialogue;
sometimes sound and music. (In early workshops, I
often limit improvs to a narrator telling the story as
others pantomime the action. Absence of dialogue can
free creative behaviors.) Again, an improvisation is not
rehearsed, only planned. Dialogue will happen
spontaneously as well. Being clear about the storyline
makes it happen.

6. *Critique:* – or, 'rap time.' A time to affirm effort. Reinforce
standards of believability, quality of planning. Extend
critical awareness. Discuss the 'how else' a story might
have ended.

7. *Closing time:* Coming together through ritual, chant, and validation
of each other's efforts; always in a circle…passing a
laugh, passing and building a sound from soft to a
rousing cheer, passing a funny face. There are so many
fun activities to be invented on the spot. And often we
end with 'wishes for the week.'

We ended our project in the springtime with a large pageant, improvised
within the framework of a scenario I'd written. Sponsors, government
officials, principals, superintendents and relatives attended. There was no
separation of ages or cultures. Participants blended. There were elders
down on hands and knees creating banners spontaneously with

12-year-olds. Others jumped into today's dances with teenagers. Students learned the Charleston, and Jitterbug, even the two-step.

At one point, the scenario had elders and youth facing each other to present peace poems composed in an earlier workshop. An improvisational music group of 20 students and elders accompanied them on sound and rhythm instruments.

Near the finale, a proclamation was read by a Board of Education member:

> WHEREAS, this exciting program brings together youth and elders;
>
> WHEREAS, the generation gap is bridged with caring, sharing, respect and understanding;
>
> WHEREAS, we gather here today to launch a Time Capsule, one that tells the future that young people and elders have discovered each other, studying and learning so both generations are prepared to help shape the future as a time of community and peace.

The Mayor stood up: 'I hereby proclaim today as the Day of All Ages.'

A young student read from Forest Center's *The Education of Little Tree (A Cherokee Boy)*:

> If ye don't know the past, then ye will not have a future.
>
> If ye don't know where your people have been,
>
> then ye won't know where your people are going.

With everyone holding hands in a circle and with faces glowing, we chanted after an artist-leader:

> I place my hand in yours
>
> And together we can do
>
> What we cannot do alone.

Then, singing Louis 'Satchmo' Armstrong's 'Wonderful World,' the circle divided right and left, moving single-file out the two doors to exit. The drums and horn announced the pageant was over.

# Notes

1    Jim Crow is a term for promoting the segregation and separation of African-
     Americans.

10.

# What does it mean to be Hispanic in Rhode Island?

The oral history/life story theatre project

*Naida Weisberg*

## Part I: What does it mean to be Hispanic in Rhode Island? A journey with Hispanic elders

*From the Elmwood Community Center in Providence:*

'I have never seen people that when they play the music, they move like that! Merengue is like that. You can easily identify a Dominican by that. Because, you know, they could be quiet, but once you play a merengue, they start moving immediately! I mean immediately!'

'I recall a terrible space of loneliness when I came. Especially when you have in your mind the image of a New York City so different – a *colorful* New York City. And then when you come, it's *grey*!'

'It's summertime all the time over there. You may make excuses not to go to work, but not because of bad weather! In heavy rain you work outside. I started working when I was twelve years old.'

'Almost always when one leaves his country, for whatever the reason one leaves, due to the matter of getting a better job or

better anything, one needs his country. The country, friends, people, food, the family we miss, we all miss that.'

In the late 1980s, when the Rhode Island Department of Elderly Affairs (DEA) urged !Improvise! Inc. to think about offering a multi-arts program for 'underserved' Hispanic seniors at the Elmwood Community Center in South Providence, we jumped at the chance. As creative drama specialists we had been helping people discover 'the artist within' for about twenty years, mostly in schools where we worked with educationally and physically handicapped as well as bilingual and 'normal' children. Subsequently we found ourselves carrying our bags of colorful scarves, flowers and herbs from the garden, tapes, tape-recorders, stories, poems and puppets, etc., into nursing homes and senior centers, and knew for a fact that the magic worked there in the same way! Even more so because we watched our methods breathe life into passive, noncommunicating men and women whose meaningful stories and memories were just waiting to be 'sprung' by listeners like ourselves. They smiled, they laughed, they moved, they listened to us and to each other; they expressed opinions and improvised roles and events in their lives.

In recognition of this, we were invited to train activity directors in our area and elsewhere. We knew how powerful and enabling our tools were – the tools of the expressive arts therapies, and we were determined to spread the word to caregivers, especially as the population of elders was growing ever larger.

So !Improvise! was fully ready to concentrate on the issues of some of our city's newest arrivals, displaced in their later years to a completely unfamiliar environment and climate; neither here nor there, because they returned 'home' to touch base with family as often as possible. We acted on the DEA's recommendation and consequently participated in a fruitful experience that led to another one, equally fruitful, with unexpected results. For we never imagined that when this program ended, we would soon find ourselves working with most of the same men and women, plus their adolescent counterparts, in Central Falls, a suburb of Providence with a very large Hispanic population.

To begin with, for a better understanding of how the intergenerational program in Central Falls came to be, let us 'rewind' to the Elmwood

project as it unfolded in Providence on a bi-weekly basis for the better part of a year. Staff-wise we were a team of drama, music and movement therapists – with an interpreter, because none of us was fluent in Spanish. And because the Rhode Island Committee for the Humanities, our primary grantor, also specified academic/scholar consultants, we were joined part-time by an oral historian, an ethnomusicologist, and a professor of Spanish literature.

Calling ourselves the 'Oral History/Life Story Theatre Project,' one major goal was to know the members as individuals, and learn about the Hispanic community as a whole, through interviews and the creative arts process. To quote Gail Sansbury, our oral historian: 'Though the bilingual interviews were often difficult to arrange and conduct, the results reflected the positive context of the larger project: the trust, goodwill and understanding created through the universal languages of music, drama and dance.'

Likewise, in the words of Dr Martha Davis, our ethnomusicologist who had spent many years teaching in the Dominican Republic, '[They] found ways to evoke self-expression and enhance self-image from participants who were not used to being creative, for creativity is not a positively reinforced aspect in their culture.' A further intention of ours was to bring an agreed-upon story to life, dramatically, that would hold a mirror up to all of us as members of the human race.

Immediately apparent was that these men and women loved to have a good time! Despite language differences they were an easy group to get to know. They loved singing, dancing, playing the musical instruments and telling us about their previous lives. Of course this fueled our creative energies from the start, so spontaneous music-making and dance were a part of every session. They brought us their favorite tapes to play – they always seemed to have one more; and, as our relationships deepened through this kind of artistic, rhythmic exchange, memories of personal and cultural events in their lives emerged naturally.

We brought in household items, different foods, pictures; they brought in photographs of home and family, and told us how to cure a variety of ailments with plants from the garden. Consequently, by listening to them and following their lead, we became more and more comfortable with talking about our similarities and differences, and honoring the gifts of

their tradition. An added bonus was that our pregnant music therapist often brought her charming, musical two-year-old to the class. Our elders were so family-minded, they showered her with affection and advice. And when she had to balance her guitar on her bulging belly as she played, they were enthralled. We felt so connected to one another then, it was as if we all belonged to a caring, extended family.

The places they had left behind were the Dominican Republic, Colombia, Haiti, Guatemala, Argentina, Bolivia, and Puerto Rico. And as our group shared both funny and heart-rending stories from their lives – many came here from oppressive governments – we also told each other folk tales. For instance, in the story of 'The King's Tower,' the king wants to build a tower to the moon and insists that only he can do the climbing. The carpenter in charge of construction must hand up 'boxes' one by one, but he must not climb up himself. When the king says he needs one more box and instructs the carpenter to take it from the bottom of the pile, the tower collapses, of course. A torrent of words and feelings was released at that point about abuse of power and the helplessness of people in some Latin American countries.

A few of the tales we heard featured 'the devil' or a person's 'soul', and we discovered a humorous story we thought would appeal to them called *The Beautiful Soul of Don Damian* by Juan Bosch, a former president of the Dominican Republic. It concerns a rich man, Don Damian, surrounded on his deathbed by people with major plans for using his money when he dies. They moan and groan about how much he will be missed and they can't love him enough! Everyone laughed at the obvious hypocrisy, 'But isn't that the way people act?' they said. So we decided to write a script based on the story and present it to the public, Reader's Theatre style. No stage action was required; our interpreter, as narrator, would provide the audience with explanations, e.g. a synopsis of the story, a description of the scene and the characters; and the performers had no worry about forgetting their lines because she would cue them, if necessary, by asking them questions. Few risks, much pleasure – and they were excited.

We had no casting problems. They seemed to know instinctively who they wanted to be and chose their parts quickly: 'much younger' wife, wife's mother, doctor, priest, nurse, housekeeper, and Don Damian's soul. Everyone who wanted a part had one and the rest became the chorus.

Afterward they learned lines, new songs, and without any hesitation created masks on our long table, advising and teasing one another as they went about it.

We had been videotaping for a few weeks so they could see what their drama looked like, when the public cable company we borrowed the equipment from offered to shoot the play at their studio. A professional video of the program! It was an offer we should have refused; on the day we drove to the studio, our actors 'froze' – admittedly a mistake on our part. However, they were thoroughly into their story and beguiled both family and friends at the center when the time came. A particular hit with everyone was the song, 'Deme, deme, deme el dinero (Give me the money).'

In essence, we had chosen one story to dramatize, by Bosch, and entitled the adaptation of it 'Las Mascaras de la Vida' (literally translated, 'The Masks of Life'). Yet in a much wider sense, through oral histories and the creative arts, we had celebrated the communication of many stories that connected us to one another, present, past and future. It had been a delicious, sensory, year-long feast for the spirit – of laughter, warmth, and very special friendships. As Dr Davis commented, 'The human bond established by the project between these elderly Hispanics and the program personnel transcended differences of language, culture and class…the process of interviewing Hispanic elderly persons about their lifestories had a special symbolic meaning. For it put them – and their stories and wisdom – into the spotlight.' To quote a gentleman from Argentina, 'Don't you see how they ask the old people, "Who were you?" They made them stir their minds! They are reborn!'

## Part II: Voices from Central Falls: A journey with Hispanic elders and high-school students

Now Progreso Latino, a social service agency based in Central Falls, urged us to apply for funding to run an intergenerational program for Hispanic elderly and high-school students in their town. It so happened that about half of the original group had come from Central Falls, driven to Elmwood by Progreso Latino. So this time the agency was willing to transport the seniors who lived in Providence to Central Falls, fortunately for us. And, happily, our grant applications found committed supporters again.

Our major problem was logistics, and it *was* major. The seniors were used to meeting in the morning at a center where they also ate their noontime meal, and some of them were not at all keen on an after-school activity, even if it included transportation. All we could do was encourage them to 'just try it' and hold our breath. In the meantime, with the eager support of the ESL (English as a Second Language) high-school teacher, who viewed us as a valuable adjunct to his own classes, we were meeting with prospective students – almost all of whom either worked after school or had other 'very important' places to go and things to do. One thought we had, that the kids might walk over to the center after school, was definitely out. We would lose them. The sessions, if they were to happen, would have to take place at school.

While this kind of negotiating was going on, we continued to meet with the adults by themselves at their center and with a few interested students, also by themselves, at the high school. Once again, we were a staff of creative arts therapists (not all of whom had to be present all the time), joined by the ESL teacher and, later on in the program, the high-school art teacher. With bilingual students, we did not need a translator this time, nor were academic consultants necessary.

Taking a cue from the previous program, we chose music and rhythm as catalysts for quick warm-ups with both groups. Our percussionist was the favorite! So after meeting separately half-a-dozen times and coming to the realization that the two ages had much in common – the parents for one! – we eased very carefully into a mixed group at the high school.

*Figure 10.1 Trying out the triangle*

*Pablo Mijares*

*Figure 10.2 'Warming up' with the drums*

*Pablo Mijares*

*Figure 10.3 Working on the mural*

*Pablo Mijares*

Within a few weeks, the site and time of day difficulty was no more. The grandparent generation sat in the school auditorium seats, watching out for eight to eighteen kids to rush in. Then came the chit-chat, music and dancing they adored. The elders were hooked; they loved to be near the youngsters, and gradually the students found their way to us on a regular basis, to interview the 'grandparents' and be interviewed by them. Which is one of the ways in which we learned what was most important for them to express in story, song, dance and mural.

One story we told that precipitated almost endless response was 'The Country Mouse and the City Mouse.' At first it was the dancing that was different: the 'country cousins' claimed their steps were better; the 'city cousins', theirs. Most of the country cousins were the 'grandparents'; all of the city cousins were students. Holidays, they said, were so much livelier in the old country; in the US, 'sad'. Here they were in agreement. Did they want to return to the 'mother' countries? Some said yes, some no. There were mother/daughter improvisations and father/daughter/boyfriend improvisations inspired by the story; and when an elder took the part of a teenager and vice versa, we all felt the effects of a 'new understanding.' A chant that drew a batch of quick responses was this one:

'I have a feeling that I think you know.

You've had it too, isn't it so?

I've had a feeling that I'm sure you've had.

Sometimes I'm sad and sometimes I'm glad.'

The poetic coaxing produced:

'I feel glad when I have money'

'...when I give someone advice and it works'

'...when I'm with people I'm comfortable with'

And 'I'm not so glad when I'm away from my family'

'...when I have stress'

'...when I'm in a no-win situation'

*What were their issues?*

We took notes. On the part of the elders: lack of religious faith among their children and therefore the grandchildren; parents were too permissive; children had no limits. Their own feet were not firmly planted in the new country; one foot was in the old, and they had no reason to learn much English. They babysat a lot because the parents went to work, but still they were not 'the authority.' In a real way, they were in limbo.

Feelings of loneliness and alienation were voiced constantly by both groups. The elders were uncomfortable in the 'new land'; everything was different, and their children and grandchildren no longer showed the respect that they once had. They were alone a lot.

At the same time, the students talked freely about their struggles with the 'American' kids, feeling different, trying to belong and not being allowed to; name-calling. A special hurt were teachers who patronized them and who seemed to discourage even the brightest of them from considering any of the better colleges and universities for their higher education. They were criticized, they said, for speaking their own language in the halls between classes. At home, some of the parents were strict and denied them the same privileges their American classmates took for granted. A frequent complaint was that their parents refused to speak English with them.

As time went on, they continued to share their experiences with one another and us, and sang and danced and began to conceive of a mural backdrop for a stage presentation to offer the school in the spring. None of us was sure what form that event would take, but ideas were popping; we had a goal, and working together on the mural helped to clarify what they wanted everyone else to be more aware of: the vulnerable 'newcomers', the 'Americans', 'the problems of not being accepted', 'drugs'. It turned out that one side of the mural became a bright, exotic, sensual-looking landscape of 'the old country', and the other was a sinister, greyish-black picture of a city street crowded with people whose faces were completely hidden – America.

Picking up on the words she was hearing week after week, our music therapist wrote a song called 'A Seed from Somewhere Else' about what it feels like to long for friendship with someone your own age who ignores

you, even though she/he lives next door. A boy and girl duo moved many of us to tears when they sang 'Accept me' in the refrain.

With consistent encouragement from the ESL teacher, the students were using their classes to write personal stories they later enacted for us. This was autobiographical theatre that 'blew us away'! One scene, about a grandmother criticizing her granddaughter because of her questionable lifestyle, included a criticism of the girl's mother who granted the child too much freedom. The girl's response was interesting because she explained logically how her grandmother had misinterpreted her actions – and she made good sense.

Another featured a student searching for guidance from his elders. He felt confused about his dual allegiance: Hispanic and American. Their answers were sympathetic, but they begged him not to forget where he came from, his religion and his heritage.

One of the most compelling scenes, written and presented by a high-school senior, was her struggle to fend off drug pushers and 'drinking' contemporaries who tempted her with companionship if she joined them. 'But,' she confided, 'I've got my ticket out. I'm going away to college next year and I'm not coming back.' Her portrayal was both startling and convincing, as were her classmates who played the other roles.

Altogether there were ten highly individual scenes that emerged from our weeks of play and discussion. And while interest was still high, we talked again about sharing their stories with the rest of the high school on the stage in the auditorium. But it was not to be; their theatre was too personal, too confrontational to be shared with a live audience. They would not feel good about performing it, even though they were glad they had done it and wanted 'certain people' to know about it.

We were glad we had 'done it' too, and were more than satisfied that the creative arts processes had served us well. The team of arts therapists and teachers had cooperated with talent and gusto, and many obvious, positive changes had occurred among our intergenerational group members. Besides which, everyone felt exhilarated and enriched! But the next bit of good fortune promised to extend the life of the program in an unexpected way.

Along came an Hispanic videographer, Pablo Mijares, with a strong sense of devotion to his immigrant community. He suggested we preserve the scenes on tape so that at least Progreso Latino staff and clients could see and learn from it. No objections were raised, everyone agreed, and all the scenes were shot in two days, after school, with only one or two retakes because the students were running out of steam and the graduating seniors were getting busier! Our elders obliged willingly; they were not pressed for time.

We edited the tape during the summer at a public access video station, with the expert supervision of our videographer; and a prominent local citizen of Hispanic origin introduced it. With elder/student singing and people-focused scenes of the city's colorful downtown as background to the intro, 'What Does it Mean to be Hispanic in Rhode Island?', 'Voices from Central Falls' was launched. It is 27 minutes long, suitable for airing on local public television.

However, the video did not air; it was still considered too personal, literally too close to home, by the students. What we were commissioned to do in the following school year was tour the program to senior centers and middle and senior high schools. In the classroom, it was presented as a lesson in 'social studies'; and since there were students from many different backgrounds in these classes, we submitted a list of questions for the teachers to ask the children after they viewed the tape. For example:

1.  Often, immigrants end up in a crime-filled neighborhood. What threat does this pose for the family? What can they do about it?

2.  What does the 'seed from somewhere else' mean? Is the soil here good for the immigrant's seed? What do you have to give up to make the seed grow? Should you?

3.  What is similar to your own life on the tape?

4.  What makes a person 'American?' The children's verbal and written responses provided us with so much insightful information about their own special needs and concerns that we enlisted our videographer once again and made another video we called 'What About the Dream?'

From 'Las Mascaras de la Vida' to 'What About the Dream?' Looking back at this work, we are still a little in awe of how one creative, healing, multi-arts experience, eye-opening and cathartic, led to an even more challenging other, and then another, substantially contributing to the knowledge and emotional well-being of many hundreds of people of all ages in the community – not to mention our own.

11.

# The folk tale as catalyst

*Rose Pavlow*

Over the years, the use of intergenerational drama in nursing homes and daycare centers for handicapped seniors has convinced me that a kind of magic takes place between various age groups. They seem to inspire one another to respond freely; and the humor they share, the discussions in an atmosphere of high spirits, enhance the possibilities for dramatic improvisation based on carefully selected stories.

Frequently it is necessary to repeat the facts of a story for the hearing-impaired and for late arrivals to the session. But repetition keeps everyone focused on the storyline and provides increased opportunity for members to take part.

*Figure 11.1 The gap is bridged...Cranston Senior Center, Rhode Island*

## A Rhode Island nursing home

The time is 2:30 in the afternoon in this nursing home. The meeting room is bright and cheerful and there is always an original collection of paintings on the wall. Today my group is a mix of 14 residents, all of them women, and six young female aides from multicultural backgrounds. Four of the aides are part-time high-school students. Their contact with the residents has been pleasant but minimal. They don't really know each other. They wait on tables and perform simple tasks.

For this reason, I suggested to the activity director that there would be benefits both for them and for the residents if they participated together in our sessions. Since the effect of drama is to help reveal the many sides of human nature, I explained that they would acquire a new understanding of one another as well as increased mutual respect. Besides, young people generate vitality and the seniors offer experience and wisdom; a happy blend!

Our improvisation will be based on a Russian folk tale about a clever judge, so famous for his justice and wisdom that people call on him from far and wide to settle their disputes. Two villagers appear before him and ask him to arbitrate their quarrel. This is how the story unfolds:

'Tell me your story,' the judge said to the plaintiff.

'I had to leave my village to attend to business elsewhere and all my wealth was 100 gold coins,' the plaintiff answered. 'I did not come by them easily. I had to work hard for them and I didn't want them to be stolen while I was away but I didn't want to carry so much money with me on my journey. So I entrusted these gold coins for safekeeping to this man here. When I got back from my journey, he denied that he had ever received the money from me.'

'And who saw you give him these 100 gold coins?' asked the judge.

'No one saw it. We went together to the heart of the forest and there I handed him the coins.'

'What have you to say to this?' the judge asked, turning to the defendant.

The defendant shrugged his shoulders. 'I don't know what he is talking about,' said the man. 'I never went to the forest with him. I never saw his gold coins.'

'Do you remember the place where you handed over the money?' the judge asked the plaintiff.

'Of course I do. It was under a tall oak. I remember it very well. I can point it out with no trouble at all.'

'So you have a witness after all,' said the judge. 'Here, take my signet ring. Go to the tall oak under which you stood when you handed over the money, set the seal of my ring against the trunk, and bid the tree appear before me to bear out the truth of your story' (Deutsch, B. and Yarmolinsky, A. 'A Clever Judge' from 'Tales of Faraway Folk,' in Arbuthnot, M. H., *Time for Fairy Tales*. Glenview, IL: Scott Foresman and Company, 1961).

At this point in the story, I decide to explore the characters of both men, so I divide the group: witnesses for the plaintiff on one side and witnesses for the defendant on the other. I play both judge and facilitator in order to heighten the drama and keep it moving. The side for the defendant speaks first:

'He never lies. He always tells the truth,' says a young aide.

'He's an honest man,' from a resident.

'He's a good friend,' claims another resident.

The side for the plaintiff responds:

'Are you gonna leave something for my side?' asks an aide supervisor. [Laughter]

'You've been saying all the good stuff,' says a young aide.

'He trusted his friend. His friend deceived him,' a resident adds.

'It isn't fair that his friend did this to him,' chimes in a young aide.

'He's a very fair businessman. He saved his money and he took good care of it. He doesn't take chances,' a resident explains.

I interrupt to question how well he or she knows the person who appears to be honest. 'They say the plaintiff never lies and they say the defendant never lies. Who can you believe?'

Witness for the defendant (a young aide) then says, 'He wouldn't do such a thing.'

I ask: 'How long have you known him?'

She answers, 'All my life. We grew up together.'

I say, 'Why would your friend say he doesn't have the money?'

'I know my buddy wouldn't lie,' she says.

I attempt to draw out a resident who wasn't contributing. 'What do you think? Is the defendant telling the truth or not?'

'I don't know him at all,' she replies.

I try again. 'But you're a character witness for this man!'

'I can't help it. I don't know a thing about him,' she insists.

I wasn't sure whether this resident understood the story or was just being arbitrary. Nonetheless, she drew quite a bit of laughter with her noncommittal answers, stimulating the following rapid-fire exchange between residents and aides.

'He gives a lot to charity,' asserts a resident for the defendant.

'He has a lot to give to charity if he keeps his friend's money,' replies a young aide for the plaintiff.

'He's like a brother and every time I need something, he always helps me,' adds another aide for the defendant.

'With our friend's money!' sneers the first aide for the plaintiff.

'Does your friend drink?' questions an aide for the plaintiff.

'No he doesn't!' exclaims a resident for the defendant.

'Maybe he gambles,' says an aide for the plaintiff.

'It's possible,' answers a resident for the defendant.

I remind her: 'You're supposed to be on his side!' [Laughter]

> I continue, 'What do you think about the judge's decision to have the plaintiff go into the forest, set the signet ring on the tree and have the tree appear as a witness?'

> 'He's crazy!' blurts out a resident for the defendant.

> I say: 'But he has a reputation for being wise.'

> 'He's not wise,' argues a resident for the defendant.

> 'Maybe the judge wants to give him time to think about what he's done,' rationalized an aide for the plaintiff.

> 'I think the judge is kind of off the beam!' jokes an aide for the defendant.

> 'If he's a smart judge and everyone comes to him for advice, there must be a reason. I know the judge personally,' sums up a resident for the plaintiff.

> I say: 'She knows the story, and it's time to finish it.'

So I go ahead and finish the story:

> The plaintiff took the signet ring and went off to carry out the demand of the judge. The defendant remained behind and waited for his return. After some time had passed, the judge turned to the defendant and asked: 'Do you think he has reached the oak by now?'

> 'No, not yet,' he answered.

> After more time had passed, the judge again turned to the defendant and asked, 'Do you think he has reached the tree by now?'

> 'Yes,' was the answer. 'By now he must have reached it.'

> After a while, the plaintiff returned.

> 'I did just as you asked, but the tree refused to budge.'

> The judge replied: 'The tree has already borne witness in your favor.'

The defendant exclaimed: 'How can you say that?'

'You said you had not been in the forest, yet when I asked you if the plaintiff had reached the oak, you knew how long it would take him to get there. Therefore you were in the forest. Now, not only must you return the 100 gold pieces, but you must also pay a fine for having tried to cheat your friend.'

So the tree was a witness, and justice was done.

'A Clever Judge' is a simple folk tale with an unusual ending, and an effective catalyst for intergenerational improvisation.

Next we talked about court cases that the group members had either read about or experienced. One of the residents told a story about a split among family members when a great-grandchild was born after the great-grandmother had died. The parents of the child insisted she was entitled to part of the estate. Without my having to assign roles, both residents and aides volunteer to take sides. A fiery exchange follows:

'This new upstart didn't know her great-grandmother!' a resident contends.

'She wasn't a part of her life,' another resident agrees.

'Everyone else is entitled to the money. Why not her?' says a young aide.

'Your family has its own money. There's no reason why she should get any,' a young aide insists.

Bickering continues about whether blood or timing is more important.

'You know you guys have to make such a big deal of it. We don't want the money anyway!' (Everyone applauds the aide's decision.)

*Other comments*:

'She and I always had a good relationship until this thing about money,' explains an aide.

'This is disgraceful! Blood is thicker than water. They should be more considerate of the family's well-being than worrying about the stupid money,' comments a resident.

'The lawyers are having a good time! They're going to keep most of the money anyway,' remarks another resident.

A resident concludes: 'Get born at the right time and make sure you have a lawyer on your side of the family.'

'This was great fun!' remarked a young aide. She had never been exposed to spontaneous drama before.

The young employee in charge of the teenage girls spoke for herself and the aides when she said: 'It makes me feel closer to them (residents). It's amazing to see another side of the residents that you don't see in the dining room. Mrs C acts like she's not with it, but the dramatization gave her life. And you don't often hear that kind of laughter in the dining room!'

Improvisational drama can turn a relatively unresponsive group into lively 'actors'. As shown above, dramatic improvisation with mixed ages accomplishes this by allowing participants to explore issues in role. Even when they differ (and it's exciting when they do), it is fun for them to stand in someone else's shoes temporarily, to gain a different perspective. Just the idea of sharing an enlightened understanding of the human condition creates a common bond, no matter what the age differences are.

## In a day care center

### Seniors and little ones

The seniors knew that I worked with schoolchildren; they questioned me about my experiences almost weekly. I described a number of typical sessions for them, telling them also how I deal with children who have problems and sometimes disrupt activities.

I told them about a class of kindergarten children who were pretending to be animals living in the woods. One child, who was very bright, but aggressive and full of anger, proclaimed that he was a hunter. I visualized an abrupt end to the peaceful playing of the rest of the children, so I

pointed to an imaginary sign posted on a tree and read out loud, *'Hunting forbidden in this area.'* I explained that this land had been set aside by the government to protect the wild animals, and it was against the law to kill any of them. The boy studied the sign as if it actually existed and then very seriously offered to act as a guard to protect the animals. This gave him the opportunity to assert his leadership in a positive way.

The seniors were impressed with the effect of creative drama on this child's social behavior. They asked if it was possible to bring a group of children to the center, which pleased me because I had intended at some point to introduce intergenerational sessions.

I contacted the directors of several nursery schools in the area to arrange for the children's visit. They were delighted, and when I informed the seniors, they could hardly wait for their first encounter.

## We make plans

We discussed what we would do with the youngsters. We agreed it was important to accept the children's ideas, no matter what we had originally planned for them. To establish a mood for working with the children, I asked the seniors what games they recalled from their childhood. Jacks, ring-toss, and jump rope were a few favorites, and they pretended to play them. Since most of our sessions begin with warm-up movements, these were natural activities for them.

I threw out one end of an imaginary jump rope and an amazing thing happened. A man named Everett, who always complained about being too tired to move, got up and jumped by himself. When we gasped with surprise, he commented matter-of-factly, 'Oh, I was just waiting for the right moment.' He had completely forgotten about his physical problems in his excitement about this childhood game.

## Pilgrims and Indians

Since the children were scheduled to visit in late November, the seniors decided to improvise the 'first Thanksgiving.' The week before the children were expected to join us was spent reviewing the problems and difficulties the first settlers were faced with. Many of the seniors were able

to relate to this because of their experiences when they were young. They pantomimed chopping wood, fishing, farming, baking bread and hunting.

I asked them what we should do to be sure that everyone would be actively involved in the play. They suggested that the children be the Indians invited to the celebration, and the seniors, as pilgrims, would teach the Indians how to prepare the feast.

The children had been told that they would be Indian guests at the first Thanksgiving feast. When the 'Indians' arrived, I introduced them to the 'Pilgrims,' who were already busy miming their various tasks. The large, plain, cheerless room was transformed – and it became alive with an intensity of activity! Some little hands were guided into the intricacies of kneading bread and mixing pudding. Others were vigorously chopping down trees and looking for twigs to place on the fire. One very feeble senior was showing a small Indian how to dig clams.

THE WONDERS OF SMALL CHILDREN

The four-year-olds paid no attention to the seniors' handicaps. They enjoyed the individual attention, whether it came from someone in a wheelchair or someone with limited arm movement. They even seemed to understand the ones who did not speak clearly.

After the children left, the seniors, exhilarated by the experience, chatted about the wonders of small children – so bright, attractive and affectionate. They noted the different behaviors: the timid, hide-behind-the-teacher child, and the rambunctious one looking for attention.

They anticipated a visit from the five-year-olds from the same school, but it was agreed we should wait two weeks to give us time to plan. They saw how important it was for them to play with ideas in advance, since familiarity with a subject increases the ability to improvise. Even though some group members have very little recall from week to week, they were caught up with the excitement of the occasion, and somehow they found a way to participate and interact in the improvisations with the children.

*Seniors and teens*

One day I questioned the seniors about the things they weren't supposed to do as children, to help them to realize that all the behavior of today's

*Seniors and teens*

One day I questioned the seniors about the things they weren't supposed to do as children, to help them to realize that all the behavior of today's teenagers is not as outrageous as they assumed it to be. This discussion opened a floodgate of vehement criticism by a few of them. Strong words were used to describe teenagers: self-indulgent, troublesome, violent, and lacking respect for their elders and authority. They compared the strict rules they remembered with the complacent, uncaring attitudes of many of today's parents. Several of the women placed blame on working mothers.

I brought in a few lines from Carl Sandburg's poem, 'The People, Yes':

> Why did the children
> Put beans in their ears
> When the one thing we told the children
> They must not do
> Was put beans in their ears?

With these lines, I prompted the seniors to respond with memories of what *they* were not supposed to do as youngsters:

> I wasn't supposed to buy pickles
> on my way to school. The first thing I did was buy a 2-cent pickle.

> I wasn't supposed to go on the ice alone.
> There was a pond near the house.
> One day I went on the ice.
> My mother came down to the pond and said,
> 'You come home this minute.'
> I said 'No!' She came after me.
> Every time she took a step, she would
> go through the ice because of her weight.
> She got wet. I ran up to the house.
> That night when my father came home,
> I got the strap.

> 'Don't go backwards, Annie!' grandmother said.
> And I walked backwards, backwards.

A boy caught me. I hated the boys.
Turned around and, punch! punch! punch!
I ran away and tripped over a barrier.

## SENIORS AND TEENS: A COMMON BOND

Coincidentally, at this time I was leading a creative drama program with
fourteen- and fifteen-year-old girls in a health science course. Part of this
included role-playing based on building relationships with patients of
different ages. I felt that this was an ideal time to bring the young girls and
seniors together. This would give them an opportunity to get to know
each other and, I hoped, would dispel some misconceptions and stereo-
typical attitudes between the two age groups. I asked the seniors if they
would be interested in meeting these young people, and they were willing.
I had previously discussed this with the health science teacher, and she
agreed that it would be an excellent adjunct to the program.

When I first spoke to the girls about getting together with the elderly,
they were not enthusiastic. But after I described some of the humorous
experiences told to me by the seniors and read some of their poetry, I could
sense a change in their attitude, and a heightened interest in working with
the elderly.

## EACH GROUP PLANS

Only two sessions were available for meetings between the handicapped
senior group and the teen girls. I wanted to give each age-group the
opportunity to plan some part of the encounter so they would feel more at
ease and comfortable with each other. By actively participating in the
planning, they would also gain a sense of responsibility for its success.
Both groups were familiar with my introductory activities such as name
games and warm-up movements. I found it satisfying that they both
suggested similar ideas for learning about each other. Because we would
become a fairly large group (about 40 people, including the staff), the
time element had to be considered carefully so that the entire first session
would not consist of introductory activities. I wanted enough time left for
dramatic improvisation. Above all, I had to allow for flexibility within the
planned structure, depending upon what happened.

The first joint session started with an imaginary ball-throwing game. In turn, each catcher of the ball gave his or her first name. A spark of hilarity was introduced when one of the students changed the procedure a little by saying 'My name is Monique, and I like money.' This started everyone trying to outdo each other with exaggerated likes and dislikes, beginning with their first initial.

Then I began a movement activity, using long, colorful, filmy scarves. I asked them what the scarves could do, and how many different ways they could be moved. 'Floating, snapping, thumping, bouncing, swirling, bumping,' came the responses. We tied the scarves together to make a huge circle and danced with them to music.

Then I wanted the students and the seniors to establish a one-to-one relationship, so they would use the scarves to work both together and against each other. My point was to stimulate changes in attitudes and emotions. When I called out, 'Work against each other,' there was an immediate release of strong feelings and much laughter as they tugged the scarves or twisted them around each other.

Next, I led them into reverse role-playing. I first asked them what daily annoyances were most irritating to them. A consistent gripe of many of the students was that parents and siblings interrupted their telephone conversations. This led to an improvisation in which the students became the parents, and the seniors became both the teenagers being interrupted, and the pesty brothers and sisters. At first the seniors were a little hesitant, but once they assumed the roles, they acted out their parts with enthusiasm. The student/parents particularly enjoyed scolding, cajoling, and threatening the 'teenagers.'

### THE GAP IS BRIDGED

A partylike atmosphere had developed during the session, and by the time the students had to leave, they had become friends. It was obvious to me that the teenagers and the seniors had begun to bridge the generation gap. Next time we could further dispel stereotypes by exploring the characters in the story of 'Cinderella,' using the techniques of interviewing.

EXPLORING 'CINDERELLA'

In the planning sessions before our next meeting, we discussed what feelings and opinions they had about this fairytale. Both groups felt it was about love, magic, rags-to-riches, greed, family rivalry, and good triumphing over evil. The stereotypes were the cruel stepmother, weak father, mean and jealous stepsisters, and the beautiful and good Cinderella.

At the second joint session, various seniors and students took turns assuming the roles of the father, the stepmother and Cinderella, while the remainder of the group questioned the characters to uncover the various facets of their personalities and the causes for their behavior. I suggested that those doing the interviewing attempt to be objective, and try not to attack the student who played the role of the stepmother!

One of the seniors agreed to be Cinderella's father. I started the quest-ioning by asking him what kind of work he did. He replied, 'Milkman,' which he actually was, prior to his retirement. The questions from the group showed a real interest in his work and his feelings and observations about Cinderella. When asked if he noticed the poor appearance of Cinderella, he replied that he had tried to help her, but that she was ex-ceptional. The questions and answers continued: 'In what way was she exceptional?' 'She was moody.' 'How come you left her with a stepmother who treated her so badly?' 'I thought a stepmother would be good for her. She would take care of her and she would snap out of her moodiness. I realized that Cinderella wasn't up to par, and a little backward.' I thought that this was a strange answer until I found out that he had a retarded daughter.

When introducing the student who volunteered to be the stepmother, I explained to the group that she might be a different kind of stepmother than expected, and might give us a rationale for the behavior of the character she was defending. One of the seniors wanted to know why Cinderella didn't have any nice clothes and why she wasn't taken to the ball. The 'stepmother' replied that she had burned her nice clothes sitting next to the fireplace. 'Why did she always sit next to the fireplace?' 'She would think of her real mother and sit there and cry. I tried to be nice to her but she was always crabby to me.' 'Why were there always bruises on her?' 'She's very clumsy and bumps into things.' The teenagers questioned

her at length about the bruises, because there were numerous news items at
the time about child abuse.

The direct questioning stopped, and the participants became 'neighbors' who took opposite sides arguing about the situation. One of the neighbors insisted that the stepmother was good to Cinderella, and spent as much time with her as she spent with her own daughters. There was considerable disagreement with this opinion. Another ally of the stepmother said that she noticed that Cinderella was an ungrateful child and had temper tantrums. There were also pros and cons concerning the stepsisters.

I asked the group what they thought happened to Cinderella's relationship with her stepmother and stepsisters after her marriage to the prince. Some of the answers were: 'She was nice to them because she brought them to the palace to live with her.' 'Sure, she was nice to them! She stuck them in the dungeon.' One of the seniors was quite upset with the vengeful ending because she was hoping that all would be forgiven and they would live happily ever after. She was appeased when I explained to her that we were looking for different possible endings to the story.

During my next meeting with the seniors, we reviewed our joint sessions with the students. I was pleased that they remembered individual students and many of the details of the improvisations. While they were somewhat disappointed that the joint sessions could not continue, their comments indicated great satisfaction in having had the brief opportunity to interact with the teenagers. The students expressed similar favorable reactions. It was not only a valuable learning experience, they felt, but an exciting, personal encounter. They said they could not have anticipated the active and imaginative participation of the seniors.

# Music and sound to liberate the individual

Music is an abstract universal language which can penetrate to the human heart and spirit in an instant. It requires no introduction or bridge; aspects of harmony, rhythm and tone resonate in each person's experience.

**Marian Palmer**, with vast experience in the field, tells of her processes adapting music therapy as part of a treatment plan to meet each client's total needs. Working with groups of elders and training health care professionals, she draws techniques from other therapeutic models to promote physical, mental and psychosocial well-being.

**Christoph Grieder** recognizes that older psychiatric patients may initially find comfort in other art modalities. He designs creative arts space in a hospital setting to include areas for listening to music, painting, horticulture, poetry and storytelling as choices for each patient, leading finally into music improvisation with a wide range of percussive and ethnic instruments.

**Delight Lewis Immonen**, leading music activities in nursing homes and senior centers, details how music can be an antidote to lethargy and disconnection. Through sensitive planning, it can be a potent change agent. She encourages initiative and personal expression. With choice anecdotes, she reveals how she adapts her work to each person's realities while stimulating the full group to share together in rhythm and song.

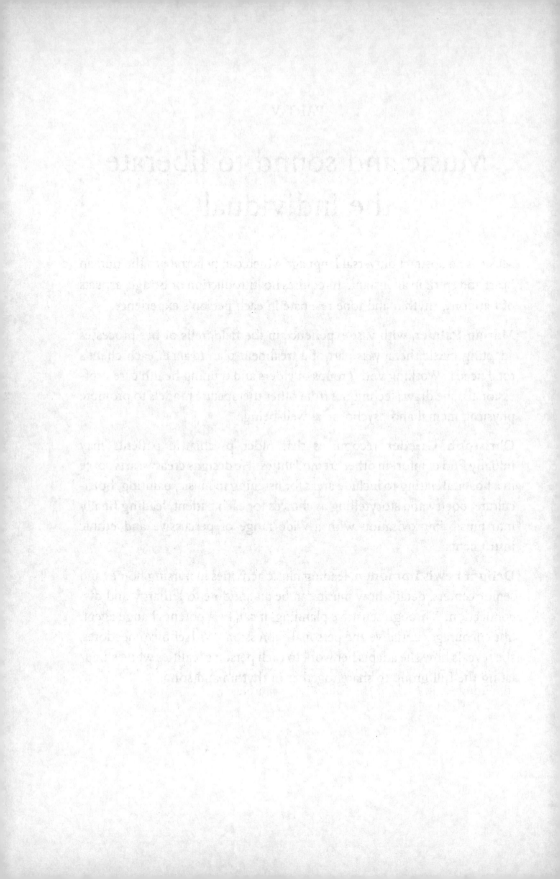

# Older adults are total people

## *Marian Palmer*

> The basic goal of the music therapist [therefore] is to evaluate the physical condition of the client and develop a treatment plan that will enable that person to attain...as much independence as possible.

If the quality of life for older adults is to be improved, and if they are going to be helped to function at their maximum potential, they should be involved in a therapeutic program which meets their *total* needs. The music therapist who works in the field of gerontology today is concerned with the total person and, therefore, develops programs which meet physical, mental and psychosocial needs.

Unfortunately, most of the care provided for the elderly in extended care facilities is purely custodial, meeting their physical needs only, and most of the programs developed for older adults in community-based settings are purely social, meeting those needs only. We, in music therapy, recognize that these needs are completely interrelated. For example, if the mental and psychosocial needs are not met, the result will be physical deterioration. This article will discuss needs in these three categories: physical, mental and psychosocial. However, all three are being met in some degree in each of the following examples.

*Improving the physical condition*

Most elderly adults, whether in a health care facility or in a community-living situation, exhibit some physical impairment or debilitation which limits their activities of daily living to some extent. The basic goal of the music therapist, therefore, is to evaluate the physical condition of the client and develop a treatment plan that will enable that person to attain and maintain as much independence as possible. In some instances, the first goal is simply to counteract the contracture which develops when the resident sits with fists clenched and arms folded, a common posture of residents in nursing homes. Utilizing familiar music, the music therapist can encourage clients to relax while moving their arms back and forth in an 'arm dancing' exercise, and to open their hands in order to clap along with the music.

For example, a resident of German descent was brought to the facility because she could no longer be cared for at home. She was difficult to transfer and had no self-care skills. In the beginning she sat in the posture described above, head down, and was nonverbal. She struck out at anyone who disturbed her, which was her only use of the upper extremities. However, when the therapist played recordings of German folk songs, she would visibly relax and allow the therapist to straighten out her arms and move them back and forth in time to the music. Her arthritic fingers could be straightened out and held in an open position to enable her to clap along to a German polka. She would allow this because she so enjoyed participating in a musical activity using familiar songs. Soon her head position improved. She would look and smile at her peers and in a few months she was even singing along in German!

As a result of this involvement she became able to assist in some daily living activities, such as raising her arms to brush her hair and wash her face. With an adaptive spoon she was again able to feed herself. Perhaps, though, the most important improvement, at least for her family, was the fact that she would smile and speak to them when they came for a visit. She was obviously enjoying life once again.

For many post-stroke clients rehabilitation is a matter of strengthening damaged muscles, or restoring muscle tone, through exercises. However, such physical exercise can be tiring and painful unless it is presented as

part of an enjoyable music activity. For instance, playing maracas along with a mariachi band (using recorded music) gives the resident an opportunity for movement of the upper extremities while joining peers on an imaginary trip to Mexico. Likewise playing a song flute or melodica provides an enjoyable and rewarding experience while improving, for the post-stroke client, the oral muscles which are needed for regaining speech.

Involvement in an eurhythmic session (rhythmic movement to music), using either hoops or batons, can also provide muscle-toning exercise while creating entrancing patterns to music. This is particularly reinforcing when done in front of a mirror where the members of the group can have the immediate satisfaction of seeing the patterns they are creating.

In larger groups, the upper extremities can be effectively exercised by utilizing a maypole. This maypole is placed in the center of the group, which may be composed of both ambulatory and non-ambulatory clients, and a ribbon is given to each member of the group. The movements are demonstrated by the music therapist, who improvises whatever movements are needed for the proper exercise in this situation. (This also affords an opportunity to reinforce color concepts, if appropriate for the group.) The maypole can be made by the participants themselves, using ribbon from floral bouquets, which offers both a purposeful activity and an opportunity for peer interaction. In this situation a variety of needs are met, although the primary goal is physical improvement.

Fine motor coordination is often improved by utilizing musical instruments, such as the autoharp, guitar, portable keyboard or tone bells. The music therapist works at the functioning level of the client, developing color- or number-coded scores for those unable to read the traditional musical score. With the development of instruments by the composer, Carl Orff, and others, which require only minimal ability, almost anyone can be included. The joy of making music with others becomes the motivation to improve the physical functioning of those involved.

Marching or dancing to music helps the ambulatory residents retain this ability and develop more confidence and grace in their walking. It also offers an opportunity for those with Alzheimers and related disorders to relieve some of the excess kinetic energy they often experience.

## Improving the mental condition

In the area of mental functioning, the goal for those in most extended care facilities is to maintain contact with reality. The work done in reality orientation classes, however, has been proved to be quite ineffective unless it is reinforced on a 24-hour basis. This involves the support of the entire staff, so the music therapist uses reality orientation techniques in all sessions. Indeed, some music therapy sessions are specifically geared to this concept when it is seen to be the primary need of the individuals involved. The session may be, on the surface, a simple sing-along; however under the direction of the therapist it becomes an occasion for recalling songs of the past, putting them in the proper time perspective, and helping the residents make and maintain contact with the present. Learning new songs is also an opportunity for them to redevelop memory skills which may not have been used for years.

The music therapist can also reinforce color concepts, body concepts and spatial concepts where appropriate, and can help orient the participants to the season of the year with appropriate seasonal music. With a higher functioning group, the session can provide good mental exercise as they recall songs beginning with the letters of the alphabet or songs connected with famous people. In any of these sessions the goal is to stimulate mental functioning, recognizing that the brain is also subject to the 'use it or lose it' factor.

Higher-functioning residents can be involved in song-writing sessions. This provides them with the opportunity for good mental exercise and a new and successful experience, especially when the song they have written is performed by the choir or other performing groups. Again, these sessions provide enjoyable social experiences while concentrating mainly on the goal of improved mental functioning.

Frequently the confused arteriosclerotic resident in a nursing home does not know the names of others in the same area. Sometimes they have difficulty remembering their own names. With these residents the music therapist often utilizes a song at the beginning of each session, which calls each resident by name. They enjoy being singled out for this recognition and are pleased with the individual attention. With constant repetition they can store this information in their long-term memory.

At the end of each session the therapist may ask how many are in the group, giving them a chance to practice their counting skills, and also encouraging once again their looking at one another. They then join hands for the final number, which provides warm interaction and develops a community spirit. As they become more aware of one another and as they develop a sense of belonging to a group, they become more accepting of their new life-style. This change in attitude often results in a great improvement in their physical well-being as well as their mental and social functioning.

## Improving the psychosocial condition

The psychosocial needs of the older adult present what is perhaps the greatest challenge. For the most part, our society has, in a variety of ways, made it clear to them that they are inferior beings or in some instances non-persons. Many of them have lost not only their significant role in society and many of the significant others in their lives, but also some physical and mental functioning ability. All of this results in damaged egos. The challenge for the music therapist, as for all staff members, is to restore to them healthy self-concepts. If they have suffered severe losses they are frequently no longer interested in living and will withdraw into a world of their own, hoping to die. The challenge in this situation is to convince them that there is a reason to live, that they can still find purpose and enjoyment in life, no matter what their current functioning level.

Since music has been part of everyone's experience, it becomes an excellent means of drawing these residents back into the present world and giving meaning to their lives. By delving into residents' background to find out what they have enjoyed in the past, as well as what interests and talents they had, the therapist may find the key to reaching them and developing a program that will speak to their individual needs.

For example, a woman was brought into our facility who was nonverbal and totally unresponsive. She spent her days lying in a fetal position, eyes closed, exhibiting no interest in her surroundings and giving no response to staff members. However, one of the staff noticed that she would open her eyes and watch the music therapy sessions which were held on her unit. Her family mentioned that she had always loved

baseball and in the past had enjoyed listening to the games on her radio. Individual attention from the therapist, utilizing the song 'Take Me Out to the Ball Game' eventually brought a response. By working with her gently and patiently the therapist was able to bring her into the group, not only to sing along and enter into the conversation but also to use her good right arm to play a rhythm instrument. During these sessions her body would straighten out and she would endeavor to participate in all the movements to the extent of her ability. This improvement in functioning eventually transferred to her other activities of daily living. As she became more alert and more involved in activities, her physical condition improved. Apparently she simply needed a reason to come out of her shell and become part of a world she had totally rejected.

In another situation the goal with a group of residents was to help them overcome negative attitudes regarding their current life situation. In each instance there was much physical deterioration, although the mental functioning level was high. The trauma of going from being totally independent persons who had lived fruitful and active lives to being dependent on others, even for their most personal needs, had been too much for them to accept. The result was a group of negative, hostile and (by choice) mostly nonverbal residents who were totally unaccepting of the change in their lives, and found no reason for living.

In order to get them to interact with each other and to share their feelings, the therapist used familiar music of their day. This evoked some memories and eventually they began reminiscing with one another. They found they had much in common and so began transcribing their feelings and experiences into songs. The therapist gave them a familiar melody and helped them with the rhythm. Their role was to turn their thoughts into the lyrics of a song. This turned into a particularly gratifying experience when a song they wrote about their state was sent to the governor, who wrote them a letter of commendation for the fine state song. Building on this successful experience they were led to involvement in other activities which offered other satisfying experiences. They learned that in spite of their physical limitations they still had much to contribute and much to enjoy.

Another example was a gentleman who was unable to be cared for at home and was admitted to the intensive care unit with a diagnosis of

terminal cancer. With the support of the entire staff it was explained to him that although his diagnosis was terminal cancer, it might take a long time to actually end in death. In the meantime it was a beautiful day outside and there was much going on that he could enjoy if he would come out of his bed and his room. Since he was a music buff, he was brought in to rehearsals of the band, which he joined, and soon became the leader of the percussion section. At Christmas he was one of the Wise Men in the pageant put on by the residents. Three years later he was still thoroughly enjoying life and had moved to the residential area where he was mostly capable of self-care, and independent. This highly intelligent, delightful man had learned that dying can take a long time, so living each day to the utmost makes a lot of sense. The physical diagnosis did not change but his attitude did. He was no longer just waiting to die – he was enjoying life.

Many residents who have lost their significant role in the larger community find that they can assume an important role in this new one. They can join a performing group, such as a choir, band or drum corps. They can develop new talents or be encouraged to relearn old skills such as playing the piano or singing. In any case, the goal is to provide them with new opportunities for success. As they assume these responsible roles in their new living situation, they develop a more positive attitude towards life itself. This improves not only their psychosocial behavior but also their mental and physical functioning. As they attain and maintain their highest level of functioning they once again enjoy a worthwhile quality of life.

## In the community

Today a great deal of attention is being given to the intermediate facilities – those which come between total independence and nursing-home care. This encompasses assisted living facilities, community centers and those day care centers which are designed for special-needs populations. Programs are developed to provide purposeful activity for these clients, recognizing their need to stay active and involved so that they do not slip into further deterioration. Here again, the therapist draws on the experiences of their past in order to design a program which will meet their present and future needs and be acceptable to them.

Some of these elderly find enjoyment in joining a performing group. For others performance is not appealing, but they enjoy attending concerts as a group or participating in a music appreciation group. Again, since music has been part of their past it becomes a very natural way to help them find new and enjoyable activities for these latter years. The goals are the same; however, the activities are altered to be appropriate for the functioning level of those involved. By meeting the needs of the elderly in these environments, the need for nursing-home care may be delayed and even greatly diminished.

### Goals and documentation

While some needs may be specific to a certain situation, there are certain needs which transcend all conditions. For instance, one of the great needs for all persons is recognition. Therefore it is of paramount importance to end each session with individual recognition, by name, thanking each person for their contribution, whatever it might have been. This can be accompanied by a hug or handshake, acknowledging the therapeutic value of physical touch. Other examples of these universal needs would be such things as the need

1)   to be as independent as possible

2)   to have successful and enjoyable experiences

3)   to develop an improved self-concept

4)   to be treated with dignity and respect

5)   to have some control over decisions regarding their life

6)   to have the opportunity to learn and to grow

7)   to anticipate something good in their future.

Meeting these needs must be included in the goals set up by the therapist and staff. Unfortunately they are often overlooked in the 'problem-oriented' reporting system used in many facilities. The documentation must be clear, complete and concise as it records the progress being made towards the stated goals. In this way the programs can be altered as

deemed necessary to achieve the desired results. 'If it isn't documented, it doesn't happen' must be the rule-of-thumb for all involved in the care plan. Only in this way can the therapist be sure that the needs are indeed being met and the desired results are taking place. When this procedure is followed, the result is an improved quality of life for each person involved in the music therapy session, and that is the basic goal of every music therapist.

## Coda

One of the interesting sidelights to music therapy programs with the elderly is the reaction of the families involved. Attending a program where their family member is involved or seeing them in new roles can help the family also to accept the new living situation. There is improved communication, and visits become more enjoyable. Frequently the families then become more involved within the facility, and when this happens, *everyone* benefits.

## Suggested Readings

Caplow-Lindner, E., Harpaz, L. and Samberg, S. *Therapeutic Dance Movement.* New York: Human Sciences Press, 1979.

Elder Song Publications, P.O. Box 74, Mt. Airy, MD 21771: Songs, music, games and activities.

*Activities, Adaptation and Aging* (journal), Haworth Press, Inc., 10 Alice Street, Binghamton, NY 13904–1580.

Idyll Arbor, Inc., 25119 S.E. 262nd Street, Ravensdale, WA 58051: Music in therapeutic recreation.

MMB Music Inc., 3526 Washington Avenue, St. Louis, MO 63103–1019: Books, music therapy and other art therapies.

*You Bring Out the Music in Me: Music in Nursing Homes,* Haworth Press: Binghamton, NY.

13.

# A route to the heart in a short-term hospital setting

*Christoph Grieder*

Music becomes a powerful mediation tool between my own and the patients' cultural world which reaches beyond stereotypes.

## A therapeutic breakthrough

On the seventh day of Ivan's music therapy sessions on our psychiatric unit, something unexpected happened. One of the group members violently struck the large Tibetan singing bowl, producing a loud and penetrating sound. Seventy-year-old Ivan broke down, crying and moaning 'The sirens! The sirens!' Then he curled up in a fetal position until he was led from the room.

The next morning, to my surprise, Ivan greeted me, smiling. 'When can we play music again?' He explained that during yesterday's session he had been reminded of something he had tried hard to forget. Within the group, however, he now felt safe. He proceeded to play the singing bowl with such intensity that group members had to cover their ears. Ivan had taken control.

### Ivan's life journey

Ivan is a Holocaust survivor. He was admitted to the in-patient psychiatric unit for post-traumatic stress disorder and depression. Both he and his

wife had been interned in a German concentration camp. They married shortly after the war and moved to the United States. He became a successful businessman until, after his retirement, he became depressed. His symptoms became so severe that he was unable to perform basic activities of daily living. Ivan decompensated to the point where hospitalization on a psychiatric unit could no longer be avoided.

## The creative arts are interactive

Before I continue with Ivan's journey through the arts modalities, let me explain how I work. I am primarily a music therapist. I also see my work as encompassing all the creative arts, and therefore consider myself a creative arts therapist as well. There is a progression for many people who often respond initially to one or another medium. Therefore my room is set up to offer nonverbal and verbal therapies.

To establish an in-patient creative arts program in a major hospital is an exciting challenge. The building blocks of the program are the creative modalities, which are very much alike but also differ from each other. This is a key feature: the creative arts have to do with self-expression and being human, while the individual modalities are preferences and 'routes to the heart.'

With this in mind, my program includes energizing movement, storytelling (often with music), horticulture, painting, poetry and music. I will explain how one art form leads to the next in the following pages.

## Ivan's journey through the processes of the creative arts

Ivan rejected any form of therapy except for listening to music during the initial days of his hospitalization. On the fourth day, while I was playing a familiar klezmer tune on my cello, I noticed that he was tapping his feet rhythmically. Since not every patient shows signs of communication during their early music encounters, I felt encouraged to pursue my musical flirtation. This first musical intervention established contact between Ivan's world and my own, and became the fertile ground from which an intense therapeutic relationship would grow.

Storytelling was not his medium of choice, at least not during the early days of his hospitalization. He seemed too preoccupied and unable to concentrate. Eventually he did attend the storytelling group, sitting quietly, deep within his own thoughts. It was perfectly fine with me to have him present, even if he was not ready to participate.

In horticulture I watched him sitting with a bonsai tree during a session. He cleaned the leaves and bark of the Japanese maple. Then he leaned back, looking at his accomplishment.

Another day Ivan placed his bonsai tree in front of him and he proceeded to paint with watercolors. He appeared tense and unable to move the paintbrush over the paper. He was literally stuck. I introduced him to the technique of painting on wet paper. I soaked a thick paper in a tray filled with water before I placed it in front of Ivan. I dabbed the excess water with paper towels. He chose the color blue and simply dropped the brush down in the middle of the wet paper. He watched how the droplet became alive and changed shape dynamically. Next he added more colors, until the session was over.

From then on, he painted in this way. His pictures were all similar with only a few variations: his name framed with a number of expanding colored circles.

Some days later in the poetry group, Ivan said, 'No, I do not like to write. Can I paint?' I look at this as a patient taking control, being in charge. So he ended up painting in poetry group.

Ivan had moved from music listening to horticulture, painting, and finally music improvisation. His most significant step, which led him to the therapeutic breakthrough I described earlier, was the result of a carefully planned process. He came well prepared to the music therapy session when he took his major step towards self-actualization.

At the moment when one of the group members struck the Tibetan singing bowl, Ivan broke down. Until then, his coping mechanisms consisted of repression and decompensation. However, it became evident that he was about to change when he asked me, 'When are we going to play music again?' Ivan was now in charge of himself, and ultimately he did not need to be hospitalized any longer.

## Sequencing my workshops

*Figure 13.1 Music therapy in a hospital setting*        *Dan Della Piazza*

### Music listening

Every day I play the cello. By playing live music I am reaching out to the patients; often before I speak with them directly, I play for them. This way establishes, first, contacts on a nonverbal level. From a patient's point of view, it provides an opportunity to watch and analyze the therapist in action from a 'safe' distance. At the same time, it also helps me as therapist to receive a first impression through observation.

The entire concept of establishing a therapeutic relationship is reflected in the music I play for the client and, later, with the client. Sometimes I play classical music like 'The Swan' by Saint Saens, or maybe 'Amazing Grace,' the well-known Gospel song. Another day I may play blues or klezmer tunes. It depends on who is listening, on individual reactions, and to a large degree on my own intuition. Music becomes a powerful mediation tool between my own and the patients' cultural world, which reaches beyond stereotypes.

*Energizing movement*

This is the first program being offered in the morning after breakfast. Don't think of movement in common terms. Imagine slowly drawn out shapes beautifully painted into the air with our hands, arms, and legs. The movements have symbolic value, such as standing straight up in the present. Leaning backwards and feeling the space behind us symbolizes the past. Through bending forwards while forming a nice circle with arms and hands, we embrace the future. Sometimes I like to do the exercises to softly played music. However there are days when I prefer to lead the movement silently, without sound.

If people have limited capability to physically engage in movement, they may just sit in silence, observing. Other patients make small, undefined moves. As time goes on it is possible to see how movements are growing stronger. The goal is for members to form nicely rounded circles with their arms and hands. Or I may look for stretched-out arms in parallel lines. Such movements may sound easy for a healthy person, but it is a big task for someone suffering from depression to work on body form and image. These movements, though simple and noncompetitive in nature, can increase the range of motion, promote deep breathing, help emotional well-being, and they are a positive way to start the day.

*Horticulture*

For us, this involves taking care of the Japanese bonsai trees. The plants need nurturing every day and patients love to be among the greenery. Their chores include careful watering, cleaning, cutting, shaping, and feeding. Patients place themselves into the following groups: plant lovers, students eager to learn, and people who, according to their own statements, 'kill plants.'

Horticulture therapy is a part of every day's creative arts program. Patients may choose between working with plants or painting, so there are usually several activities going on at the same time. An elderly man once said: 'Plants are no luxury; they are necessity. Plants are life!' When another patient was about to be discharged, he asked me, 'Would you let me take home my plant? I feel that the plant and I went through a lot together, and we helped each other grow.'

## Painting

Patients often tell me that painting is something they did in kindergarten. I may reply, 'How sad, it is about time that we do something to change that.'

Painting can add a different dimension to the creative arts repertoire. I look at pictures and images as a form of symbolic communication. Feelings often are more immediately expressed through visual arts. Therapeutic painting does not depend upon artistic or technical ability. Using a non-directive approach, I encourage patients to explore the meaning of their pictures through free association, or direct interpretation if indicated.

I offer a variety of materials during art therapy: color pencils, pastels, crayons, watercolors, and acrylic paint. Watercolors are my personal favorites and I encourage people to at least experiment with painting on wet paper. Especially if someone is depressed and does not feel inspired to do anything, painting on wet paper offers a wonderful alternative.

## Poetry

Writing or listening to poetry is practiced several times a week. I place a selection of inspiring poetry books on the table, arranged around the bonsai trees. We start with a selected reading, then we talk about it, and finally I encourage everyone to write. Maybe a poem, a personal story, or just a present thought.

Listening to or composing poetry promotes emotional, intellectual and physical interchanges. During the process of writing, it usually is very quiet. I see members looking up words in the dictionary. After enough time, I ask people to share their creations, without pressuring them.

An 82-year-old woman who had been a writer but felt no inspiration to pick up a pencil any more, near the end of a group session wrote something down, handed it over to me and said 'Here, I wrote it for you.' With her permission I am happy to incorporate her poem.

> I am as near to God
>
> as you are.
>
> All temporal points
>
> are equidistant to eternity —

I do not fear

even the vast black space between the stars –

it is not 'nothing;'

It is also God

in negative image.

## Storytelling

I also enjoy telling stories. Although storytelling takes place within a more concrete framework than music or painting, I utilize the two modalities almost in the same manner. With both, I am the person who reaches out through performance, and initially I do not necessarily expect the listeners to become participants.

We meet around the table in the creative arts therapy room. I try to select tales filled with universal appeal, symbolic value, and analogies. A very special atmosphere develops: the room gets quiet, some people close their eyes, while others seem to wander in their dreams. Directly or indirectly, I hear about the connections group members are making when they begin to share issues and memories that come into their consciousness. Storytelling is a powerful but non-threatening creative arts modality which alerts people to think about and start working on personal life issues.

## Music therapy

Among the creative arts modalities, music draws the most attention from patients. Everyone feels touched by music of a preferred style. Music therapy is often successful in assisting people with physical, mental, or psychological problems. I observe on a daily basis how patients become isolated through their illness. Breaking through this barrier is vital for any change to take place. Music can symbolize speech, and may become a means of communication without the anguish or embarrassment which often accompanies verbalization. Music creates circumstances under which healing can take place.

The musical instruments chosen for music therapy improvisation should be selected according to high quality standards. Criteria for music instrument selection include a wide range of tone, the potential for extreme dynamic variability, and orchestral polyphonic possibilities. Since in music therapy the participants are mostly not trained musicians, the instruments should respond easily and the person in therapy should be rewarded with beautiful sound.

The instrument collection I like to work with contains rhythm instruments such as congas, bongos, an Irish drum, snare drum, handbells and maracas. I often incorporate the xylophone, slit drums, singing bowls and cymbals, as well as flutes – but wind instruments are controversial for hygiene reasons. So I use pieces of a cut plastic tube, slip them over the instruments, and use them as a one-time-only mouthpiece. I even found a way to create two instruments which loosely resemble the Australian didgeridoo.

My collection of string instruments contains an auto harp, a guitar, and an Irish lap harp. In addition a keyboard comes in handy, as well as the human voice, an instrument always and everywhere available.

## The structure of a music therapy session

The typical music therapy session is structured into three parts: a warm-up improvisation, the main musical section, and the conclusion, which includes verbal processing.

When the patients come in, I like to be prepared. I form a large circle with chairs around a table big enough for all the instruments to be laid out. Then I offer an instrument to everyone who did not reach out for one already. We all sit down and start the session with a warm-up improvisation. Someone with a rhythm instrument usually starts with a beat and gradually everybody joins in. Depending on the constellation of the group, the music might develop towards a rhythmically balanced structure. It is then my task as a music therapist to lend support. I might pick up a shaky Conga rhythm with the cello initiating a steady beat. I stay with that rhythm in order to provide grounding. After repeating the same musical phrase again and again, the patient eventually is able to play alone. I musically move away and join another person who might need a little

challenge. First I join and match the rhythmical phrase. Then I start initiating a rhythmic variation while adding melody and harmony. There may also be a patient who is shy and afraid to play more than one string on the harp. Again, first I will mirror this single note with the cello until I feel inspired to substitute missing elements through soft challenges.

Music therapy is hard work. I have to be ready and always flexible to change, while being aware of the group as a whole and every individual at the same time. If the music therapy group works well together and creates a homogeneous sound, I know that one or more group members took on responsibility and were able to provide what I have provided so far. To me, that is the ultimate goal. I love to see people expressing themselves through playing instruments, not because they are asked to do so, but because they want to.

The music therapy session always ends with time to process. People might talk about personal discoveries and observations. It is also a time to share experiences, feelings, and plans for the future. What happened in music therapy is always related to real life events. I look at music therapy as a microcosm of the macrocosm.

Sometimes, however, it is not necessary to talk much, especially when everybody seems quiet but filled with joy. In a situation like that I might just suggest before everybody leaves, 'If you liked what you experienced in here, keep it with you and remember it whenever you want. It is a gift for you to keep.'

## The three pillars of music therapy

Thinking, feeling and willing are basic human elements. In music we have melody, harmony, and rhythm, the three elements which support the musical foundation. The human elements and the musical elements are congruent. With this relationship in mind, the core of music's therapeutic significance has been reached. Music provides direct access to the human being and therefore provides a key to human identity. Music is the art of the ego. Based on the relationship between the human and musical elements, I am able to assess and develop interventions for groups and for individual clients.

Whenever I am trying to lead a music improvisation group, the first element I emphasize is *rhythm,* which requires will power to maintain. Once rhythm is established, I introduce the melodic element. Most of the time *melody* does not flow by itself; it requires the power of imaginative thinking. *Harmony* is a naturally occurring phenomenon when several people are playing together. Being in harmony with each other reinforces feelings. Whenever all three elements are present, or coexist alongside each other, my goal has been reached.

A well-rounded music therapy group is a symphony of melody, harmony, and rhythm. The same is true for individuals. I look at the human being as the perfect musical instrument that functions like a symphony. What happens if a person is weakened through illness? I still like to think in symphonic terms. A few instruments might be missing and the ones still playing are most likely out of tune. Here is my opportunity as a music therapist to intervene through substituting the missing elements which could be either melody, harmony, or rhythm. In such a situation, the client might experience her or himself more fully through being in music. Music is a holistic phenomenon and it makes sense to define wholeness in musical terms.

## Dealing with obstacles

If I were a baker, I wouldn't have such a hard time explaining what I am doing. Being a creative arts therapist means that I have to constantly clarify my work in order to be understood by nurses, social workers, and doctors. Being a creative arts therapist means to educate and talk about one's work in relationship with clients on a daily basis. This is not a simple task. A painting or a musical composition in the art world can be perceived and measured by quantitative means. However, in our setting, since the picture is the result of a therapeutic process, and the music the product of intense emotional work, it is almost impossible to evaluate. Therefore, I often invite co-workers into my sessions. I have them paint, or play an instrument, because I want them to experience the qualitative aspects of the arts.

Another obstacle I face is interruptions. There is nothing more disturbing than being interrupted in the middle of an intense music

therapy group. It always happens in a similar manner. The door opens with a loud click. A medical staff person walks in, asking to take blood pressures. I say, 'Not now, please!' And the door closes with a loud bang. What do I do? I hang a sign on the door which reads, 'Group in session. Do not disturb. Thank you.' In addition, I tell the nurses when I go into session and ask them not to interrupt.

Another plan which works well is to observe and count the interruptions during sessions throughout the day. Then I take the findings into consideration when scheduling my programs. During the first half of the day I schedule energizer, horticulture and painting when it is easier to tolerate having doctors call patients out, or nurses arrive to finish their work. I plan storytelling, poetry and music groups later in the day when the chances of interruption are much less.

A big inconvenience occurs when colleagues do not stick to their schedules. Nurses and social workers are also conducting groups. If they are significantly delayed, the entire daily schedule can fall apart. I deal with this through a direct approach to staff members, hoping that something can be worked out.

The TV is another obstruction of therapy, and since the day room is often used for my sessions, I have to stand up against movies and talk-show hosts. I apologize to my patients and turn the TV off.

Due to budget cuts and the overall crisis of health care systems, there is a shortage of staffing. I feel the results immediately. Before I start a group, I must make a round of the patients' rooms to inform everybody, and ask them to gather in the day room or the creative arts therapy room, which they do. However, by the time I have finished my rounds, some of the patients are already back in bed. The cycle starts again. I have to round them up all over again. Time is being wasted and waiting time increases.

I cannot do this job without help. It really needs two people, so that one can stay with the group while the other one goes from room to room. My recipe to deal with these problems is flexibility. I always ask for help. If that is not possible, I continue to go from room to room alone and encourage patients to stay together. Sometimes I just have to accept a smaller group. But this is not satisfying for me or for patients who would benefit from the sessions.

In spite of the obstacles, I feel deeply rewarded to be able to accompany patients through crisis as a creative arts therapist. When I see therapeutic breakthroughs, I feel privileged to have contributed to them.

## Suggested readings

Ansdell, G. *Music for Life: Aspects of Music Therapy with Adult Clients*. London: Jessica Kingsley Publishers, 1995.

Beaulieu, J. *Music and Sound in the Healing Arts; An Energy Approach*. Barrytown, NY: Station Hill Press, Inc., 1987.

Bruscia, K. *Improvisational Models of Music Therapy*. Springfield, IL: Charles C. Thomas Publishers, 1987.

Bruscia, K. *Defining Music Therapy*. Spring City, PA: Spring House Books, 1989.

Bruscia, K. *Case Studies in Music Therapy*. Phoenixville, PA: Barcelona Publishers, 1991.

Nordoff, P. and Robbins, C. *Creative Music Therapy*. New York, NY: John Day Company, 1977.

14.

# 'We've no less days…'

## Music as an activity in nursing home and senior center

*Delight Lewis Immonen*

The last verse of the hymn, 'Amazing Grace' , closes with the words 'We've no less days/To sing God's praise/Than when we first begun.' In working with music and older people, I am constantly aware of this. Singing, in whatever style, with whatever instrument, provides a short space of timelessness; and most of the participants do have 'all the time in the world.'

In both nursing homes and senior citizen centers, 'Amazing Grace' has been enjoyed: sung unaccompanied with a resident on a ward of very withdrawn patients; used as a background for instrumental improvisation on another ward in the same building; or prepared in three-part harmony with a choral group of senior citizens in a community center. The lyrics communicate a positive attitude toward music, and the simple melody reinforces this.

In this chapter I will discuss various music activities in nursing homes, and others more applicable to senior citizen centers. In both settings, an activity or recreation director is the one who usually arranges for a music specialist to supplement the weekly programs.

Although I am a music therapist, I was hired as a musician to lead music activities in nursing homes and senior centers by the Rhode Island State

Council on the Arts. I have worked mainly with groups rather than on a one-to-one basis, but there are many times that I am aware of the therapeutic implications of my work as it affects individuals.

## Potential for change

The potential for change in the various individuals present in a group should never be overlooked. The leader must always be on the lookout for possibilities of a change for the better, for those individuals who still have an interest in 'moving.' People who initiate a change relationship themselves may indicate their readiness by asking for help with a song, or for specific music at the next meeting. Or they may express a desire to learn to read music. All these requests may be met successfully; certainly they merit the extra time spent arranging music or rewriting it on larger manuscript paper if necessary.

But there may also be an unspoken, implied need for change on a deeper level – the individual asking for help to make adjustments, through music, in dealing with his or her life situation. In these instances, it is very important not to assume the role of therapist unless one is properly qualified.

Even more important, the musician/therapist must be there often enough, and over a long enough period of time, to be able to see the client, which the individual will become, through any sort of change that might be initiated. Music therapy is an adjunctive therapy and should be administered as part of a therapeutic team effort on behalf of the client. Often, more harm than good may come unless it is treated as such.

## In the nursing home

In nursing homes, groups are generally made up of those residents who would like to 'go to music,' especially those who have had a previous interest in music and are urged to continue it. Many look upon the sessions as a class and regard the group leader as a teacher. Held at the same time each week, classes are preferably announced on a calendar ahead of time. In the larger institutions, the workshops are announced beforehand over a loudspeaker.

The residents who come together for music are frequently as much strangers to each other as they are to an outsider, so it is very important that names be used. It is often a fine idea in the beginning to sing songs like 'Mary,' or 'Sweet Sue,' but substitute the names of everyone in the group. Using a songsheet that includes all the names of the members is also a good way to break the ice.

## The leader's role

The leader of a group is, of course, fundamental to the direction a group will take. Consequently, a little soul-searching about one's own desires and expectations is important. The group leader who asks for loud singing may get just that – and only that. And the leader who likes particular songs may fashion a session to include these alone, falsely assuming the residents like them also. When group participation is truly welcomed and new material constantly elicited from the members, activities express the growth of individuals and of the group. The leader needs to take stock of the autonomy he or she wishes the group to assume.

## Resistance

One form of resistance from residents often encountered by a group leader is the attitude, 'Whatever you want to do is fine.' Residents are used to abdicating their power to make decisions, to think, and to have opinions. A way to challenge this passivity and resignation is to ask a specific person, e.g. 'Bill, would you like the group to start with "God Bless America" or "The Battle Hymn of the Republic"?'

Frequently I hear 'I never could learn to read music…or play the piano …or sing.' I answer cheerfully, 'Now is now;' and follow with an activity that allows for instant success. For example, it is the rare person who says, 'I always wished to play the piano,' and who comes to the piano to try. But a small, moveable keyboard instrument, brought to the person to play, is a nonthreatening guarantee of involvement.

Too often there is interaction between the leader and the various members of a group, but very little among the members themselves. It may even seem that the leader is initiating all activity, and that the residents are

not even reacting to the leader, let alone each other. One completely nonverbal stimulus is to offer a tambourine or drum to an individual. This can elicit a musical response from the group, who may sing or play as an echo to the drummer's beat.

Any group's membership, in one way or another, is composed of those whose musical expectations are either vague, based on former musical experiences, or completely dependent on the leader. In any event, all the members hope to enjoy themselves, or they would not have come – although there are times when the staff may make that decision for them.

Dealing with differences in a group's choice of material is always a difficult part of a leader's job. Perhaps it is best handled by being certain that all requests are treated with respect, even though the choices of some members may seem silly or even insulting to the others. The more capable leader will usually rise to the challenge of accepting a request for a child's song like 'Three Blind Mice' by adding an extra part such as a descant to satisfy the more sophisticated members. (A descant is a countermelody; many satisfying descants are contained in music textbooks from the fifth grade on up.) Almost all requests can be filled. It is important for the leader to make everyone feel welcome by honoring all their suggestions. It is far better, when confronted with an unfamiliar request, to say 'Let me see if I can have that for the next time,' than 'I don't know that one.'

It is not a good idea to limit choices by offering one particular set of song sheets. Group members themselves may be able to make up the words to songs, perhaps to melodies they have composed. When this occurs, their names should appear on the copies and someone with an artistic flair may design covers for the compositions.

Once material has been selected and a group established, more questions can be raised by the leader regarding:

- tempo – should that song be slower or faster?
- meter – should we play with a one–two or one–two–three beat?
- dynamics – are there any parts of that song that should be sung very quietly?

Often the most sensitive reactions may not be verbalized, and it is up to the leader to recognize this input as well. One should be aware of such cues as

hand gestures and toe-tappings. In turn, the leader's responsive smiles and nods when a tempo feels correct are signs of approval and support. This acknowledgement will please the members.

### Involving guests

Meetings are generally scheduled after medications have been handed out, or before and after meals. Visitors who arrive at those times certainly wish to speak with the person they have come to see. Involving them in the informal music group with that resident will help them feel welcome and at ease. Some may even offer to play the piano, or sing, or help hand out instruments. Singing songs that visitors suggest can extend the musical experiences. This is more positive than having them talk on the sidelines. It is also a pleasant change for the residents to have their guests participate, perhaps more fun for both sides than trying to hold conversations about situations from which the resident is now removed.

### Listening to records

Recorded music can also be well received, if the tape player is of acceptable quality. But one should never play endless 'soothing' music *at* the residents. They should be allowed to discuss the selections they are going to hear and evaluate them afterwards. Their views are welcome; they are an important part of the planning of the future meetings. Listening becomes active when appropriate instruments are added or when participants tap their fingers and feet. However, the fact that a person is quiet and actually listening is not the same as 'nodding off.' Silence in a listening group can be the best indication of involvement.

### Peak experience

A peak experience is a special moment that will be remembered. It is often worth repeating a particular number enjoyed by all. By noticing a song which went well and suggesting that the group sing it again at the close of the meeting, one can reinforce the group's sharing. I always aim for at least one peak experience during a session, in case a member is not present at future meetings. Each session should offer a complete experience in case

some of the long-term musical goals prove to be impossible. These long-range goals should never be ignored, however; and discussions with the staff of the institution will help to relate them to the goals of other planned activities for the members.

## You can do it

Attempting to teach someone something implies that that person is worth the time spent, and that the teacher judges that person capable of learning; so even if some members of the group complain 'We can't ever do that,' they may actually be looking for reinforcement of their own capabilities.

It is for this reason that a planned performance may be incorporated into the activity. 'We sounded so good on that, we really should sing it for someone else,' may not be unanimously received, but if a situation is arranged with a minimum of stress (chairs in the front row of an audience, or a semicircle facing the rest of a large group instead of on a stage), the feeling of pride acknowledged afterward is well worth the trouble.

## The club

There are many residents in nursing home facilities who are very active and intellectually aware. They have previously enjoyed music; some may play instruments, and many love, or 'used to love' to sing. For such people, a weekly music club or music appreciation group is a welcome addition to the activity schedule – a supplement to, rather than a replacement for, a sing-along.

The club may begin with an examination of music related to current events, or folk music for holiday celebrations. A group may wish to study the origins of its members through ethnic music.

People who have been soloists in the past will probably be glad to share the words and melody of a remembered song. In one club, after the group had heard the story of *Carmen* and listened to recorded excerpts, a former opera singer – now almost deaf – stood with a cane and treated the group to a rousing performance of the 'Toreador Song.' In the same group, a woman who obviously used to spend a lot of time playing piano for sing-alongs, would sandwich 'Mary' in between every song the group decided to do. Since none of the residents seemed to mind this repetition,

the pattern was continued. 'We sang that already, but it's a grand old song, and she certainly likes to play it!'

### Developing group support

In informal music groups, if a resident seems to have withdrawn and is chanting away, alone, playing of the rhythm of that chant by members of the group, with instruments, will let the resident know that people are still with him or her, and still care enough to communicate.

One little lady, who was not oriented most of the time, always joined in the singing of her song, 'Let Me Call You Sweetheart.' The whole group came together when this song was sung, because everyone was cooperating in the effort to 'bring her back.' Another woman constantly complained 'I don't know where I am,' and the group usually responded with the old favorite, 'Show Me the Way to Go Home.' Often such casual good humor offered by fellow group members is the best way to let someone know that he or she is not alone with a problem, and that others understand.

If a resident does not speak, or is unintelligible, a glance at the wrist identification tag may suggest an ethnic background. One woman, whose last name sounded German, not only joined in all the words for 'Du bist mein Herzen,' but led the rest of the group in the singing.

One very old man came late to a large informal group on the ward and announced that he didn't like the songs the group was singing, but that *he* could play 'I Love Coffee, I Love Tea' on the piano. Immediately, one of the women started singing all the lyrics to the tune, and all joined in once they heard the song. He was surprised to find there were words to the music, and happily accompanied the singers.

If a group member feels silly at being asked to play an instrument, another way to involve this person should be found. He or she may rather just sing, or in some cases take responsibility for the musical direction of the group. People who do not easily join an activity sometimes surprise themselves and the others by having a natural feeling for a downbeat. A baton lends even more significance to the position of conductor to start their group off and keep it together.

## Staff participation

Music groups, of course, are run for the benefit of their residents, not the staff on duty. But the positive attitude of the latter will help to create a sharing, often festive atmosphere, if they actually participate. This positive attitude may not always be evident when the activity is begun. The staff are busy, and after all the care they administer to the residents, they may find interruptions a burden, particularly if the activity occurs during their break. But if their participation is welcomed, they may prove a pleasant addition to the group.

In one nursing home, a cook joined the instrumental section with two of his best pan lids from the kitchen. In another, a nurse offered to teach the group a Spanish song. Aides who are free enjoy playing the more difficult melody instruments. And the patients, seen as equals in a situation like this, sing along with them. They are sharing a social activity. It is no longer 'We're the well ones and they're the sick ones.'

Just as important is the attitude of alert residents toward group members who are disoriented. Often these alert residents tend to be somewhat exclusive, possibly because of the fear that 'the same thing could happen to me,' as if they could catch the lack of awareness, the regression, of another. They want the group leader to realize that they are not 'like that' and do not wish to be associated with it. And it is possibly for the same reason that some members of the staff treat residents with more objectivity and less humanity than seems appropriate.

## Reaching the disoriented

Music is one realm in which people can be creative at any level of intellectual awareness. One group did Scottish songs for those members of the nursing home who were never brought to the weekly meetings because they were considered too disoriented. Curled up in a corner was a woman yelling nothing relevant in a high voice. She was given two small maracas, which she played vigorously in time to the music. She enjoyed them so much that everyone in the room benefitted from her pleasure.

It is amazing how such 'disruptive' people can be 'called back' with a simple, practical remark. When asked by name to join the singing instead of making noise that is interfering, they will often answer 'All right,' and

begin to participate. If given an instrument, they will put all their energy into playing it. It makes one wonder if boredom is not at the root of much antisocial behavior. Or perhaps what we sometimes see is resistance against the passivity that is often encouraged in residential facilities. *Never assume that someone does not want to participate.* Rather, search constantly, during the session and in-between meetings, for a way to include that person.

## Handling individual problems

If members of the group have assumed an active role in the structure of the activity, then if one patient did not wish to come to the meeting in the first place, but was wheeled or walked there by a member of the staff, his or her wish to leave should always be respected. Or, if the prevalent attitude is 'This is a special musical group and that person is spoiling it,' the person in question might be encouraged to leave a little early. However, a follow-up of the individual's interests is made, and an invitation to return and partic-ipate remains open.

## Designing personal folders

Members may be given, or may help to prepare, folders or booklets containing songs sung at group meetings. In the case of ethnic music workshops, songs and information about the different countries could be included. It is wise to have spare copies on hand for those who forget to bring them back. But just having them gives the group members a feeling of importance. One resident I know keeps his music folder, and a small flute used for sound effects, in the pouch attached to his walker. Others keep theirs to show visitors, and rarely bring them to meetings. Many have decorated their folders, and one woman designed a stencil to decorate all the folders in her group.

In some cases, a resident may know a song no one else knows. He or she adds to the resources of the group by giving the words to a member of the staff or by writing them down to be copied. A good idea suggested by members of many groups is to have all pages of such notebooks organized in the same manner, with the pages numbered.

## Senior centers

A substantial number of senior citizen centers have formed music groups. The most active members generally request the activity because of the many seniors who like to sing, and who play instruments. Often, however, there are not quite enough people to achieve a good group sound, and there are few who will want to come on a regular basis. But if the nucleus is encouraged and asked to suggest songs for the group and to help develop general rehearsal procedure, those few will recruit others.

### Respect individuality

Working with older adults in music is in many ways similar to conducting a class for younger people. The same discrepancies in background and aptitude are encountered, the same difficulty of working with individuals in a group setting. But here, situations and people who seem very similar at first are often not at all similar. Two men who play the same instrument and come originally from the same foreign country may now live in different suburbs of the same city, have different lifestyles, and feel there is a world of difference between them. The leader should be aware of this and treat them as individuals.

But if a group of people of, say, Italian descent can learn the words and music to a Portuguese song, it gives them a feeling of accomplishment, and it also gives the few Portuguese members in the group a special feeling of belonging.

### The leader

Perhaps the leader has presented a song from a particular book and a majority of the members say that the words of the song are 'wrong.' It is usually wise to alter the lyrics or have the members use pencils to make the changes themselves. In other musical matters, however, the leader must occasionally say 'Do it this way.' Indeed, if the group becomes too democratic, members who often remain quiet at meetings may come to the leader separately and request that the leader not let so-and-so run the group.

Some people feel embarrassed about singing alone, and some have never been part of an organized music group. They will come if they feel welcome, and if they feel their voices are blending in. If they express concern that their voices are too low, or that they cannot see the words easily, it is important to respond in a relaxed manner. Some casual remarks about the pleasant blending of high and low voices may be helpful. Be very supportive if you feel that a person actually knows most of the words already and does not need to read them, or suggest a little 'lip-reading' if glasses are forgotten.

## Range of songs

Simple techniques such as 'warming up' may be unknown to untrained vocalists, and many have negative ideas about vocalizing; but it is easy enough to choose a song in a comfortable range with few high notes until voices are sufficiently loose. Some group members – and, in more cases, staff members – may complain that a song is too high or low.

If the leader is a trained musician, transposition should be easy enough, even though the written accompaniment has to be reduced to simple chords with the new symbols penciled in. However, if the leader is not the accompanist, and the accompanist is not proficient at transposition, the uncomfortable singers should be encouraged to put the melody down an octave, or to sing a harmony part. Non-professional leaders may be surprised to hear spontaneous harmonizing from members who find a pleasing way to blend their voices in a comfortable range. There is no need to make the accompanist, who may be a peer of the rest of the group, feel that he or she is not making an important contribution to the group's activity.

## The space

In senior citizen centers, a piano in the space where the midday meal is served is a help, for informal music will always be welcome after lunch. Serious rehearsals in that space are very difficult to conduct before the meal. With all the noise of preparation and people coming in to eat, the music group is a source of aural competition. Therefore, it is wise seriously to consider moving at least the initial meetings of a group into a smaller

area, where the members will not feel self-conscious, and where the music in preparation may be discussed quietly.

## Organization

As in working with people in nursing homes, clear presentation of material is particularly important. Songsheets clearly printed and uniformly arranged are necessary. Here, although the possibility also exists in nursing homes, the appointment of a secretary from the group to help keep things in order will certainly be well received. Other officers can help heighten spirit, interest, and attendance. Time should be spent, as soon as possible after the creation of the group, to discuss conducting techniques for those who would like to try to lead the singing. By reminding the senior who occasionally forgets reading-glasses to bring them the next time, you remind that person to be responsible for personal needs.

*Figure 14.1 Men and Women Relish the Music Workshop in a Senior Center*
*Sarah Hopkins*

## Performance

As soon as a group has prepared a few selections, a performance may be suggested. This can mean a few numbers after lunch, or a performance at a

nearby nursing home. If relatives or friends of some of the members are in the home, a special sense of sharing is added.

A microphone will probably be necessary for the announcement of songs; and, when possible, the members of the group should take turns making the introductions. They can choose which numbers they feel comfortable announcing, and should practice doing so at least once before the performance.

One senior group, at Thanksgiving time, performed in white pilgrim collars made from heavy white paper. At Christmas, red and green bows were added; and by St Patrick's Day, the members decided to consider different costumes. Such discussions should not be allowed to take up the group's valuable rehearsal time, but they should be held afterward, because the members should be encouraged to make these decisions themselves.

## In conclusion

Since each group and each situation is different, it is probably unnecessary to offer more than a final word of encouragement to those of you who would like to take an active part in forming and/or participating in a music group with older people. Indeed, the most exciting thing to happen to you may be your own musical growth and sense of enjoyment. As one staff member in a senior citizen center put it, 'Come and work with the seniors; they have a lot to teach you!'

## Suggested readings

Ansdell, Gary, *Aspects of Creative Music Therapy with Adult Clients*. London: Jessica Kingsley Publishers (1995).
Gilroy, Andrea and Lee, Colin (eds.), *Art and Music Therapy and Research*. London: Routledge (1995).
Feil, Naomi, *The Validation Breakthrough: Simple Techniques for Communicating with People with 'Alzheimer's Type Dementia.'* Baltimore, MD: Health Professionals Press (1993).
Suzuki, Asako Iwai, 'The Effects of Music Therapy on Mood and Congruent Memory of Elderly Adults with Depressive Symptoms.' In *Music Therapy Perspectives*, American Music Therapy Association: 16, 2, 75–88 (1998).

# Writing – The word unites experience: Past, present and future

With the written word, poetry or prose, we can conjure up the world of images, feelings, metaphors, stories, and dreams. Past, present, and future coalesce in word, fact, and fantasy.

**Laura Fox** describes her voyage as a writer/teacher leading older citizens to get their 'tellings onto paper' at nutrition sites and in nursing homes. Her narrative insightfully introduces us to the individuals who slowly join her workshops. They submit, with fear and wonder, their early writings as they discover that the words are all there, inside them, waiting to be released.

# Is it literature, is it art?

## Writing workshops with literate and illiterate

*Laura Fox*

It is articulation. It is translating something of the self into language, which for even the most unlettered human is our uttered being. And if, beyond that, we can engrave the utterances in writing, something of our being remains.

## My beginning

My Russian Jewish grandmother, who lived with us, told me stories. She drew for me and peopled a mythic interior landscape which is still with me. This landscape seems to provide references, recognitions, a sense of the *almost* familiar in my wanderings at home and abroad. Beyond the delightful idioms she gave me, grew a sense of idiom; beyond the faces and gestures she drew, a sense of proto-images. She initiated me into the universal village, the human tribe.

Years later in the early 70s when we were experiencing a bathos of national guilt about the plight of our aged, I thought of her often when I was stricken by the voicelessness of these other grandparents. Where were they? Why didn't we hear them? What of the children? When the development vandals had carried the elders off to the retirement villages, the condo tracts, the shopping malls, had their tongues been paralyzed?

At this time I was at 'liberty,' after an intense two-year effort to bring 'disadvantaged' university students to the writing of English. Before that I had worked with minority adults in similar programs – trying to bring the inarticulate to voice. What, I thought, of this largest minority of all – the aged? In many ways they were the most disadvantaged in our youth-oriented culture. Shouldn't we be trying to bring them to voice – so that our children could hear them, could grow on the stories?

Since I was teaching a writing course in an adult education program at that time, I proposed, to the approval of my director, a course exclusively for older people in which they might stimulate each other to tell stories out of their lives. I would then help them develop techniques for writing these down, reasoning that, in this time of ruptured oral tradition, it was important to find ways of getting tellings onto paper. I foresaw many critical, artistic problems – written folk tales were in themselves an anomaly.

But my first problems were far less esoteric. All the publicity about this original program and all the eager inquiries had yielded a first class of two persons. Our older citizens had stayed away in multitudes. I learned the first basic lesson for practitioners in this uncharted field: daytime programs only.

My two eager students, two women in their seventies, and I moved into a local church where we began working one afternoon each week. The two brought two more and quite soon we were twelve, which was for a long time a constant.

It was great fun and easy. My genuine delight in their material and the enthusiasm of their peers seemed to be all that was needed to generate a flood of stories, even poems. I believed that demonstrating that we really cared, really wanted to hear, was all it took to open older people to telling and to inspire them to undertake the struggle of getting tellings onto paper.

I was aware that the people in the group were unrepresentative of the vast majority in our senior citizen population. This was a university community. These people were, in the main, professional retirees still in control of their own lives, with the means to live comfortably and even to seek cultural enrichment.

## A serious apprenticeship

They had the problems common to all who age in a youth-oriented society, and the real problems of aging in any society. They also had the problems common to well-bred, middle-class people of any age. Here, in this group, which was not a club, they had to make the hard move from conventional attitudes of polite praise to the workshop attitude of 'How can this material be made stronger?' They had to be willing to relinquish prettiness of language for honesty and accuracy. They had, in short, to accept all the hard learnings attendant upon a serious apprenticeship in an art. But I had expected this. One has many of these problems in any workshop. And, as in any writing workshop, there were the few who were desperate to publish. For them, the workshop was the vehicle of the last chance. Their desperation threatened to rock the workshop. But weak members grew stronger and the workshop prevailed.

At that time, at least a year before Marc Kaminsky's book describing his poetry groups in senior centers, [1] and years before the book by Kenneth Koch about his poetry workshops in a nursing home, [2] I could lean only on my own previous experiences. I did find in the Teachers and Writers Collaborative of New York City a shared teaching philosophy and, although their work was with children, many intriguing ideas in their publications. [3]

When my workshop published a collection of writings [4] reflecting only six months of work and resulting in an unsolicited grant, I was convinced of the magic of the method. Essentially it was:

1) enthusiasm about people and their material, even if the work itself was weak

2) strengthening of this work by constructive criticism, e.g. 'How can this scene (speech, mood, etc.) be made more vivid (accurate, true, etc.)?' We would never say a work was good or bad, better or worse.

The small grant enabled me to start two new workshops. I decided to go to a large nutrition site in a poor area and to a well-known nursing home. In this first flush of success, armed with my 'method,' I began at the nutrition site.

## At the nutrition site

I made several visits to 'drum up trade.' It was not easy. The staff at the center loved the idea of something 'so creative' but they did not help. However, when I finally met with my group, I felt it had been worth the effort. In a dank basement room a large group assembled, few with much interest. They didn't know what to expect. Typical of their acquaintance with writing was the remark of a hearty Irish woman, 'I never wrote anything except a laundry list.' We laughed. She was not joking.

## The group

The group was fascinating. The largest number were Italian, some from the 'old country,' some from New York's Little Italy. Others were Irish, Blacks (from the city, from the south, and from the Caribbean); several Germans, Hispanics, two Swedes, two Hungarians, one Jew, and two native Americans – members of a group split off from the Shinnecock Indian tribe of Eastern Long Island. Formal schooling ran from two years in a rural southern schoolhouse to high school in the city.

They introduced themselves to each other and told a bit about their backgrounds. A quarter of them had been orphaned and raised in institutions or foster homes. Most of them were widows. There were two couples, one of whom was Shinnecock. Most of the women had worked in factories or as domestic servants. The three men had all been laborers. They ranged in age from middle sixties to middle eighties.

Most were lively and outgoing. We talked about their various backgrounds, their roots (that was before the TV series based on Alex Haley's book), and why that mattered; why stories of the past should be passed on. I told them about my grandmother. One person volunteered a story about her grandfather. We heard about the Irish potato famine in a village in County Cork, about a volcanic eruption in a village in Sicily. They were now as excited as I was. Then I passed out paper. Silence fell. A black woman said bravely, 'I can't spell, I didn't have but two years' schooling in Carolina.' Nobody else said anything. I told them that spelling didn't matter at all for this kind of work. We'd just get it down, no matter how, and then we could fix it together. They should write it just as they spoke it and then it would be strong and ring true. There were murmurs of

disbelief. I asked the man who had told us so stirringly of his grandfather running away during the potato famine if he'd say the same thing, just the same way, on paper. 'Nope,' he said implacably, 'can't do that.'

'Peg said she never wrote nothin' but a laundry list, I never even wrote that much,' said another woman. 'And anyway, who the hell would care about what I done? I'm nobody.' Eileen was articulate and angry. (The teaching situations described throughout are factual; the names of partici-pants in workshops are not.)

## The right to write it

I remembered Tillie Olsen in *Silences* talking about the poor, the marginal, in our society. 'How much it takes to become a writer...but beyond that: how much conviction as to the importance of what one has to say, one's right to say it...' [5]

How could I confer on them the conviction of their worth, the importance of what they had to say, their right to say it? I had not met anything like this in my first group. There, with whatever fears or miscon-ceptions, they had come to write. I tried to tell them what I felt about the importance, the uniqueness of each life and why it mattered to tell about it. I talked rather wildly – a passionate mishmash of elementary anthro-pology, psychology, linguistics.

'Sound like our preacher back home,' a black woman said happily. At least they did not disapprove of me but they would not write for me when they really believed they could not. No, it was not quite enough to confer on them the right to say it; they would tell me their stories eagerly, but that wasn't the point. I could not bestow on them the right to write it; they had to believe they could, before they would give themselves the right. I remembered how the poet Kathleen Kranidas had plunged young children right into the act of poetry. [6] The children had not believed they could make poems. Of course they were not fearful, in the paralyzing way of these older people. Still, I had to do something quickly.

## *Strategies*

I asked them to play a word game with me. Just a game. Faces lightened. They know word games from TV. The blank white paper was a problem,

but I had to use it, since I had no lined worksheets. I asked them to copy the three incomplete sentences I wrote on the board:

1. From the deck of the ocean liner, the people saw...

2. The lost child sat crying in the woods and he saw...

3. The woman was afraid and in her dream she saw...

Several began. Copying was not a great threat. I went around the table helping those who were not writing. 'Got my hand crippled-up with arthritis,' one woman said. This was a cover. I could now write for anyone who could not for any reason. I asked the members who could write easily to help me. Even so, it took long. Finally, we had the sentences down – with a lot of space after each one.

Someone grumbled that it felt like school. Someone else asked what happened to the game. 'Now – right now, the game,' I promised. 'Call out to me, sing right out, the names of birds – any bird.' Quickly I erased the sentences from the board. They all knew some birds. This was easy. Voices competed. Each one, even the most reticent, contributed a bird. It was fun. The list grew.

'Now words that tell what birds do?'

'They sing.' 'They fly.' 'They make nests.'

I wrote 'singing,' 'flying,' 'nesting,' on the board and elicited more till we had a good list. I asked them to look at the board, then the first sentence, and to complete it with the name of a bird and the action of that bird. I gave examples and I assured them that there were no right or wrong answers. Whatever they chose made it theirs. I realized that several had difficulty reading the sentences I had written for them. I helped again. We went on to do the other two sentences.

My hands trembling, I gathered up the papers and read the sentences as beautifully as I could. I performed them. I wanted them to be impressed. They were. So was I. They had all, with the exception of one woman who was on powerful tranquilizers, chosen birds and actions appropriate to the situation. Many, where there was a choice, had seized a particular mood and enhanced it. The tones were true. These are a few representative sentences written that day:

The people on the deck of the ocean liner saw a group of buzzards feasting on a dead whale.

The people standing on the deck of the ship saw an eagle soaring after the seagull who was gliding after a sandpiper.

The lost child sat in the woods crying and saw a vulture eating on its prey; it was very ugly for a child to see.

A lost child sat in the woods and saw a rabbit peeping at her as she was crying and she stopped and lost all fear.

The woman was afraid and in her dream she saw a vulture swooping over her new baby.

The woman was afraid and in her dream she saw a bat flying around and around in her room.

## A teaching instrument

Now I had a teaching instrument for them, their own work. I told them I would show them how much they already knew about the artistic use of language. As I read I pointed out images (I called them pictures) that were particularly strong. I invited them to guess why that was so. They hesitated, not trusting their instinctive responses. Finally Eileen, the angry one, said, 'Heck, a vulture could scare the pants off you!' Everyone laughed. 'Exactly,' I said, 'and that's why you chose it.' 'Well sure,' she admitted.

And so it went. I showed them how, with the lost child, some had made frightening pictures, some soothing ones. 'But which is right?' someone asked anxiously. I told them that each was right; some had chosen to go with a lost child's fear, others chose to reassure the child. Each had made a choice and then very sensitively created just the right picture to reveal what they had chosen.

'Ain't we something?' Mary said. They all looked pleased. I closed the session by asking permission to keep their papers. And then I bribed them to come the following week by promising to return their work to them beautifully typed. I had decided to call their writing *work* since they were of a generation with respect for work and workmanship. And since they

were so pleased with themselves now, I promised that we would play another game, much like this one, next time.

At the next session most of them were there, with the addition of several new faces. They were enchanted with their typed work. Typing gave it status. Someone said it looked like print. I agreed as I passed out colored folders for each person's work. As they were inserting their first work into the folders, I passed out worksheets for the new 'game.'

## The second step

I told them how much I enjoyed their work. I asked them to do another game with me, and they agreed. This exercise [7] was a big leap forward. I prayed that it would seem simple to them, like the last one. I asked them to look at the photocopied worksheets which had this on them:

> With you
>
> I am a…
>
> …
>
> Without you
>
> I am a…
>
> …

They looked puzzled, but I thought to myself that they did not seem too afraid. Quickly, lest consternation grow, I asked for names of animals. With some prompting for wilder animals, we got a good, varied list. I need not have worried that this lesson, designed for young children, would seem patronizing. They enjoyed it hugely. I asked for the action words – what animals do – and, as before, wrote them on the board below the animals: barking, roaring, leaping.

Then I sat down and asked them to think of someone who is, or was, important to them. 'Visualize this person,' I suggested. 'Try to get a feel of his or her presence.' I told them, once they had 'gotten hold' of the person, to start writing. I asked them to leave the first line as it was but to complete the second line, which was blank, to tell what that animal was doing.

The form bothered a few, and I told them that it was really like the other thing they did. To my delight, someone asked if they could write more. I told them to go on as the spirit moved them. Some went to work at once but several looked upset. One woman said she could not compare a person to an animal. I said that we do it all the time, and gave her some examples: strong as an ox, wise as an owl. Someone called out, 'A regular snake in the grass!' Everyone laughed. They called out more examples. I had to urge them back to work. As before, I helped several with the writing, although fewer than last time claimed physical disability.

Their work was astonishing. True, strong poems came from many of them. They were enthralled. There was little argument that it was poetry. The lady of the inspirational verse was truly inspired in her poem. She had written:

> With you
> I am a tiger
> stalking through the field
> and thicket of your heart.

Some wrote only 'With you.' One wrote only 'Without you.' Most wrote both. Sally, of the Shinnecock Indian couple, wrote:

> With you
> I am an elephant
> so big and fine
> and walking slow
> thinking elephant things,
> such large love.
> Without you
> I am a mouse
> dirty and scared and skinny,
> wondering is this
> my life. I sit
> and wait for you
> to do for me.

Her husband Bill wrote:

> With you
> I am a fox
> cunning and smart
> as any one around.
> In the forest my sharp nose
> can smell out all the
> different smells
> and my sharp ears
> can hear the
> slightest sound
> and my legs can
> run me swiftly
> into the underbrush
> Without you
> this fox
> is always on the run
> lookin' out for hunters
> that stalk me in the woods
> to take pot shots at me.
> I hide mostly
> in underbrush
> or the hole in the tree.

Melba, a soft-spoken Jamaican woman who was quite blind, dictated so rapidly I could hardly keep up:

> With you
> I am a lamb
> gentle, bleating,
> a little lamb that stayed
> away on the hillside
> bleating. You take me home,
> bind up my broken leg.
> Without you
> I am a barking dog
> a perfect nuisance

restless, watching for you –
lost, helpless without you.

Eileen, the angry Irish lady who wrote the following lines, remained a difficult but ardent member until she died two years later. She read her poem with irony and bitterness:

> With you
> I am a pussy cat
> against your St. Bernard.
> Without you
> I am a lost soul
> frustrated, but you tell me
> I'm very good
> for my age.

She wrote, during the two years she was with us, almost as compulsively as she talked – jagged, poignant pieces about a mean, impoverished, motherless life in New York's Lower East Side. Although many of our members had rejected her formerly because of her rude, abrasive behavior, they began to accept her as they came to know her through her work. Her death, the first one in that workshop, was a blow to all of us.

Martha, a seemingly jolly lady wrote:

> Without you
> I am just a little gray mouse
> Trying to pretend I am an ape
> Swinging and laughing through life.

Ellie, gentle, a recent widow who had never said anything in the group, wrote three moving verses:

> With you
> I feel content,
> Carefree as cows
> layin by the shady oak
> watching the world
> go by.
> Without you

> I feel like a traveler
> in a strange land
> lookin for shelter,
> food and water.
> I am thirsty,
> lost and lonely.
> And in a strange country
> I am so lost without you
> I am a lost glove, just waitin
> to be mated up with the other.

Hilda, the dazed lady on strong tranquilizers, wrote the only piece that mixed its metaphors.

> Without you
> I am a deer, lost, frightened, confused and frustrated
> Trying to find a way to get
> Back on an even keel.

When I read it, Bill, who had been the fox in the underbrush said, upset, 'That don't go – that about an even keel with being a deer.' I asked him why and he mumbled, annoyed with me, something about, 'First she's in the woods and then she's on a boat – all mixed up.' Melba, the blind woman, said softly but with irritation, 'She admitted she was confused, right in the poem, didn't she? Well, maybe that's why that happened.' We finished on a great high.

Several, on their own, wrote similar poems at home and brought them in to the next session. Without the form or the words on the blackboard, the poems were freer. Bill wrote:

> With you
> I can fly the highest
> and sing the loudest
> than any other bird.
> Without you
> I turn into a roaring tiger
> destroying everything in my path
> as I go through the woods
> that is in my way.

Sally wrote:

> With you
> I am as large as
> the Blue Ridge Mountains of Virginia
> spreading out its beauty
> in all directions.
> Without you
> I am like a sluggish stream of water
> looking for a large flow to join
> now that spring has come.

## 'Lessons' and dreams

After this strong beginning the group moved through many exercises. They demanded 'lessons' in the workshop. Soon many were writing at home as well, but only in response to specific assignments. This way of working continued until they were writing so much there was no time for anything else.

They moved through dreams. They wrote their dreams in the first person, present tense. 'As if you are in the dream now and it's happening,' I urged. Millie, who would become one of our most powerful and prolific writers wrote:

> It's almost morning and I look out of my back window and I see a small blond-haired girl in a long nightgown with a ruffle at the hem and on the long sleeve ends – she is running along my fence as if she is scared. I yell, 'Hey Bill there's a little blond girl running around in the yard, she's about three years old – how the hell did she get in over the fence?' We both run out and when we get there she is on the other side of the fence sitting in a pile of junk and this little boy is just pulling a rusty wire out of the heel of her foot. I rush over and pick up the little girl – she isn't even crying – she just looks up. Now I find myself walking along Main Street and I am stopping in to the stores and asking does anyone know this child? (I never saw her before.) I too am dressed in a long white nightgown with a ruffle on the hem and at the sleeve edges. No one seems to know the child. All of a sudden a woman dashes out

of the paper store – never says a word, just grabs the child from me
and starts to walk off and I yell to her, 'You bitch, you better get
her to a doctor before she gets blood poisoning!' and I wake up.

Others wrote interesting dreams but with somewhat less than Millie's
palpable immediacy. Those who said they did not dream were asked to
write dreamlike memories.

Dreams, and memories as dreams, loosened the prose writing which
had been too self-conscious, and then the group began to write early
memories touched off by specific thematic assignments. At this stage the
assignment gave them a lot of security although, it is interesting to note,
they often ignored it and took off on their own. The first of these assign-
ments asked for a memory of having done something that was naughty or
forbidden. This lesson was enjoyed enormously and some delightful
pieces were written. The poem that touched off the memories was
Theodore Roethke's 'Child on Top of a Greenhouse.' [8] It provoked
wonderful discussion about the excitement, as well as the fear, involved in
doing the forbidden or dangerous.

I began every lesson with the reading of more poems. This was not for
any critical analysis of the poem. It was to introduce them to new pleasures
in language, to loosen them up, to open a world of possibilities. They
wrote a lot. Some were natural storytellers, others poets. But almost
everyone tried everything. They were enthusiastic and generous with one
another.

The workshop, which continued for four years, became the center of
their lives. Mine too. During those years we lost some members to illness, a
few to death. And others came. The basic core group of eight or nine
devoted writers remained constant. Their work appeared in two issues of
*Taproot* magazine. [9] Some of it was dramatized for a university production
which they attended on opening night. They laughed and wept together.

## At a nursing home

Almost a year after the beginning of the nutrition site workshop, I began
another at a nursing home. It was a fine private facility of excellent
reputation in a beautiful area. Most of the residents were well-off econom-

ically, or had children who were, but thanks to Medicare and Medicaid there were some residents from all classes.

Poet-playwright Claire Nicolas White joined me in the work there soon after I started. We began with about eight residents, acquired more, but often had far fewer, due to the serious illnesses of many of our members. We were struck by the vast differences in physical health, from quite hale-looking ambulatory members to extremely frail or crippled ones, and by the wide range in educational and class background. At one end of the spectrum was Mrs Maynard, an elegant, ambulatory lady, university educated, of wealthy family background. She had always liked to write letters, essays, journals, and had begun to write for us shapely, interesting autobiographical stories in a very careful prose. She was impatient with most of the others and was disdainful of our 'lessons.'

At the other end of the spectrum was Mrs Bushberry, a merry, frail little lady of ninety-one, wheelchair-bound for many years. She had only a few grades of schooling but had been thoroughly educated, as she used to say, in the school of hard knocks. Hers had been a life of poverty – adventures and misadventures straight out of Dickens – and she saw herself clearly as the heroine of the life story she was determined to write. In simple declarative sentences, pure McGuffy Reader, each one starting with 'I', Mrs Bushberry wrote a chapter each week, benignly moving through hair-raising episodes. All of us in the workshop, plus a few families and co-workers, waited with bated breath for each new chapter.

Near Mrs Maynard's end of the spectrum was Mr Weston, an erect, courtly gentleman of ninety-two, who wrote sonorous ballads in heroic couplets. He told us some salty little tales of the peccadillos of old Long Island characters – baymen and minor bandits – and, after a few months and much flattery from the ladies, he began to write these stories for us.

Somewhere towards the middle was Mrs Hartly, afflicted since girlhood with crippling arthritis, but eager to translate the brilliantly clear memories of her mining-town childhood into stories. And nearer to Mrs Bushberry there was Mrs Dearly, who had been raised in a hotel by ebullient uncles and a staid Quaker grandmother. She had fostered almost a hundred children in her lifetime and had almost as many stories to tell. And there were several others. Everyone here was literate, and, with the

exception of Mrs Maynard and Mr Weston, they were as eager to please as good schoolchildren.

I came to the nursing home convinced that the techniques which worked so dramatically at the nutrition site could work anywhere. After all, I had seen the first lessons slash right through all the inequities and the fears and plunge the participants into real writing.

### Resistance

Claire, my poet-playwright partner, and I tried. Most seemed confused or vague about what we expected. The alert, intelligent Mrs Maynard and Mr Weston balked. She would not, on principle, relate people to animals. He thought it was pointless, kindergarten stuff. At my urging a few people constructed poems mechanically, obviously getting nothing from the process – so different from the other group. I knew that they, although unable to articulate it, had felt the poem happening in them. Their joy, their gut reactions, had made me a believer. So I persisted. But here, although they tried gamely to comply, there was no engagement. Nothing happened for them. When I gave up, miserable, my colleague suggested that we read poems to them.

She read some Whitman; I read some Williams. They relaxed. They liked being entertained. Some listened with seeming pleasure. Some looked glazed. Some slept. I wondered if the glazed or the sleeping heard anything. I wondered later how much any of them could hear. Only after a lively woman impatiently gestured me to wheel her nearer to us did I notice her hearing aid – then two more. 'If I turn it up high it buzzes,' she explained.

### Group poem

We decided to try a group poem, and explained that each person would contribute one line and we would write it on the board. When I started to erase the animals to make room, Mr Weston suggested that we not waste it, that we make the poem about animals. Mrs Maynard agreed to participate 'if we didn't get silly.' She had nothing against animals. A very quiet woman, who had not yet said anything, said she liked dogs, that dogs keep

us from harm. That became the first line. The quiet woman smiled shyly. This is the poem to which everyone but one, who really slept, contributed – even the glazed people:

Dogs keep us from harm
With a dog one is free to roam
An eagle goes where he pleases,
it represents the United States
where everyone is free.
I used to want to be a butterfly
but not a caterpillar.
We like to watch squirrels and chipmunks
early in the morning,
they always have something to do.
Be industrious like a beaver
if not in body, then in mind.

They were very pleased when they heard it read. So were we. They had used animals and made metaphor, after all. One of the ladies said they ought to do another, so they wouldn't forget how. Someone suggested a Christmas poem, as it was late fall. The talk came round to very special gifts they remembered, not the usual. So that we might get specific details, we gave some examples. This was their second collaborative effort:

### A Gift for Christmas

A very sharp knife to peel an apple with.
A comb shaped to fit the head.
A poinsettia plant I couldn't afford.
A little blue box of Battersea enamel
that says 'gift of a friend.'
The arrival of a longed-for letter.
An evening at the opera.
A big fat check, a winning ticket.
A walk through the meadows with grandchildren.
A good pair of legs, a mended heart.
Accomplishments, things done for others,
Freedoms – of various kinds.

> A gift of laughter, the effervescence
> of true joy, of inner warmth,
> a festival of lights.

This poem, just as it was created that day, was the result of 'on-the-hoof' editing. Pleading inability to get everything down fast enough, we let the weakest lines go by, making sure, however, that each person who spoke up had at least one line in the finished piece. The lines of the last verse were created by the two intellectuals. They felt the other lines were lacking in idealistic feeling. Later we would suggest ways of invoking even the noblest feelings through specific images. But for now we let it ride.

Our time was up. Attendants swarmed in to whisk our students off to lunch. Mrs Maynard brought us a stack of nicely-typed essays. Mr Weston waited politely until she left, whereupon he handed me several long, beautifully-scripted ballads. He said charmingly, 'Enjoyed myself more than I expected. But can't call that poetry.'

I worried about the glazed ones and the sleepers, but the assistant director assured me that we had gotten remarkable participation. She was truly excited.

### Three distinct groups

We had a lot to learn about what to expect of ourselves and them. I was angry with myself for having been so set and so naive.

After a few sessions we knew that it was a very different thing we would be doing here, if we could do it. What would it be if it survived? It did, and became a workshop. Each workshop was proving to be totally different from the preceding one, and this one evolved as three distinct groups.

Mrs Maynard, by herself, was one group. She continued to write her well-executed stories, which my colleague or I critiqued as we would any writer in a university class. Her stories grew more professional, and we and the group enjoyed them whenever there was time. Since our time was limited to one hour (our other workshops ran two and three hours) and the attention span was fragile for so many, we could not allow ourselves this treat very often. But Mrs Maynard seemed pleased with her special status. To our surprise, after a year or so, she took a flyer into poetry and really

enjoyed it. She periodically grew terribly impatient with the 'childishness' of the rest of us, but would, after periods of absence or stony silence, return to the workshop.

Mr Weston, our Edwardian gentleman of the iambic pentameter, Mrs Bushberry, our *Perils of Pauline* author, Mrs Hartley and Mrs Dearly and several others who came to us later, constituted another unit. They wrote eagerly, were the central group that determined the character of the workshop. 'Lessons,' which had to be extremely spontaneous, were mainly for them; they required some structure, or at least some point of departure, before they could move into writing. All except Mrs Bushberry, who moved doggedly from chapter to chapter through her life, one each week, health permitting. This central group loved to do blackboard (collaborative) poems, and became very good at them. Sometimes some of them dictated their own poems, spontaneously, to the scribes.

The third group were those I called the glazed or the sleepers. This group contained one or two real 'sleepers,' in the movie sense, who would periodically wake up and produce surprising things. Among the glazed were some who were listening, on some level, for they would occasionally make contributions to the group work.

My colleague became the resident teacher there for the next three years, with me relieving her when it got too rough emotionally or when she had to be away. So I was able to stay in close touch and learn with her.

Recently, I found a collective poem, produced about a year after this workshop began. The offering of individual lines had grown to the offering of whole verses:

### Five Ways of Looking at a Chrysanthemum

1.

Sad looking flower
with prickly white petals
smelling like Chinese food
unforgettable.

2.

Delicate and feathery white
it reminds me of a festive

formal dinner
that made me miss
a Saturday afternoon
football game.
The flower looks at me
through a yellow core
like a watching, patient eye
viewing life as it rushes by.

3.

The white flower
like a firework
bursting in the air
smells sweet
like the perfume Chanel
which my sister gave me.
It feels like rubber.

4.

The small one, reddish pink
strange smelling,
sweet but earthy.
The large one
a dark center
a sweet odor
feathery, graceful
and starlike.

5.

I always think of chrysanthemums
on Election Day
because I saw so many people
wearing them at the polls
in New York City.
The clean smell is soothing.
I will hang it in my closet
so when the door opens
Chrysanthemums!

I had never, before our experience in the nursing home, favored using group poetry beyond the initial session in any workshop. I had admitted that the group poem was a good device for loosening people up, helping them to deliver lines less self-consciously, since they were not responsible for the total effect. It helped to establish camaraderie in a new group. But I felt that the group poem was just another word game.

I felt, too, that many of the leaders of the rapidly proliferating poetry workshops were using the group poem as an end in itself – an easy out, producing what looked like poetry. They got a product they could show, that gave some momentary pleasure to the participants while obviating the real process, which had to be solitary, inside one individual, but which yielded poetry.

I think now that while I was not wrong, I was narrow. I had failed to see the collaborative poem as a teaching instrument. With vocal 'on-the-hoof' editing by the group leader, it can be an effective teaching technique in work with the very old and the very ill. Our members in the nursing home taught me that it was of critical importance for people to speak out, reach out, touch each other, even if minimally. Here, the fight against the encroaching isolation of the person was the primary struggle. Before people could tell stories or make poems they had to be aware, even a little. Without some sense of the self, of others, the environment, what would one say – to whom? Being in life had to come first.

So we brought flowers, stones, shells, lockets, pictures, parsley, into the workshop. People handled and smelled and passed things to one another, even the sleepy ones. We brought things of bright color, of pungency, of rough texture and smooth – water and sand and seeds. And then sometimes the group would make a poem, starting perhaps with something just held. I learned that it really didn't matter what they started with.

Claire Nicolas White, in writing of these collaborative poems for the third collection of workshop writings [10] said, '…the result is, on some days, a stronger and more honest expression of the feelings than the individual writing efforts.'

*No One Way*

So in this kind of a workshop – the third – new ways again had to be found. Clearly there was no one way, no method. There were techniques, some useful here, some there. In time, as the workshops grew in number, my teaching colleagues and I collected a 'big bag of tricks.'

During the next few years we became an organization with a staff of four teachers. I began new workshops with new colleagues who would then take over while I went to other places. We worked in other nutrition centers, other nursing homes, and in community groups like the first group, which has continued unbroken and is thriving today. And we went into schools as well, so children could meet grandparents and hear their stories. To be sure, this was not the same as having a resident grandmother telling tales on the long winter evenings, but the children responded joyously. The need is there; the voices to fill this need are also there – somewhere.

As the workshops developed, so did my conviction that anyone who can feel, think, speak – can write. And all over the country poets, teachers, and just plain people with golden ears, are proving this.

'But what are you getting?' many have asked, 'Is it literature, is it art?'

It is articulation. It is translating something of the self into language, which for even the most unlettered human is our uttered being. And if, beyond that, we can engrave the utterances in writing, something of our being remains.

Walt Whitman, speaking of a vanished Indian tribe, says in 'Yonnondio': [11]

> No picture, poem, statement passing them
> to the future
> Unlimn'd they disappear.

A workshop member who was losing her sight said, 'I want people to see me, to know I was here.' And another one, harking back to her Southern Baptist childhood, said, 'We are raising up our voices, they going to hear us. Glory be, we are bearing witness!'

## Definition

What we do is close to poetry therapy, for the act of writing honest poetry brings revelation, liberation, transcendence. We focus on the work; I do not mean the works, although these are valuable and often beautiful. I mean the *working*, because that is a powerful force for growth at any age. Such work requires life review, but with the psyche, led by the need for artistic choices, selecting what it wants, what it can deal with. Indeed, our work is close kin to the work of oral historians, but it requires of the writer-respondent a different kind of commitment to ongoing work.

I think I work to evoke this commitment to one's own development because I must keep proving to myself that at the center we stay green, capable of new growth, to the end of our days. I do this for myself.

I think too, that I work so that at least in the microcosm of the workshop none shall go unlimn'd. Probably, I do this for my grandmother.

## Notes

1. Kaminsky, M. *What's Inside You It Shines out of You.* New York: Horizon Press, 1974.

2. Koch, K. *I Never Told Anybody.* New York: Random House, 1977.

3. Teachers and Writers Collaborative and Teachers and Writers Magazine, 84 Fifth Avenue, New York City 10011.

4. *Taproot*, a journal of senior citizen writing, Winter 1974–1975. Taproot Workshops, Inc., Box 2-567, Setauket, NY, 11733.

5. Olsen, T. *Silences.* New York: Delacorte Press, 1978, p. 27.

6. From an unpublished work by poet and fiction writer, Kathleen Kranidas – techniques shared with many colleagues by this generous and brilliant teacher.

7. *Ibid.*

8. Roethke, T. *Collected Poems.* New York: Doubleday, 1966, p. 43.

9. *Taproot*, Spring/Summer 1977 and *Taproot*, Winter 1978–1979, Taproot Workshops, Inc., Box 2-567, Setauket, NY, 11733.

10. White, C. N. *Taproot* No. 3. Taproot Workshops, Inc., Box 2-567, Setauket, NY, 11733.

11. Whitman, W. *Collected Poems of Walt Whitman.* E. Holloway (ed.), Garden City, New York: Book Club Associates, 1926, pp. 432–433.

# Significant resources: A psychologist and a poet

Implicit in the writings of all our contributors is a profound belief in the creative process. So closely allied with play and spontaneity, creative process is different from imitation and all that is associated with meaningless busy-work. It has to do with the innermost cravings of the human spirit, the anima, to express often unreleased, unheard feelings kept captive since childhood.

Creative arts practitioners who work with older groups sometimes encounter resistance to activities that may at first seem childlike, that help release long-protected inhibitions. For this reason, it is important to know the leader/facilitator role well and the subtleties of group interaction. Only then is it possible effectively to guide individuals-in-group to paths of self-discovery and growth.

For this section of the book, we have invited two professionals to share their unique but harmonious views on creative process: the role of leader and the evolution of the group.

**Marilyn Barsky** was a clinical psychologist whose own work led her to incorporate many of the techniques of the creative arts with her clients. Highlighting some of the pitfalls in the way of reaching individuals in a rehabilitative group, she delineates the personal qualities and skills desirable in an effective leader.

**Marc Kaminsky**, psychotherapist, educator and poet, suggests, in passages from an essay, that the concerns of group work lie within the sphere of interest of writers and other arts leaders. He illuminates distinct phases in the emergence of a group. Then, using metaphor and other

poetic prose, he describes ways in which the creative artist/leader encourages individuation-within-community.

16.

# The creative powers within us
## A philosophy and a rationale

*Marilyn Barsky*

A bird does not sing because he has an answer;
he sings because he has a song.

Chinese proverb

Anyone who has worked with the aged in a nursing home knows how
little it takes to bring a light into the eyes of a burned-out old man or
woman. I firmly believe that even a simple, loving smile, a squeeze of the
hand or a light pat on the shoulder can help to retard the effects of physical
deterioration or organic brain syndrome. How well I remember one old
gentleman who, though I saw him weekly, could never remember my
name. Yet he knew my face and his own face lit up whenever he saw me.
He would recite poetry learned in early childhood, and accurately too. We
used to sit on his bed and recite poetry like 'Barbara Fritchie,' or sing songs
like 'Molly Malone' and 'When Irish Eyes Are Smiling.' This man came
alive during our hours together through his songs and poems.

My main intention was to help him have a meaningful interpersonal
exchange with another human being, to keep him in contact with reality,
to stimulate his memory and one or more of the five senses so that deterio-
ration, physical and psychological, would be, at the least, slowed down.
And I wanted to reconnect him with a sense of imaginative play, by means
of his remembered songs and poems.

## Let's pretend...

'Let's pretend...' Remember how often that phrase was used among us when we were kids? For many of us, it is only when we are children that we indulge in such imaginative pursuits. Except for professional and amateur creative artists, adulthood often means the suppression of the deepest need of the human spirit for rejuvenation through the use of the imagination and creative pursuits. Yet at every age from the cradle to senescence, there is the need to utilize the creative powers that lie within all of us if we could only find a sure way to tap them.

The nineteenth-century English poet Samuel T. Coleridge called the imagination 'that willing suspension of disbelief that constitutes poetic faith.' Freudians think of creativity as 'regression in the service of the ego,' believing that our creative powers come directly out of the unconscious, or, in other words, from our childhood wishes, dreams, and fantasies, not yet suppressed for the sake of the 'reality principle.'

In a society in which the Puritan ethic has been the predominant mode for many older adults, the pleasure principle is often relegated to an inferior position. For many of us, an early connection has been made between the pleasure principle and creativity. To our detriment, we are bidden to put away childish toys in adulthood, and by doing so are often barred from the use of our fullest, active creative powers. What price maturity!

### Creative stimulation and survival

Yet for the child, creative play is work, the stuff through which he or she tries on roles and rehearses for maturity. But creative stimulation for the infant and child is much more than that. Mental health workers like John Bowlby, Rene Spitz, William Goldfarb and others long ago demonstrated how lack of sensory and affective stimulation in infancy can often lead to stunted intellects, warped personalities, and even to 'marasmus' and death.

When the adult grows older, retires, and no longer can participate in the mainstream of American society, he or she may often also be cut off from important sources of affective and sensory stimulation. Is it too far-fetched to state that when this happens to the senior citizen in our society, the person, like the deprived infant, can shrivel up, deteriorate,

develop the adult equivalent of marasmus, and die? There is ample evidence that just such sequelae are the rule for many elderly people in our society.

Only very recently has society begun to pay attention to its elderly, and to acknowledge its debt and obligation to them. We are now seeing a proliferation of day-care centers and assisted living for senior citizens, of nursing homes for long-term care, golden age programs, and geriatric activities. For the first time in American history, many kinds of personnel are being hired or are serving as volunteers to implement creative types of programs for this population in the community and in institutions.

Senior citizens share human needs in common with all other groups and in addition have some unique needs. Like the rest of us, senior citizens need continuing physical, mental, and emotional stimulation; affection, approval, recognition, a feeling of self-worth.

Uniquely, many older persons are experiencing decline in their physical prowess, often a decrement of their mental powers, and quite typically, personality tendencies to withdraw from others which become exacerbated and overt. At the very time when these internal events are inevitably occurring to older citizens, their middle-aged children may tend to push them aside, and sometimes they must even uproot them and place them in impersonal homes. This phenomenon occurs both because of the inevitable new pressures on the middle-aged, and because of the prevailing attitude in our society that 'the old don't count.' For this age group, then, creative outlets are tantamount to survival.

It cannot be emphasized too strongly, however, that by creative outlets I do not mean the perfunctory and token programs, too often seen in nursing home facilities, in which prefabricated, stereotypical, and uninspired arts and crafts programs are presented to senior citizens; for example, paint-by-number kits or the copying of magazine pictures. Authentic creativity means, rather, the expression of one's innermost, highly individual experiences through whatever medium is natural.

## Creativity: reciprocal and transactional

Senior citizens, like all groups in the population, come in all shapes and sizes. The rates and qualities of the aging process are different for each

person, as are the talents, backgrounds, perceptions, and inner lives. The task of the creative arts worker is to encourage and nurture that which is already there and only needs awakening or reawakening.

Creative arts workers can learn to utilize their own innate creativity for the benefit of the senior citizens they work with and, incidentally, for the enhancement of their own creative powers. Creativity, in this context, is reciprocal and functions in the interpersonal field to enhance both the geriatric worker and the elderly individual. Creativity, in this sense, is transactional. An important result of the use of creative arts methodology is the development of the capacity for positive relating with others.

## Desirable traits: creative arts therapists and leaders

How do workers tap their own creative powers for enhancing the life of senior citizens? In addition to the special training they have, and the talents they bring to their own particular creative endeavors, whether it be dance, art, music, or drama, to work successfully with old people they must develop certain other assets and personality traits.

First, and perhaps foremost, workers must *like* old people. They must enjoy associating with the elderly, for, as with small children, older citizens are very sensitive to nuances in demeanor and nonverbal cues of all kinds in others. They know well enough when a smile is forced, or a pat on the hand perfunctory. Workers must have or attempt to cultivate what psychotherapists call 'accurate empathy.' For the lucky few, this trait is inborn; for others, it must be carefully cultivated and honed. It is sometimes helpful and comforting to discuss thorny problems with colleagues and sympathetic supervisory staff.

Workers must possess enough personal self-esteem and inner resources to be able to accept the fact that the appearance and behaviors of more than a few older people (like younger people!) can be quite unappealing. But, as a psychologist working with all kinds of people, I have often been surprised to discover that the least likely people can become attractive to us as we understand them better. And if we succeed, at last, in helping them, they can become beautiful.

Arts workers will find that some elderly people are difficult to involve in any organized activity. With some, it will take all one's ingenuity, wit,

and charm to engage them even slightly. And, no matter how persistent and resourceful the workers are, some they will fail to involve at all. For these moments of truth, it is imperative that each worker has stored up confidence enough to take in stride such blows to self-esteem.

It is most important that these workers enjoy people in general, and find satisfaction in relating to others. In many nursing homes and other institutional settings, workers will face resistances, albeit subtle, from many sides. They may have to win over skeptical, even hostile, administrators, as well as nurses, aides, and other day-to-day caregivers. It is amazing how many residents in a facility cannot be found on any particular day if just one nurse takes a dislike to a worker, or does not comprehend the purpose of the program!

Overall, creative arts workers must be:

- *spontaneous* and open to their own feelings and to those of others. They will need to use their openness to cut through layers of resistance and defense, as well as to tap their inner resources and wellsprings of creative energies.

- *flexible,* coming to their task with a wide repertoire of techniques and strategies to gain maximum involvement.

- *calm, collected, and well-organized.* A temperamental personality is not an asset, but verve and energy are musts.

- *persistent, with great patience.* The satisfaction of even one success with one elderly person is enough to compensate for less successful moments. If one senior citizen can become more open, more alive, and more feeling through utilizing the imagination and creative powers, something valuable will have been attained.

## Creative goals and methodologies

As a consultant psychologist in a long-term county nursing facility, I ran a weekly group where I attempted a variety of creative approaches. For a group therapist or counselor, there are two kinds of groups. The first, a traditional therapy group, is essentially rehabilitative, with a major focus upon obtaining certain personality changes for individuals within it. The

second kind I would call 'inspirational,' in which the focus is on infusing the individual with spirit or zest for life.

While the aim of a rehabilitation group is to liberate individuals from the bondage of their own hang-ups and self-destructive life-styles, the goal of a group in a long-term nursing facility is to help individuals adjust to current realities. Yet, in a very true sense, they can be liberated in spirit. They can be helped to lift themselves out of the doldrums and to find creative powers in themselves for the first time, or to rediscover them. In the particular group that I will describe, this was precisely the mission, and to this end certain creative methodologies were introduced.

The group consisted of senior citizens who were in the nursing home primarily because they were too incapacitated to be taken care of elsewhere, and a number of young, severely handicapped adults who supposedly could not function outside this highly protective setting. The rationale for mixing the two groups was simple: one subgroup could serve as catalytic agent for the other. The wisdom and experience of the elderly could be a valuable resource to the young, while the enthusiasm and zest of the latter could fuel the spirits of the elderly. On a dynamic level, the participants could serve as surrogate parents and children for each other.

As a group facilitator, my goals for the members of this group were:

- to increase *self-awareness* by helping each member to clarify inner feelings, goals, strengths and weaknesses, needs and fears

- to increase *interpersonal skills* by assisting all individuals in the group to develop a greater capacity for trusting each other and for increasing self-disclosure, as well as ability to listen and empathize with others; to develop increased awareness of other people's feelings and needs and temperamental difficulties

- to help members clarify their *value systems* by sorting out their philosophy of life; providing the opportunity to discuss, in an open atmosphere, death and dying and its significance for each person, as well as other kinds of spiritual concerns

- to promote *sensory awakening*, an awareness of one's body, its movement and rhythm; to stimulate sight, sound, touch, and smell

- to develop *spontaneity* through a sense of playfulness and participation in song, dance, role-play, guided fantasy, use of dreams, imagery, poetry and story.

Let me emphasize that these were ideal goals for the group, and of course, in reality, the group fell far short of reaching all these aims.

It consisted of nine individuals, three of them under fifty years old. Incidentally, attendance throughout the program was close to perfect, due both to the enthusiasm of the members themselves and also to excellent cooperation from administration, nurses, and aides.

An ultimate goal of a creative worker who deals with the elderly is to encourage senior citizens to get along without professional intervention. In other words, we want them to seek and find what they need and want from other seniors and, when possible, from friends and relatives in their environment. This is a way to remain vibrant and alive, giving and receiving creative solace and nurturance until the very moment of death.

I remember a beautiful eighty-five-year-old woman who came into the nursing home against her will with all her faculties intact. She had been placed there by a relative who was no longer able to care for her. She was in a deep depression when I first began work with her, feeling not only a sense of loss, but one of betrayal and abandonment. The most crucial part of my task was to teach her to reach out to those around her, to those who wanted and needed a relationship with a caring, loving, still very vital person. When she began to take an interest in and to seek out those residents who were less fortunate physically and mentally than she, I knew that my job was done. She adjusted to the home and found a new purpose in living. She then became her own therapist. At the same time, like Grandma Moses, she found a new profession in her old age – that of a 'therapist' for others!

## Role play

One technique successfully used with this group was role play. Naturally, the use of any technique of this kind must be postponed until the group members have learned to be comfortable both with the therapist and with each other. It must wait, also, until there is group cohesiveness and trust. In

addition, any technique used must arise out of the spontaneous discussion and needs of the group. This can be described as a 'spontaneous event.'

One example occurred in the following manner. The group session began with glum silence. There seemed to be a great deal of covert discontent displayed in the demeanor and countenances of the various members of the group. A latecomer, a twenty-five-year-old quadriplegic woman, had zoomed into the room in her electric wheelchair, her rather jerky and hyperactive movements and facial expression suggesting actual fury.

I waited patiently for some member of the group to open the discussion. Finally, the quadriplegic opened: 'I'm so dammed pissed!' she said. Gradually, other group members elicited the reasons. A seventy-year-old woman in a wheelchair, who often played the role of surrogate mother, coaxed the younger woman to tell her problem. The young woman exploded about the rehabilitation nurse who was threatening to take away her electric wheelchair and replace it with a manual one in order to 'give me more exercise.' Several other group members empathized with her because they, too, had experienced difficulties with this particular nurse. Now some other members in wheelchairs, both old and young, joined in with angry accusations about this worker's 'cruelty.'

After allowing the members to ventilate feelings for a time, I suggested that we do some role play, with the quadriplegic playing herself having a conversation with the rehab nurse, played by the seventy-year-old woman. I set up the scene.

The first time around, both were somewhat self-conscious and stilted. We then switched roles, using the same scenario. Gradually, others were brought into the scene to play different roles and bring their own ideas, as well as their own unique and individual feelings, to their parts. On one occasion, when I felt that a member could not express what he was really thinking and feeling, I used a psychodramatic technique called 'doubling.' I stood behind the person and voiced what I thought he was really feeling and thinking, in terms of my estimate of his core problems.

By the end of the one-and-one-half hour session, the results were gratifying. Not only did self-consciousness and reluctance abate remarkably, but also the whole tenor of the session changed to a less angry,

more jocular and humorous tone. A great deal of anger and frustration had dissipated, concerning not only the rehab nurse, but also other frustrating issues between various workers and residents in the nursing home.

In addition, through identification, the residents began to get in touch with other, more positive, motives of the workers. They discovered that distance and a sense of humor are effective antidotes to anger and despair. Finally, this first attempt at role play led to others, when this technique seemed to be the most efficacious and meaningful route to deal with day-to-day issues. Thus role play can be utilized both for assertiveness training and for rehearsal of real-life situations. A fringe benefit of such creative maneuvers is that a group becomes closer, more cohesive, and more trusting of each other.

## Guided imagery

Relaxation with imagery was another successful strategy used with this group. This standard induction technique consists of promoting progressive relaxation, starting with the muscles of the head, neck and shoulders, and progressing downward to the legs, feet and toes. Seven of the nine members of the group became deeply relaxed. The two members who did not attain a relaxed state quietly watched the procedure and were quite fascinated by it.

While the group members were in this relaxed condition, I suggested that they imagine themselves in a lovely green forest, that they try to see themselves in their mind's eye walking along a path on a crisp, sunny autumn day, smelling the aroma of pines. 'Visualize the beautiful orange, yellow, and red leaves of the trees; notice the vivid colors of the fall flowers,' I said. 'Imagine yourselves bending over to pick the flowers. Feel the soft velvety stems and buds in your fingers. Hear the laughter of children running through the woods, and the birds singing.' (The group leader was scolded by several members for encouraging the group to pick the flowers in the forest!)

The rationale for using this methodology is to train members in deep relaxation and to heighten sensory stimulation by the use of imagery. Later, I encouraged members to induce their own fantasies and to use the

particular imagery that gave them the most pleasure and relaxation in order to encourage their own innate creative powers.

Other techniques I used came from the encounter movement. Group exercises were initiated in which members were asked to sit back, close their eyes, and imagine a layered ball with an inner core, a middle and an outer layer. I asked them to describe it to themselves. Each member, in turn, was asked to tell the group what he and she had fantasized.

In rehabilitative groups, such an exercise is used to help individuals deal with character armor and then to look deeper into the ball to find the 'core' self. In other words, the ball is a symbol for the self. For example, a person who visualizes a hard outer core with an inner core that is soft as a marshmallow can be hypothesized on a dynamic level as being a person who is covering up considerable vulnerability. In this group, however, the technique was used more for the purpose of inspiring some creative types of fantasy. One old gentleman fantasized a white steel cruise ship that had three layers. In the outer layer, hanging over the side, there were lifeboats. When we talked about it, he confided that he always wanted to travel around the world on a tramp steamer.

At another time I asked the group members to close their eyes and to try to remember themselves at a particular age, such as six, twelve, or twenty-five, and then to report their remembrances to the group in as vivid a way as possible. This caused some rather deep psychological material to emerge from a few members. I particularly remember the seventy-year-old woman who ventilated angry feelings harbored towards her long-departed mother, which she had suppressed until the current disclosure. She reported to me later, in private, just how liberating it was to talk about her feelings in a non-judgmental, sympathetic atmosphere.

An art therapist might try such a technique through the utilization of members' drawings of themselves at various ages, then have them show the result to the group. Acting out and/or drawing the dreams of individual members is another useful technique for eliciting interesting material.

*Death and dying*

Another encounter-type technique was to ask each member what they would do if they found out they had only six months to live and had just inherited ten thousand dollars. For older people particularly, this exercise can stimulate discussion about death and dying – topics about which most people are ambivalent. Though we long to be able to open up and discuss this sensitive issue, we are constrained by old taboos and superstitions. It is helpful, particularly for senior citizens, if they can be encouraged to talk openly with each other about such matters. A word of caution is in order, however: the safest approach is to wait for a group member to initiate the discussion of death and dying. If you are going to use this technique, be very sure that you know each group member well, that group members know and like each other well and are comfortable and nondefensive.

## Autobiography

Group members were encouraged, also, to use a tape-recorder between sessions, in order to record their life-stories. This autobiographical technique had only limited success with this particular group. Another similar method is to encourage group members to keep a journal, writing in it for a few minutes every day. This works, of course, only for those individuals who can still write. Many older people have stopped writing altogether because of crippling arthritis. If some of these people can be induced to do some writing, it can not only stimulate their creativity, but may also help to reduce crippling of the fingers and hands.

These are only some of the techniques I used with this group. The number of methodologies for group or individual work are virtually endless, limited only by the goals, motivation, creativity, and particular training of the worker or volunteer.

## The importance of creative transactions in the interpersonal field

It must be emphasized that creative approaches are used mainly to facilitate process, not to bring about product. Certainly the most important outcomes of the creative process in geriatric settings are the

enhancement of intrapersonal vibrancy and joy, and more positive and rewarding interpersonal relationships among the older people, between workers and the older people, and with family members and friends.

Awakening a person to the life that is still burning within, to the surrounding environment, and to people whom he or she can love and be loved by in return – all of this represents the strongest rationale for the creative process as approached by a geriatric therapist and creative arts leader. Both of us are encouraging the senior citizen to take risk, to reach out to others and to receive in return.

Make no mistake, this is not an easy way to work. By their very reluctance and recalcitrance, the aged tax and stretch us to employ our fullest inner resources and creative powers. The pitfalls may be many, but the benefits of working this way are worth all we can bring to it. For both of us are, in essence, working with the elderly to recreate the life wish.

## Suggested Readings

Blatner, H. *Acting In.* New York: Springer Publishing Co., 1973.

Jennings, S. (ed.) *Dramatherapy: Theory and Practice.* London: Routledge Press, 1992.

Jones, P. *Drama As Therapy; Theatre as Living.* London: Routledge Press, 1996.

Kagan, J. (ed.) *Creativity and Learning.* Boston: Beacon Press, 1967.

Koberg, D. and Bagnall, J. *The Universal Traveler – A Soft Systems Guide to Creativity, Problem-solving and the Process of Reaching Goals.* Los Altos, CA: William Kaufmann Inc., 1974.

McNiff, S. *The Arts and Psychotherapy.* Springfield, IL: Charles C. Thomas Inc., 1981.

Otto, H. A. *Group Methods to Actualize Human Potential.* Beverly Hills, CA: The Holistic Press, 1970.

Robey, H. *There's a Dance in the Old Dame Yet.* Boston, MA: Little, Brown and Company, 1982.

Stein, M. *Stimulating Creativity* (Vols. I and II). New York: Academic Press, Inc., 1975.

# Invocations of group process and leadership

*Marc Kaminsky*

## Introduction

In these excerpts from an essay included in *All That Our Eyes Have Witnessed* (Horizon Press, 1982), Mr Kaminsky is preparing a group of poets and writers to teach in the Artists and Elders Project [a joint venture of Teachers and Writers Collaborative and Brookdale Center on Aging, Institute on Humanities, Arts and Aging, Hunter College]. All are proficient in their art; all are interested in aging and working with older adults. None of them, however, has much use for group work. Yet their workshops will involve small groups of older people. As a first step, he engages them in a discussion of their own experiences within all kinds of groups.

Groups are always an encounter with the unknown and surely no one can plan or foresee what comes next. This is what makes groups the miraculous things they sometimes become. No matter how many times people in a group have surprised you, shocked you, filled you with amazement, with profound respect, no matter how often you have come away with a heightened faith that group process can call forth unexpected powers, you never get to be on familiar terms with the unexpected. How often the energies of ordinary people assume miraculous shapes. And if the people

a workshop of old people writing poetry, truly incredible things can happen.

## The First Phase

Wise leaders tolerate the paradoxical nature of this First Phase. People are anxious and confused. The leader allows distance and provides structure; promotes but safeguards against intimacy. People are ambivalent about getting involved, and the leader allows everyone to have it both ways.

In the First Phase, a 'nondefinitive definition' of the group's reasons for coming together must be clearly agreed on. Like everything else, this will change, and so it must be left open to change. It must be clear, and yet its clarity must not be a mode of rigidity. Built into this early statement of purpose should be the seeds of its transformation into something which will itself be left open to include the not-yet-known.

So this is the task of the first time or times together: to build an answer to the question, 'What am I doing here?' Or, 'What is it all about?' What projects or goals make the connections among people in the room and open their lives out towards some common future? Passengers sharing the same compartment at the beginning of a journey, on discovering that they share the same destination, often start exchanging stories of their lives and recount by what crooked roads and byways they came to be in the same place, heading in the same direction. The group, then, can recreate this age-old experience, these openings of the heart in the course of a journey.

Wise leaders, knowing the natural pull toward this solidarity of travelers, do not push things, or rush them. They put their cards on the table while allowing others to keep theirs hidden. They are open-handed; they show they have nothing up their sleeves — no magical power, no secret purpose.

### Purpose

The group will be what the people in the group make it. The cards the leader turns over are in an attempt to piece together a royal house in which they can spend some time together, are a range of purposes, a starting place for the group to freely trade ideas until a shared sense of purpose begins to emerge.

In group-work therapy, this declaration of a way of being together is called a contract. In the group, as in the society of which it is a part, people are afraid of being cheated, made fools of, sucked in. The contract is a way of creating trust. The trust-work that goes on at the beginning of a group is at the heart of everything you say and do. This is the heart of the matter: to create trust in a situation in which people distrust each other. That early statement of purpose which comprehends the wishes and aims of everyone in the room is the acknowledgement of a bond among people walking the same road for a while. To that journey each one brings a capacity to trust that has, one hopes, never quite been killed off; if it has, life is unendurable. Walt Whitman once said that whoever walks a mile without sympathy walks to his own grave.

To the group, each one brings years of wandering in unfriendly cities and a desire to walk in sympathy with others. The wish for solidarity, frustrated by the way society is organized, may be timid in showing itself. It is nonetheless there, seeking its occasion, waiting for a situation in which its trust will not be betrayed. Each one knows this already, even if it is known only as the absence of something, a kind of hunger which as yet has no name.

Each one wants a world larger than his or her own skin to live in. It is only through working on a project larger than one's individual existence that one becomes fully human. The group allows people who feel that they have 'no place to be somebody' a place in which to taste the joy of generating a sense of community, of coming together, raising an emotional roofbeam and four walls, and going on, more complete in themselves for having built with others.

In this First Phase, wise leaders must actively create a sense of large possibility. They must inspire others without diminishing their capacity to take charge. In short, the leader must provide the table and the chairs but not the room arrangement; that will arise from the pushes and pulls of the people who shift things about as they make a place for themselves in the room. In the beginning, the leader will provide the coffee and cake, but will also welcome whatever anyone else brings to the table, so that the offerings will keep coming in and grow abundant, and the group will one day become a banquet.

## Phase Two

*Conflict*

In Phase Two, trouble begins. Here, the pecking order is slowly being made visible amid a whirr of flying feathers, accompanied by a lot of squawking and — among the less active combatants — ruffled feathers. Member against member, group against leader — the strain is felt everywhere; the struggle occasionally breaks out into open conflict, then grows diffuse again. The members are fighting each other for status. The group is fighting not to be diminished. What to do?

The wise leader, expecting trouble, is not alarmed, welcomes conflict for the good things it carries with it. Energy, wit, self-assertion, pride, anger, criticism — these things enliven a group and a person. Old people who at first glance seemed sleepy, after a few pecks look 'perky' — as I heard one old woman say. It is like the horseradish that I once saw another woman swallow a spoonful of, in one gulp. A flood of tears came to her eyes, horseradish tears. I asked, 'Why do you do this?' She said, 'I'm ninety-four. How else can I feel I'm still alive?' She sighed with pleasure; it was the pleasure of feeling something keenly.

Conflict is not the horseradish, but it does have value in bringing out the fullness of each person's particular flavor. 'Without contraries is no progression,' runs one of Blake's proverbs.

*Without conflict the people in the group cannot take power*

So conflict is the native element of the group at this time. Do not seek to avoid it. You may destroy the group by suppressing the active responses of its members to each other and to you. Let them in. And exercise restraint in your use of power. Allow people to criticize you. Don't merely tolerate it, take it in, and be ready to adapt your ways to the ways of the people in the group. Freely concede mistakes. And yet it would be a mistake to take their attacks personally. Often they do not refer to you or your actions. You are there as leader, as boss, as parent, and, if the group includes a few subjects of an ancient regime, as king; only you are therefore destined to fall from power. You may be subjected to their rage against oppression, against injustices and injuries they have suffered at the hands of people who have

had control over their lives and used it to make them swallow their words, choke back their tears, hold down the free movement of their arms. How wounded they have been!

Only them? Not you? Haven't you ever sat facing another person as if that person were the knife and you were the open wound? Never forget the humiliations, the mean-spirited moments when you lashed out at a friend, the rivalries, the nearly forgotten times when you were not at all masterful, you were the victim – have you already forgotten them? In a group your nights alone – lost, crying noiselessly into the pillow – will stand you in good stead. Your own war against depression will make you an ally of the anger that people in the group are no longer turning against themselves, but against you.

You will be criticized as much for doing too little as you are for doing too much. How can you keep to the middle way? It is not always possible to judge these things by the immediate reaction of the people around you. Yes, you must be vigilant and take cues from the others – let go of the reins you see them picking up. Yet you must remain your own 'locus of evaluation:' the place in yourself where you stand, free and apart from the pressures of others upon you, will be your source of stability now. If you are looking for reassurance from others, you will waver, be forced into hazardous positions, and torn apart.

And you will be vulnerable on both sides. On your right, you will hear people saying that you are too passive, a weakling, you are letting things get out of hand. They will say: if you knew what you were doing you would assume dictatorial powers over the group; you would run a tight ship, stamp out dissent, prevent underground currents from surfacing, control divisive behavior.

On the left, you will hear complaints about your dictatorial powers that are like bites of conscience. They will intensify whatever conflicts you have about assuming a position of leadership. If you are already fearful that leadership has something corrupt about it, your guilt may either cripple you, so that you use your power ineffectively, or numb you, so that you become callous and too removed from the people around you.

## Mediation

In this situation, you cannot let yourself be provoked into renouncing your role as mediator. At times you will have to fight a two-front war with the people in your group, refusing the crown that one side wants to offer you, and refusing to abdicate the position that the other side is challenging. If it is wrong to become a policeman, controlling the flow of heavy traffic, it is equally wrong to evaporate after a collision when a firm witness is needed. Be firm, too, in maintaining that 'law and order' is not the law of the group. Resist the temptation in yourself to rely on the more familiar and fascistic modes of order, and oppose it in others.

When things become dangerous, when the group is scapegoating one of its members, when someone looks as if he or she will damage someone else, intercede. A wise leader knows when and how to set limits.

Maybe the only way you can learn this setting of limits – which also involves a tolerance for anger, an ability to keep a calm eye of one's own in the midst of a hurricane – is to practice it among people. Forebear setting limits when your actions would protect someone who does not want or need your protection. And act forcefully when bullying persons are wiping off their boots on another's soul.

## Role definition

In many places the leader has been replaced by a 'facilitator.' That is such an ungainly word, too specialized. 'Catalyst' comes closer to my under-standing: that neutral person whose presence is necessary for the elements around to combine, and for change to take place. The image I like best is that of a 'conductor,' someone who knows the score, keeps the measure of things, but is hardly dispassionate. It is the leader's responsibility to make sure each one is heard.

Actually, I think it would be better not to derive the metaphor from music, but from physics. Then we might say that the conductor is a person who transmits heat and light, is capable of serving as a channel for the thoughts and feelings of others.

## Phase Three

*Harmony*

Phase three comes as a time of relief.

Each person knows his or her way around the group; it has become familiar. The free powder of anxiety which, like a light snow, covered everything in the beginning, has melted. Trust runs more easily in all directions.

The person whose leadership the group has challenged has become, for them, another person, no longer a possibly harassing master but an ally, a watchful eye around which the group conducts its affairs. Moments charged with meaning are returned to; a sense of coherence and order becomes palpable as the group, which has been an arena for stories, acquires a repeatable history of its own.

You see, this is a dialectical process. In Phase Three, everything reverses itself: before, discord; now, harmony; before, ambivalence; now, a clear purpose. Before, anger against the threat of domination; now, alliance with various sources of strength within the group.

*Idealization of leader*

But even here there is a danger. The lure of dependency may temporarily skew the perceptions of the people in the group. They may see you, the leader, as more powerful and good than you are. You may be idealized, courted, have bouquets flung at you. How gratifying this can be! How wonderful everyone feels! What warmth, what love is generated by venerating the leader! *But.* The moral elevation of the leader is at the same time a loss of status for everyone else. And you will have to resist the temptation to become a ministering angel who permits no one a moment of despair and pain.

*Dependence / independence*

I've warned you against the danger of dependency. Now I have to turn around and say: only through good experiences of dependency do we get a chance to become caring people. The more serious threat to our well-being comes from the American idea of independence. Inde-

pendence gets confused with being invulnerable, being utterly self-reliant, needing no one for anything, having enough money to command whatever services one depends on for life. It is simply inhuman, this sort of independence. People feel humiliated when they need help; they try to make themselves so independent of others that the networks of connectedness get snapped off, and people are isolated, not independent.

I do not think it is a bad thing to be dependent for a while if what you are really after is to be able to walk on your own two feet, and what you need is someone to lean on through a particularly rough part of the way. It is also necessary to know how to allow others to be dependent on you. It is important that you know what you have to give, and how much of it you are willing to give, and that you make this clear.

But the really important thing is that you do not secretly wish to attach the dependent ones to you, that you want them to go their own way, apart from you; that you do not resent their making use of you, and that you feel good will towards their separate existence. When you are conducting a group, you often have to step out of the way to allow people in the group to become interdependent. You often have to underscore the extent to which they are helping themselves and each other so that they do not become focused on getting fed only by you. Now you conduct only when other people stop being conductors.[1]

### Individuation

It occurs to me that the ultimate purpose of groups is to further the process of individuation in each of its members, that the pull toward individuation determines the life course of groups. Small groups function, ideally, as symbolic parents, wise and nurturing and powerful. In relation to them, individuals can manage to give up the phase or way of life they were living and enter upon a new life. The group can heal its members of the home-sickness – the fear and trembling and guilt – brought on by breaking with the past, and simultaneously initiate them into the ardor and bafflements of the present. What the group enables the individual to accomplish is a rite of passage.

# Notes

1    The unabridged essay speaks of a cycle which includes two additional phases: a phase in which a heightened sense of self-definition strains, but does not break, the sense of solidarity; and a phase of endings.

# Suggested readings

Kaminsky, M. *What's Inside You It Shines Out of You.* New York: Horizon Press, 1974

Kaminsky, M. *All That Our Eyes Have Witnessed. Aging, Reminiscing, Creating.* New York: Horizon Press, 1982.

Koch, K. *I Never Told Anybody: Teaching Poetry Writing in a Nursing Home.* New York: Random House, 1977.

Myerhoff, B. *Number Our Days.* New York: Simon and Schuster, Inc., 1978.

# Contributors

**Marilyn Barsky**, EdD, Clinical psychologist. New Jersey

**John Belcher**, MA, Musician, teacher and workshop leader; Rhode Island and Massachusetts

**Bernice Bronson**, MA, Playwright, director and actress; Rhode Island

**Victoria Bryan**, Co-founder and Managing Director, STOP-GAP Institute; California

**Stanley H. Cath**, MD, Associate Clinical Professor of Psychiatry, Tufts University School of Medicine; Boston, Massachusetts

**Sherry Diamond**, RDT, Registered drama therapist and freelance writer.

**Laura Fox**, Poet and Founder of Taproot Workshops; Setauket, Long Island, New York

**Pearl Greenberg**, EdD, National lecturer on art in education and gerontology. Retired professor, Kean University, New Jersey

**Christoph Grieder**, MA, Registered music therapist. St Barnabas Hospital; West Orange, New Jersey

**Jocelyn Helm**, MA, Registered dance therapist. Director and consultant, Senior Activities and Resources; Princeton, New Jersey

**Delight Lewis Immonen**, MA, Registered music therapist, oboist; Rhode Island College Faculty, Providence, Rhode Island

**Dorothy Jungels**, BA, Director, Everett Dance Company and Carriage House Theatre; Providence, Rhode Island

**Georgiana Jungels**, MA, ATR- BC, Board certified medical psychotherapist and art therapist. Professor, University of Buffalo; New York

**Marc Kaminsky**, Ph.D, Psychotherapist, gerontologist, writer; Brooklyn, New York

**Don R. Laffoon**, MA, RDT/BCT, Registered drama therapist, Co-founder and Executive Director, STOP-GAP Institute; California

**Marion D. Palmer**, Registered music therapist, national speaker/consultant and gerontologist; Florida

**Rose Pavlow**, MA, Registered drama therapist, co-founder, !Improvise!, Inc., adjunct instructor, University of Rhode Island; Rhode Island

**George S. Sigel**, MD, Community psychiatrist, program director, New England Medical Center Behavioral Health Program, medical director, Kit Clark Senior Services, Boston, Massachusetts

**Naida D. Weisberg**, MA, Registered drama therapist, co-founder, !Improvise!, Inc., adjunct instructor, University of Rhode Island; Rhode Island

**Rosilyn Wilder**, EdD, Registered drama therapist, Assistant Professor, Gallatin School of Individualized Study, New York University; New York

# Biographical Sketches

**Marilyn Barsky**, EdD Clinical Psychologist, American Board of Professional Psychology Diplomate, practiced family, group, and individual therapy in New Jersey, Florida and California. She used creative drama techniques in group work with all ages. Dr Barsky was a nursing home consultant and author of a range of articles in professional journals.

**John Belcher**, MA in Education, Harvard University; BS in Applied Mathematics, Brown University. Musician, recording artist and teacher, he has worked in nursing homes and senior centers, the Institute of Mental Health, Rhode Island, and in colleges and hospitals. Co-ordinator of the Algebra Project's African Drums and Ratios Curriculum, he also co-directs the Rhythm and Mathematics Percussion Ensemble in the Mathematics Pilot School, Boston, Massachusetts. For close to three decades he has explored relationships among music, dance, poetry, mathematics, science, culture, and healing.

**Bernice Bronson**, MFA, Boston University; BA University of Wisconsin. Actress, teacher and adjunct college instructor; also, playwright, dancer and theatre director. She has written several plays based on oral history gathered from Rhode Island elders, which include *I Do Remember* and *A Christmas Feast*. Other plays, published by New Plays, Inc., produced nationally, include *In the Beginning* and *Canterbury Tales*.

**Victoria Bryan**, Co-Founder and Managing Director of STOP-GAP. Victoria has a professional background in educational television and theatre, including study at the Royal Academy of Dramatic Arts. In the last twenty-one years, Victoria has developed an extensive network of support for STOP-GAP, made up of corporate, foundation, individual and other funding sources.

**Stanley H. Cath,** MD, Associate Clinical Professor of Psychiatry, Tufts University School of Medicine, Boston, Massachusetts. Lecturer in psychiatry at the Boston University School of Medicine; founding member and vice president of the Boston Society of Gerontologic Psychiatry, and founder and director of Family Advisory and Service Treatment Center, he is in private practice of psychotherapy, analysis, and geriatric psychiatry. Dr Cath is the author of *Some Dynamics of Middle and Later Years* and *Institutionalization of a Parent–Nadir of Life*; co-editor with Dr Martin Berezin of *Geriatric Psychiatry: Grief, Loss and Emotional Disorders in the Aging Process*. An editor of *Father and Child: Developmental and Clinical Perspective*, published by Little, Brown, Inc., he is co-editing *Stepfather: Creating and Recreating Families in America Today*, to be published by Analytic Press.

**Sherry Diamond**, RDT, has extensive experience in drama therapy, supervision, training and administration including directing day treatment, in-patient and community-based programs for a wide range of populations such as seniors, people with disabilities and older adults with dementia. A member of NADT since 1986, she currently serves as Chair of the association's Membership Committee.

**Laura Fox**, was the Founder-Director of Taproot Workshops, Setauket, New York. She has served as consultant and teacher of creative writing in California and at SUNY, Stony Brook, New York, working extensively in nursing homes and senior centers. Her writing has appeared in newspapers and journals in Alaska and Israel; she was a playwright, novelist and editor of *Taproot* magazine.

**Pearl Greenberg**, EdD. Retired after 28 years as co-ordinator, art educator and Professor of Fine Arts, Kean University, Union, New Jersey, her courses combined gerontology and art education and supervision of field work with older adults. She is the author of over 60 articles in national publications, and four books on art education, including *Visual Arts and Older Adults, Developing Quality Programs*, and co-author of *Lifelong Learning and the Visual Arts, A Book of Readings*. She helped found the Arts in Aging Committee, Society on Aging of NJ (SANJ). A fellow of the National Arts Education Association, she was co-founder of the NAEA Lifelong Learning Affiliate, and president of the University Council on Art

Education. Dr Greenberg continues to lecture at national seminars and conferences.

**Christoph Grieder**, AMTA, MA, Music Therapy, New York University; BA, Music Therapy, Montclair State University, New Jersey. Born in Zurich, Switzerland, he studied cello at the Music Conservatory, Zurich, and later obtained a Diploma in Psychiatric Nursing, Psychiatric University Clinic, Zurich. He has worked in psychiatric rehabilitation and with terminally ill AIDS patients in New York City. Currently he is a creative arts therapist in a New Jersey community hospital, using music listening, poetry, horticulture, painting, storytelling and music improvisation. He continues performance as a classical cellist, a folk-music performer, and lecturer on music therapy.

**Jocelyn Helm**, ADTA, MA, Dance Therapy, New York University. Founder and retired executive director, Princeton Senior Resource Center, New Jersey, she has been a leader in the field of aging for 30 years. She helped found the Arts in Aging Committee, Society on Aging of New Jersey (SANJ). Many of her innovative approaches to movement with elders are adopted statewide and nationally. Ms Helm has received the Gerontologist of the Year Award from SANJ, the Princeton Area Foundation Award for Community Service, and is listed in *Who's Who of American Women*. She remains active in local and state gerontology organizations; on the Advisory Board, Senior Resource Center, and SANJ. She continues to lead movement therapy and horticulture workshops.

**Delight Lewis Immonen**, M. Music Education, New England Conservatory, with a concentration in Music Therapy; BA, Music Education, University of Michigan. She has led workshops for elders in nursing homes and senior centers. A professional oboist, she is on the faculty of the Music Department at Rhode Island College. She also teaches music in the public schools of Providence, Rhode Island.

**Dorothy Jungels**, artist, dancer, choreographer, and workshop leader. An eclectic artist, Ms Jungels has been Director of the Rhode Island State Council on the Arts Touring Show to nursing homes and senior citizen centers where she also led movement workshops. She has illustrated books, and her sculpture has been exhibited in New York City, Texas,

Washington, DC and Massachusetts. Her contemporary dance companies, The Everett Dance Theatre, and Carriage House, appear on television and in concert halls of the United States.

**Georgiana Jungels**, MA, ATR-BC, past president of the American Art Therapy Association; a board certified medical psychotherapist and art therapist. As director of Art Therapy Studies, State University of New York (SUNY), Buffalo, NY, and consultant, she has developed numerous programs for people of all ages in educational and clinical settings, supervised staff and students, and collaborated on research studies with colleagues in the United States, Canada, Jamaica, England and Egypt.

**Marc Kaminsky**, Ph.D, gerontologist, writer, poet, and psychotherapist, he is in private practice in Brooklyn, New York. Formerly the director, Institute on Humanities, Arts and Aging at the Brookdale Center on Aging, he worked for many years with elderly Yiddish-speaking Jews in life-history projects and uses of storytelling. His books include *The Uses of Reminiscence; The Road from Hiroshima: A Narrative Poem*; and *Fire of Memory: Life-Review and Survivor Testimony* (forthcoming, Virginia Press). He has edited several volumes on the life-stories of older Jews, including Barbara Myerhoff's *Remembered Lives: The Work of Ritual, Storytelling and Growing Older*. His scholarly and creative work has appeared in many volumes, including *Because God Loves Stories: An Anthology of Jewish Storytelling*.

**Don R. Laffoon**, MA, RDT/BCT, serves as Chair of the National Coalition of Arts Therapies Associations (NCATA) and is immediate past president of the National Association for Drama Therapy (NADT). Don is Co-Founder and Executive Director of STOP-GAP, a non-profit theatre company providing educational interactive touring plays in schools, drama therapy services and specialized training through The STOP-GAP Institute.

**Marian Palmer**, AAMT, specializing in gerontology, initiated and co-ordinated one of the first music therapy programs in a Wisconsin extended care facility of 400 residents. She has also directed an early clinical training program for music therapy interns, and taught health care personnel. In Ohio she was a consultant at nursing homes and a teacher at Ohio State University. She is past chairperson, National Committee of

Gerontology, National Association for Music Therapy; past president, Ohio Association of Music Therapy; a charter member of National Association for Activity Professionals. She serves on the editorial board of activities of *Adaptation and Aging*, a journal for activity personnel. She currently resides in Florida, offering regional and national workshops, seminars and lectures for health care professionals.

**Rose Pavlow**, MA, RDT, has been a creative drama specialist for 35 years and drama therapist for almost 20. She leads workshops with normal and handicapped people of all ages in schools and libraries, nursing homes, senior centers, and other health care facilities. Co-founder of !Improvise! Inc., she also trains professionals and aides in the techniques of improvisation and storytelling. She leads intergenerational programs in Rhode Island and is an adjunct instructor in the Nursing Department, University of Rhode Island. Ms Pavlow is a member of the National Association for Drama Therapy.

**George S. Sigel**, MD. For thirty years his psychiatric practice has been devoted to the treatment of the chronic mentally ill, and in geropsychiatry, with older adults. Also interested in forensic psychiatry, he is program director of New England Medical Center's South Boston Behavioral Health Program, and medical director for Kit Clark Senior Services, where he teaches and provides direct care to elders. He appears regularly as host of the Alliance for the Mentally Ill cablevision TV program, *Mind Over Matter*, and maintains a private consulting practice in Norwood, Massachusetts.

**Naida Weisberg**, MA, RDT/BCT, Goddard College; BA Smith College, is the co-founder of !Improvise! Inc., a non-profit organization of creative drama specialists and drama therapists, active in Rhode Island since 1970. She provides workshops at senior centers and nursing homes, as well as with normal and handicapped children and adults, activity directors and teachers. Ms Weisberg and her staff initiate multicultural, intergenerational workshops, documented in video and text. She is on the adjunct faculty, Nursing Department, University of Rhode Island, introducing 'Exploring Loss Through Creative Arts Therapy Processes.' She has edited a recently published work, *Diamonds are Forever, but Rhinestones*

*are for Everyone*, an oral history of the costume jewelry industry of Rhode Island.

**Rosilyn Wilder**, EdD, RDT/BCT. She is Assistant Professor, Gallatin School of Individualized Study, New York University. Gerontologist and exponent of the creative arts in education and therapy, she was founder-director of Encomium Arts Consultants, Inc, based in New Jersey for 18 years. Its projects included: Autumn Stages Older Adult Theatre, an improvisational interactive lifestory theatre troupe, and Youth and Elders InterAct, collaborative programs in schools and elder centers. Dr Wilder trains activity leaders, health aides, educators and volunteers in 'life drama' at conferences and seminars. As author, her books include: *A Space Where Anything Can Happen, Creative Drama in an Urban School; Come, Step Into My Life: Youth and Elders InterAct*; and *The Lifestory Re-Play Circle: A Manual of Activities and Techniques*.

# Professional Organizations

American Art Therapy Association, Inc. (AATA) 1202 Allanson Road, Mundelein, IL 60060–3808 Website: http://www.arttherapy.org

American Dance Therapy Association (ADTA) 2000 Century Plaza, Suite 108 10632 Little Patuxent Parkway Columbia, MD 21044 Website: http://www.adta.org

American Music Therapy Association (AMTA) 8455 Colesville Road, Suite 1000 Silver Spring, MD 20910 Website: http://www.musictherapy.org

American Society Of Group Psychotherapy & Psychodrama (ASGPP) 301 N. Harrison Street, Suite 508 Princeton, NJ 08540 Website: http://www.asgpp.org

Generation United c/o Child Welfare League of America, Inc. 440 First Street, NW, Suite 310 Washington, DC 20001–2085 (202) 638–2952

National Association For Drama Therapy (NADT) 5505 Connecticut Avenue, NW, # 280 Washington, DC 20015 Website: http://www.nadt.org

National Association For Poetry Therapy (NAPT) 5505 Connecticut Avenue, NW, # 280 Washington, DC 20015 Website: http://www.poetrytherapy.org

National Coalition Of Arts Therapies Associations (NCATA) c/o ADTA 8455 Colesville Road, Suite 1000 Silver Spring, MD 20910 Website: http://www.ncata.com

# Index

AARP 22

acceptance 24, 49, 65, 70, 122, 183, 225

'accurate empathy' 244

activity directors 33, 39, 152, 164, 200

administration 122, 247

administrators 33, 96, 122, 245

adult education 32, 37, 216

advocacy 69, 77

affection 68, 121, 122, 127, 243

aging process 71–2

ageism 14–15

aides 164, 207, 245, 247

Alzheimer's disease 11, 181

'Amazing Grace' 191, 200

anger 48, 62, 119, 169, 248–9, 256–7, 258

anxiety 10, 17, 259

apprehension 44, 94 see also fear

approval 243

Arbuthnot, M. H. 165

'arm dancing' 180

Armstrong, Louis 149

Arp, Hans 79

art 44, 82, 88–9

and connectedness 11–12

see also creative arts

art centers 34, 38

art educators/artist-educators 33–4, 38, 39, 44, 140

art history and appreciation 32, 37

art materials 46, 48, 50–2, 193

art studio 40

art therapists 44, 47, 51, 53–4 see also creative arts therapists

art therapy 44–58 see also visual arts

arteriosclerosis 182

arthritis 64, 68, 180, 220, 229, 251

Artists and Elders Project 253

Arts and the Aging Program 79, 80

arts and crafts 40, 243

assertiveness training 249

atmosphere 24, 34, 65, 70, 77, 94, 119, 121, 174, 207, 250

attendance 247

attention span 47, 232

attitude 14, 34, 53, 114, 172, 173, 174, 183, 185, 202, 207, 217

audience 82, 134, 154, 160, 205

autobiography 251

awareness 18, 85, 135, 207, 235, 246

'Barbara Fritchie' 241

'Battle Hymn of the Republic, The' 202

Beautiful Soul of Don Damian, The (Bosch) 154

Blacks 218

Blake, William 256

blindness 49, 68, 72, 114, 115, 224

'Blow March Winds Blow' (Simpson) 118–19

Bosch, Juan 154, 155

Bowlby, John 242

brain and behaviour 56
brain injury and disease 47, 55, 241
breathing exercises 75
Brody, Stanley J. 64
budgets 22, 34, 86
'Buttons and Bows' 86

cancer 110, 185
cardiovascular system 63
caregivers 18, 152, 245
Carmen (Toreador Song) 205
catalyst 12, 168, 258
Center on Aging, Health and
    Humanities 24
challenge 18, 39, 183, 196, 202
change 9, 81, 82, 88, 103, 114, 201,
    254
chant 83, 206
characters (in play) 101, 103, 104,
    105, 107, 108, 109
'Child on Top of a Greenhouse'
    (Roethke) 228
childhood 126–7, 229, 236, 242
children 9, 16, 98, 115, 120, 242,
    246
    middle-aged 22–3, 243
    and seniors 169–71, 236
choice 46, 52–3, 97, 102–3, 106,
    110, 203, 237
choral group 200
Christmas 185, 212, 231
church 38, 216
'Cinderella' 175–6
'Clever Judge, A', 164–8
clinicians 13, 17, 18

Cohen, Gene D. 24
Coleridge, Samuel T. 242
colleges 32, 37, 38, 44
commitment 68, 69, 74, 237
communication 48, 49, 53, 62, 70,
    83, 100, 106, 135, 187, 189, 194
    skills 44, 51, 52, 108
communities 22, 23, 108, 113, 132
community, sense of 255
community centers 38, 44, 93, 151,
    185, 200
community settings 63, 67, 77, 100,
    113, 179, 180, 236
    music therapy 185–7
community support 69
companionship 64
confidence 42, 122
conflict 11, 17, 105, 256
connectedness 10, 122, 135, 154,
    260
    art and 11–12
connections 9, 10, 23, 24, 94, 194,
    242, 254
    empathic 9, 11, 12
contracts 74, 255
contracture 180
coordination 74, 85, 181
control 256–7
copy work 33, 36
'core' self 250
costumes 212
counselors 245
countertransference 15
'Country Mouse and the City Mouse,
    The' 158

crafts 35, 36, 41 *see also* arts and crafts
creative artists 11, 12
creative arts 10, 13, 18, 23, 94, 96, 98, 118, 135, 189
creative arts therapists 18–19, 23, 77, 197
  desirable traits 244–5
creative process 24, 41, 239, 251–2
creativity 24–5, 70, 95, 135–6, 153, 242
  natural 81–5
  reciprocal and transactional 243–4
crisis 17, 51, 199
criticism 36, 217, 256, 257
cultural considerations 53–4
curriculum 32, 36, 37, 42

dance and dancing 80–1, 83, 118, 153, 181
dance/movement 61–78
dance therapy 62
  definition 70
  typical session 73–6
Davis, Bette 13
Davis, Martha 153, 155
day care centers 23, 77, 163, 185, 243
  drama 107, 108, 112–22
  intergenerational programs 169–76
  *see also* senior centers
deafness 115, 205 *see also* hearing impairment
'Dearie' 134

death and dying 10, 16, 99, 118, 185, 225, 228, 242, 246, 251
defense 245
*'Deme, deme, deme el dinero'* 155
dementia 11, 55, 64
Dennet, Lisa 141
Department of Housing and Urban Development 66
dependence 184, 259–60
depression 13, 15, 16, 17, 18, 64, 65, 98, 188–9, 192, 247, 257
Deutsch, B. and Yarmolinsky, A. 165
direction 101, 107
  musical 206
disability (handicap) 9, 10, 34, 55–6, 101, 113, 115, 163, 246
disconnection 13
discussion 48, 50, 51, 65, 160, 175, 205, 228
disease 10, 12, 63–4
disoriented clients 94, 206, 207–8
distance 15, 101, 249, 254
doctors/physicians 21, 63, 64, 65, 69, 70, 130, 197, 198
documentation 186–7
'doubling' 248
*Dragon, Dragon* 13–14
drama 91–134
  intergenerational 135–76
drama therapy workshops 107–8
drawing 47, 52, 83, 87–8, 250
dreams 227–8, 242, 247, 250
drug
  abuse 64
  management 72

drums and drumming 82–3, 85
'Du Bist mein Herzen' (song) 206

Eckert, Edna 25
editing, 'on-the-hoof' 235
*Education of Little Tree, The* 149
ego 183, 196, 242
El-Razzaz, Mostafa 55
Elmwood Community Centre 151
embarrassment 21, 94, 194, 210
emotion 14, 62, 101, 104, 174 *see
    also* feelings
empathic connections 9, 11, 12
emphysema 63, 130
empowerment 21, 24, 103, 107, 110
encounter movement 250
environment 49, 96, 186, 235 *see also*
    atmosphere
ethnic diversity 108, 144–6
ethnic music 73, 205, 208
ethnomusicologist 153
eurthymics 181
evaluation 14, 15, 34, 180
exercise
    benefits 63, 64, 69
    and music 180–1
exhibits 42, 51, 52–3
expectations 39, 77, 202 *see also* goals

facilitator 103, 104, 105, 106, 109,
    246, 258
Famighetti, Robert A. 23
family 12, 113, 144–5, 146, 151,
    155, 168

improved relationship 180, 187,
    252
fantasy 82, 86–8, 242, 247, 249, 250
fear 42, 69, 207, 219, 260 *see also*
    apprehension
feelings 62, 65, 68, 101, 184, 232,
    245, 246, 248
    discovery 75–6
    discussion 51, 175
    expression 24, 46, 70, 98,
        117–18, 193, 235, 239
    focus on 104
    release 154, 174
flexibility (approach) 173, 198, 245
flexibility (physical) 64, 85
folk tales 113, 154, 163–76, 216
frail elderly 39, 100, 101, 104, 229
Freudians 242
friends 9, 16, 17, 151, 155, 174,
    212, 247, 252
friendship 159–60
    clients and therapists 80, 95,
        125
    seniors and teens 141, 174
fun 64, 65, 95, 101, 115, 147, 216
funding 15, 18, 33, 40, 66–7, 77,
    139, 155

games 170, 173, 174, 219–20, 222
Gardner, John 13
Geraldine R. Dodge Foundation 139
geriatric profession 21, 252
German 116, 218
    folk song records 180
gerokinesiatrics 63

gerontocrats 10
Gerontological Society of New Jersey 64
gerontology 23, 24, 33, 179
Gerontology Centre, Kean University 23
gerontophobes 10
Gershwin, George 117
'Gingham Girls, The' 79
goals 9, 19, 139, 141, 145, 182, 186–7, 205, 245–7, 251
'God Bless America' 202
Goldfarb, William 242
Grandma Moses 247
grandmothers 126, 140, 146, 160, 215, 218, 236, 237
grants 67, 124, 134, 155, 217
gratification 9, 77
Gray Panthers 68, 110
grieving 9–10
group
    composition 67–8, 218–19
    cooperative environment 24, 49
    crafts 35
    effort 96
    focus 119
    poems 121–2, 230–2, 233–5
    process and leadership 253–61
    sing-a-long 11, 182
    story 52
    support 70, 206
group leaders see leaders
growth 42, 88, 99, 212, 237, 239
guests 204
guidance 96

guided imagery 249–50
guilt 17, 18, 215, 257, 260

Haley, Alex 218
half-way houses 81
handicap see disability
Havighurst, Robert 69–70
healing 88, 98, 195
health care
    facilities 33, 38–9, 108, 80
    providers 14, 55, 56
    system 13, 17, 24, 198
health professionals 13, 55, 64 see also doctors/physicians; nurses
hearing aids 230
hearing impairment 16, 34, 36, 106, 108, 114, 163 see also deafness
helplessness 17, 154
Herodotus 56
Hispanic elders 151–62, 218
history 53
holiday celebrations 205
Holocaust 129–30, 145, 188
Honig, Margot 79
hope 11, 25, 82
hopelessness 96
horticulture 190, 192
hospitals 33
    psychiatric unit 188–99
    visual arts 38–9, 44
    see also mental hospitals
hostility 184
house sharing 110
housing progams and projects 15, 79, 81

humor 24, 25, 89, 101, 107, 111,
　163, 206, 249
Hungarians 218
husbands 53, 82
hypertension 71
hypokinetic disease 69

'I Love Coffee, I Love Tea' 206
identity 70, 77, 97, 135
illness 9, 10, 22, 63, 110, 197, 228,
　229
imagery 66 *see also* guided imagery
images 221, 232
imagination 48, 98, 242, 245
improvisation 114, 115, 119, 143,
　148, 158, 164–9, 174, 195
　　musical 200
　　STOP-GAP methodology 103–9
!Improvise! Inc 152
inactivity 69
independence 12, 15, 180, 184, 185,
　259–60
individual problems 208
individuality 67, 70, 209
individuation 260–1
inequities 230
injustice 256
in-service 33, 39, 122
insight 15, 18, 62, 65, 95, 101
institutionalization 44, 77, 82, 89
institutions *see* hospitals; mental
　hospitals; nursing homes
intensive care unit 184
interaction, social 18, 49, 96, 101,
　108, 183, 202–3

interdependence 260
intergenerational programs 135–76
Internet 56
intervention 18, 96, 247
interviews 14, 132, 153, 155, 158,
　175
intimacy 15, 254
Irish 218, 225
isolation 12, 15, 18, 38, 77, 113,
　235
Italian 209, 218

Jewish 128, 215, 218
journals 251
journeys 109–10, 111, 254, 255
joy 64, 98, 196, 236, 252

Kaminsky, Marc 217
kinesthetic rewards 85
'King's Tower, The' 154
Kittredge, George Lyman 128, 132
Koch, Kenneth 217
Kranidas, Kathleen 219
Kraus and Raab 69
Kuhn, Maggie 68, 110

language 47, 48, 106–7, 236
laughter 25, 65, 96, 115, 121, 139,
　152, 166, 169, 174
leaders
　　desirable traits 244–5
　　group process and leadership
　　　253–61

idealization 259
role in music group 202, 209–10
techniques 72–3
training 32–4
leisure 31, 34, 40, 68
'Let Me Call You Sweetheart' 134, 206
lethargy 39, 82, 98
'life drama' 139
workshop, summation 147–8
life experiences 81–2, 113
review 237
see also memories
life stories 147, 251 see also oral history/life story theatre project
lifestyles 10, 51, 160, 209
Little Italy 218
location 66–7, 73
loneliness 15, 16, 65, 113, 151, 159
long-lived 10, 12
Lopez, Vincent 129
loss 9–10, 15–17, 183, 247
Lower East Side 225
lunch sites see nutrition sites
lyrics 184, 200, 206, 209

marasmus 242–3
marriage 16–17, 53, 128–9
'Mary' (song) 202, 205
Mascaras de la Vida, Las (Bosch) 155
materials see art materials
maypole 181
media 32, 40, 41, 47, 82, 243
mediation 258

medical profession 10, 67
Medicare and Medicaid 22, 229
medication 13, 14, 22, 47, 64
memories 11, 16, 49, 62, 116–17, 126–34, 152, 172–3, 184, 228, 250
memory 48, 53, 69, 71, 96, 182, 241
men 41, 82–6, 115, 218
mental condition 15, 16, 23, 69, 101, 182–3, 179, 243
mental health services 15, 18
mental hospital
multi-arts program 79–89
methodology 34–9, 103–7, 245–51
Mijares, Pablo 156, 157, 161
mime see pantomime
mistreatment 15, 80
'Molly Malone' 241
Montague, Ashley 65, 68
mood 121, 170, 220
motility 69
motivation 62, 251
motor skills 108
movement 83, 96–7, 174
energizer 192
as a holistic tool 64–6
see also dance/movement
museums 32, 39
music 151, 156, 177
as an activity 200–12
listening 117–18, 189, 191, 204
making 80, 153
music appreciation 186, 205
music clubs 205–6

music therapists 159–60, 179, 180,
    181, 182, 183, 187, 189, 200,
    201
music therapy 179–87, 188, 194–5,
    201
    session structure 195–6
    three pillars 196–7
musical instruments 73–4, 181,
    194–5, 202, 204, 205, 206, 208,
    209
'My Buddy' 134
myths 118

names 83, 97, 182, 186, 202
Naragansett Indian 81
needs 18, 21, 42, 48, 69–70, 76–7,
    113, 179, 186, 201, 237, 243
New Jersey State Department of
    Community Affairs 66
New York Hospital 62
NewGate 124
non-ambulatory clients 96, 181 see
    also wheelchair users
nonverbal
    clients 44, 180, 183
    techniques and therapies 13,
        189, 203
nursery schools 170
nurses 84, 96, 197, 198, 207, 245,
    247, 248
nursing homes 16, 17, 23, 77, 79,
    81, 241, 243
    creative group therapy 245–51
    drama 96–8, 152, 163, 164–9

music and singing 11, 182, 200,
    201–8
    visual arts 33, 38–9, 44
    writing workshops 228–36
nutrition (lunch) sites 34, 38, 77, 79,
    80–1
    writing workshops 218–28

Olsen, Tillie 219
oppression 256
optimism 96
oral historians 153, 237
oral history/life story theatre project
    151–62
oral tradition 216
Orff, Carl 181
Orff instruments 181
organic brain disease 47, 241
osteoporosis 64, 68, 72
outreach 13, 124

pageants 148–9, 185
painting 35, 47, 190, 193
pantomime 97, 171
parents 16, 156, 172, 174, 246, 260
    leaders as 256
Parkinson's disease 63–4
Parks, Rosa 145
participation 13, 15, 24, 48, 49–50,
    83, 96, 114, 176, 202, 207–8
passivity 202, 208
patience 184, 245
peak experience 118, 204–5
perception 54, 95

performance 80–1, 185, 205,
    211–12
personal folders 208
personal history 82
personal strengths 47–8
physical condition 70–1, 101, 179,
    180–1 *see also* disability
physicians *see* doctors
piano 73, 185, 202, 205, 206, 210
Pilgrims and Indians 170–1
play 25, 65, 95, 98, 241
plays 99, 100, 105, 109–10, 160,
    239
pleasure 9, 12, 17, 18, 65, 85, 95,
    154, 207, 228, 230, 235, 242,
    250, 256
poems and poetry 82, 84–5, 99,
    118–19, 193–4, 219, 223–7,
    232–3, 237
    group 121–2, 230–2, 233–5
portfolios 42
Portuguese 209
post-traumatic stress disorder 188
poverty 219, 229
Powell, Adam Clayton 128
power and powerlessness 102, 151,
    154, 202, 256–7
Prall, Jean 142
prejudice 14, 145 *see also* ageism
pretend 92, 93, 94, 95, 136, 170,
    242
prevention 13, 69, 77
pride 205, 256
programming 40–2
Progreso Latino 155

progress 83, 115
prose writing 227–8
protection 248
psychiatric facilities 77 *see also* hospital
    psychiatric unit; mental hospital
psychologists 101, 132, 244, 245
psychosocial condition 179, 183–5
psychotherapy 13, 18
publicity 67, 216

quadriplegic clients 248
quality of life 13, 77, 185, 187

rage 256–7
reality 48, 97, 182, 241, 242
recognition 182, 186, 215, 243
reconnection 13, 18, 241
referral 14–15
regression 207, 242
rehabilitation centers 77
rehabilitation groups 246, 250
rehearsal 210, 249
reinforcement 182
rejection 184
rejuvenation 242
relationships 9, 10, 16–17, 122, 129,
    173, 247, 252
relatives 16, 148, 212, 247
relaxation 72, 249
religion 16, 159, 160
reluctance 113, 248, 252
remotivation 97
repetition 163, 182, 205–6
repression 64

resentment 15, 16, 108
resignation 190, 202
resistance 10, 17, 143, 202–4, 208,
    230, 245
respect 101, 103, 108, 135, 253
respiratory system 63
responsibility 39, 62, 173, 196, 206,
    211, 235
retirement 16, 34
    villages 23, 32
*Rhapsody in Blue* (Gershwin) 117
Rhode Island Committee for the
    Humanities 153
Rhode Island Department of Elderly
    Affairs (DEA) 152
Rhode Island State Council on the
    Arts 79, 200–1
risk factor assessment 154
Roethke, Theodore 228
role
    group leader 258
    new 185
role play 101, 103, 107, 109, 169,
    173, 175, 247–9
role reversal 158, 174

safety 47
Saint Saens, Camille 191
Sandburg, Carl 172
Sansbury, Gail 153
Satcher, David 56
satisfaction 86, 176, 245
scheduling 47, 68–9, 198
school 81, 95 133, 152, 236

intergenerational programs
    137–8, 140–1, 155–62
scores 181
Scottish songs 207
screening 70–2
scripts 132–4, 154
sculpture 25, 40, 48
security 70
self-actualization 32, 190
self-assertion 256
self-awareness 65, 108, 246
self-concept 183
self-contempt 14
self-discovery 95
self-esteem 10, 14, 244, 245
self-expression 62, 96, 98, 153
self-reliance 260
senile dementia *see* dementia
senior centers 77, 134, 161, 200
    dance and movement 61–78
    drama 93–5, 101, 107, 108,
        152
    music groups 209–12
    visual arts 32, 33, 36, 38, 44
senior citizen clubs 79, 81
senior rights 219
senses 70, 86, 241, 246
separation 77
sequencing 48
shadow show 52
Shakespeare, William 119
sharing 18, 24, 51, 86, 96, 113, 127,
    212, 254
Sheehan, James 65
Shinnecock Indians 218, 223

'Show Me the Way to Go Home' 206

Sidky, Saria 55

sight 86, 246

    loss 16, 34, 36, 48, 52, 236 *see also* blindness

*Silences* (Olsen) 219

Simpson, Minerva Maloon 118, 121

singing *see* songs and singing

skills

    arts 10, 31, 47, 80

    communication 44, 51, 52, 108

    interpersonal 246

    language 49

    memory 182

    motor 108

    self-care 85, 180

smell 86, 246

smoking 71, 130–1

social behaviour 170

social functioning 101, 183–5

social security 22

social services 13, 155

social workers 81, 97, 98, 197, 198

socializing 15, 31, 35, 38, 74

song writing 182, 184

songs and singing 11, 133–4, 180, 182, 201–12, 241

sound 86, 246

Southern Baptist 236

space 114, 210–11

speech difficulties 51–2, 115

Spitz, Rene 242

spontaneity 98, 239, 245, 247, 248

'Springtime' (Simpson) 121

staff 108, 205, 212, 218, 244

interruption 198

participation 207

support 122, 185

status 222, 232, 256, 259

stereotypes 62, 104, 142, 143, 173, 174, 175

stimulation 70, 242

stimuli 48–9, 115

stories 18, 21, 52, 113, 125, 152, 155, 160, 163, 215, 216, 218, 229, 232, 254

storytelling 194, 228

    group 189

strategies 36, 219–21, 245

stress 18

stroke 68, 115, 120, 180–1

success 185, 245, 251

superstition 251

support 36, 39, 68

    community 69

    group 68, 70, 107, 206

    staff 122, 185

suppression 242, 250

survival 18, 242–3

'Swan, The' (Saint-Saens) 191

Swedes 218

'Sweet Sue' 202

Tabone, Carmine 141

taboo 251

'Take Me Out to the Ball Game' 184

'talking' computers 55

tape recording 114, 251

*Taproot* magazine 228

Teachers and Writers Collaborative,
    New York City 217
techniques, development 115–18
technology 55
teenagers 155–62, 172–6
television 68, 82, 96, 135, 198
Thanksgiving, the first 170–1
'The People, Yes' (Sandburg) 172
theatre 91, 100, 101
therapists see relevant discipline
'This is the Army, Mr Jones' 134
threat 259
'Three Blind Mice' 203
touch 68, 70, 186
    sense 86, 246
touring plays and shows 80–1, 99,
    100, 109–10
training 32–4, 251
    additional courses 36–7
transactional 244, 251–2
transformation 82–5, 254
treatment 13
    options 13
    plan 180
trust 24, 122, 247, 259
trust-work 255
TV see television

unconscious, the 242, 253

validation 65, 104, 107
videotaping 155, 161
visual arts 29–30

training and curriculum design
    31–43
visual problems see blindness; sight
    loss
volunteers 33, 113, 140, 243
vulnerability 250, 257

walkers (walking frames) 39, 97
warm-ups 74–5, 116, 156, 170, 173
    music 195
    voice 210
Warren, Bernie 24
weight 69, 71
well-being 62, 162, 192, 259
well elderly 23, 25, 34–6, 100
wellness 12, 94
wheelchair users 39, 95, 96, 114,
    115, 171, 229, 248
'When Irish Eyes Are Smiling' 241
White, Claire Nicholas 229, 235
Whitman, Walt 230, 236, 255
widows 16, 218, 225
Williams, 230
withdrawal 12, 65, 114, 183, 243
women 41, 53, 64, 72, 80, 164, 218
'Wonderful World' 149
work 95, 221, 237
    Puritan ethic 242
World War II 129–30
writing 83–4, 193–4, 213–37, 251

Y's 32, 36, 37
'Yonnondio' (Whitman) 236